# The Absolute Artist

# The Absolute Artist

*The Historiography of a Concept*

Catherine M. Soussloff

University of Minnesota Press
Minneapolis
London

Published by the University of Minnesota Press
111 Third Avenue South, Suite 290, Minneapolis, MN 55401-2520
Printed in the United States of America on acid-free paper

Library of Congress Cataloging-in-Publication Data

Soussloff, Catherine M.
    The absolute artist : the historiography of a concept / Catherine M.
Soussloff.
        p.    cm.
    Includes bibliographical references and index.
    ISBN 0-8166-2896-3 (hc : acid-free paper). — ISBN 0-8166-2897-1
(pb : acid-free paper)
    1. Artists—Psychology.  2. Art—Historiography.  I. Title.
N71.S7   1997
701'.18—dc20                                                    96-36005

The University of Minnesota is an equal-opportunity educator and employer.

I dedicate this book to Bill and Genya,
my life and loves

# Contents

# Acknowledgments

I have been thinking about the material and the topics covered in this book for ten years. At the beginning of this project I had the opportunity to publish several articles that led me to the conceptualization of this book. I want to acknowledge the people and the institutions who made those publications possible. Thomas Tanselle taught a wonderful seminar on scholarly editing at the Columbia Rare Book School in which I started to think about the early biographies of artists as artifacts and texts containing many kinds of information. I remain grateful to David Rosand for giving me the opportunity as a very green assistant professor to join his session on "Old Age and Old-Age Style" at the College Art Association Meetings in 1985, for the generosity he showed in encouraging me to publish my expanded paper in an issue of the *Art Journal*, and for introducing me to Martin Kemp, who has become a trusted advisor and friend. I thank Arthur Marks and Mary Sheriff at the University of North Carolina, Chapel Hill, for asking me to teach a graduate seminar on early biographies of artists, which led to an article on "*Lives* of Poets and Painters in the Renaissance," published in *Word and Image* in 1990. I remember that seminar and my year at Chapel Hill fondly, particularly the work of Andrea Bolland, and my friendship with colleagues Arthur Marks, Frances Huemer, Mary Pardo, Kathy Schwab, and Richard Shiff.

When I moved to Santa Cruz in 1987, I brought with me my six-week-old daughter and the idea for a book project surveying the *Lives*

of artists in the Italian milieu from circa 1450–1700. I am grateful to Harry Berger Jr. and Beth Pittenger for their help in the further formulation of this idea, which, although no longer the topic of this book, resulted in my being awarded a National Endowment for the Humanities Fellowship for College Teachers in 1990. I am additionally grateful to all my students who in various classes, seminars, and papers have helped me to understand the significance of articulating the difficult as clearly as possible. James Michael Weiss and Thomas Crow also were extremely encouraging at this time.

In 1989, I left for a sabbatical in New York City with the idea to write a book on the genre of the biography of the artist in the Early Modern period. There, I was immeasurably aided by my affiliation with the New York Institute for the Humanities at New York University and by the supportive environment provided by Director Richard Turner and his assistant, Jocelyn Carlson, and colleagues Peter Buckley, Paul Mattick, Luke Menand and his wife, Emily Abraham, David Rieff, and Edward Rothstein. I will always be grateful to them for the daily challenge of meeting their questions and for their personalities during a very difficult period in my life. In New York I was also fortunate to have the friendship and intellectual companionship of Keith Moxey and Andrée Hayum, both of whom, in ways that they may not realize, helped me to rearticulate my original aim in the book so that it has become an entirely different project altogether and, I hope, a better, or more useful, one for both the academic scholar and the intellectual engagé.

Returning to Santa Cruz in 1991 as a single mother of a young child to teach and at the same time research and write about a topic of the scope to which the book had grown was not easy, but without the intellectual generosity and kindness of some of my colleagues, it would have been impossible. I thank them, in no particular order: Judith Aissen and Jim Clifford, Karen Bassi and Peter Harris, Christine Bunting and Richard Wohlfeiler, Richard Murphy and Christine Berthin, Audrey Stanley, Virginia Jansen, Michael and Susan Warren, Shelly Errington, Hayden White and Margaret Brose, Greta and Mark Slobin, Beth Haas and Chip Lord, and Sarah Franklin.

Over the years I have been very lucky to have had a number of research assistants, most of them my students in art history, without whose energy this book might have taken even longer to complete. I thank Carolyn Anderson, Andrea Hesse, Melissa Clyde, James Sievert,

Kate Warren, Rachel Surkis, and Dan Reyes. Judy Page and Mary Keelin, the staff in Art History at the University of California, Santa Cruz, have always been helpful and patient. Christine Bunting, Kathleen Hardin, and Claudia Weaver, the slide librarians at McHenry Library, have been extremely helpful in my research on the visual material associated with the project. At Porter College I thank Donna Riggs.

Drafts of parts of the manuscript for this book were read carefully and with generosity by Shelly Errington, Joyce Brodsky, David Cast, Steven Z. Levine, Hayden White, James Rubin, and Bill Nichols. Their comments were invaluable, but I take the usual responsibility for all errors.

Finally, I will never be able to adequately express my love and affection for the family and friends who have believed in my work and sustained my body and soul over the past ten years. I thank my dear friends Heather Thomas, Alice Donohue, Tina Meinig, Glenn and Susan Lowry, Susan Wegner, James Sievert and Francesca Gentile, Wendy Roworth, Lisa Heer, Deborah Masters, Jim Rubin, Susan Montague, and Melissa Colbert for listening so carefully and for providing me with a context in which I could both work and live. I thank my once Ph.D. advisors and now dear friends at Bryn Mawr College, David Cast and Steven Z. Levine, for their trust and help over the years. I thank my family, especially my brothers Gregory and Andrew Soussloff, my sister-in-law, Patricia James Soussloff, my mother, Barbara L. Soussloff, my cousin Marie André, and my beloved daughter, Genya, for their love and support. I thank my husband, Bill Nichols, not just for his love but also for sharing his deep learning and high standards.

The National Endowment for the Humanities and the University of California, Santa Cruz Faculty Research Fund generously provided monetary support for the research on this book.

# The Absolute Artist

## *Schematic Structure of the Artist's Biography*

### Prebirth
Portents
Dreams
Signs in nature of an unusual type

### Birth
Significance of place of birth
Family lineage
Naming

### Youth
Signs of early promise in drawing or modeling
Discovery by a recognized artist or artistic authority
Recognition of abilities by teacher, fellow students (including
  competition among artists), patrons
Virtuosity in one or more media
Early works described

### Maturity
Descriptions of major commissions
Ekphrases of completed works in prominent locales or collec-
  tions, including author's own

### Old age
Descriptions of late works in terms of artist's spirituality

### Death
Circumstances of death
Artist's preparations for death
Illustrious patrons and peers affected by death

### Fate of body
Physical appearance and personal habits of artist
Burial, memorials, tombs, inscriptions

### Fate of works
Artist's artistic lineage: students, schools, technical secrets
Significance of artist for author

*Figure 1*

# Introduction

We need history, certainly, but we need it for reasons different from
those for which the idler in the garden of knowledge needs it, even
though he may look nobly down on our rough and charmless need
and requirements. We need it, that is to say, for the sake of life and
action, not so as to turn comfortably away from life and action,
let alone for the purpose of extenuating the self-seeking life and the
base and cowardly action. We want to serve history only to the ex-
tent that history serves life: for it is possible to value the study of his-
tory to such a degree that life becomes stunted and degenerate—a
phenomenon we are now forced to acknowledge, painful though
this may be, in the face of certain striking symptoms of our age.[1]

FRIEDRICH NIETZSCHE

This book locates the artist in the discourse of history. By doing so, it
seeks a richer and more nuanced understanding of the artist, a cultural
figure whose significance cannot be disputed, but whose meaning has
rarely been examined or questioned. Paul Bové takes discourse analy-
sis to be "a privileged entry into the poststructuralist mode of analysis
precisely because it is the organized and regulated, as well as the regu-
lating and constituting, functions of language that it studies: its aim is
to describe the surface linkages between power, knowledge, institu-
tions, intellectuals, the control of populations, and the modern state
as these intersect in the functions of systems of thought."[2] The debt to

Michel Foucault in Bové's definition is obvious. It will be incurred throughout this book as well.

By locating the artist in the discourse of history I accept several givens about the subject, the artist: (1) the artist can be separated from other categories of human beings in discourse, (2) the artist is always gendered male unless called "the woman artist," and (3) the artist is constituted by and constitutive of discourse. Correlatively, the artist in discourse also means the artist in the discipline of art history. In my approach, a genealogical one, I take the concept of the artist to be central to the practice of an art history that has traditionally been driven by concerns with attribution and the delineation of individual and period styles. These concerns entail the artist, art, and art history with the "art market," a topic that I cannot pursue in this study.[3] I hope that my approach and the conclusions of my readings here will suggest how art history might contribute to a renewal of the project of art criticism, participating actively in a critique of the visual culture that is so central to today's lived experience.[4] This book attempts a "new historiography" for art history in order to bring the relevance of history, in all of its discourses, into alignment with a variety of theoretical methods that have been employed since 1968 to interpret texts.

The appearance in history writing of the concept of the artist should logically lead to historiographical writing (the writing about history) where the historian has traditionally been most aware of how cultural and philosophical concepts operate in texts, that is, discursively. However, the obvious lack of critical discussion about the concept of the artist in exactly the literature where one might expect to find it was precisely one of the motivating reasons for the present study. In a little-noticed but important book about the artist-creator in philosophy Milton Nahm demonstrated that the very construction of the concept "artist" necessitated the contradictory conclusions (present in literature from every field) "that no problem is presented or that, if there is a problem, no alternative to their inferences is possible."[5]

Following Nahm, I use the word *absolute* to describe the cultural condition, or lack of conditions, pertaining to "the artist" in art history and other literature. *Webster's Seventh New Collegiate Dictionary* gives the commonly used definitions of *absolute*: "1a: free from imperfection b: pure 2: being, governed by, or characteristic of a ruler or authority completely free from constitutional or other restraint 3a: standing apart from a normal or usual syntactical relation with other

words or sentence elements 4: having no restriction, exception, or qualification 5: indubitable, unquestionable." It is my desire to release the artist from this state of pure being between the knower and the known (see definition 3) so that his social relations with culture can be detected and interpreted. I want to find a way beyond the absolute position described by Maurice Merleau-Ponty in his essay on Cézanne: "Thus it is true both that the life of an author can teach us nothing and that—if we know how to interpret it—we can find everything in it, since it opens onto his work."[6]

Concerning the situation of the artist in the realm of the absolute, Hegel's concept of "the Absolute" provides a useful starting point and may also be a determinant in the lack of philosophical understanding of the artist probed by Nahm. In the *Philosophy of Fine Art* Hegel wrote: "Art is no longer absolute beyond the stage at which art is the highest mode assumed by man's consciousness of the absolute."[7] For Hegel, art's necessity and value lay in its ability to indicate the absolute. When art was no longer spirituality or religion itself, then it became art, not the Absolute. Accordingly, the artist provides the insight into sense perceptions allowing us—his culture—to see the underlying concept of which images are the manifestation.[8] Thus, the artist has a special relationship not only to art but also to the Absolute, unlike other humans. It would seem that this special relationship is exactly what invests the artist with an absolute cultural status of his own. The artist is not just unlike others but absolutely different *because* of the concept of art.

The inseparability of art and artist establishes an important beginning for the investigation of the artist in historical, or any, discourse. In *Art and Its Objects* Richard Wollheim argues that the focus on the object by art history concerns not only the object itself but also the concept "art."[9] According to Wollheim, "art" is a necessary precondition of art's history, and it follows from this that questions of definition regarding media or its critical terminology follow from its constitution conceptually. Moreover, these questions, according to Wollheim, occur in the later, more developed phases of a discourse on art, in spite of the fact that they are generally raised in "connexion with the beginnings of art."[10] Hegel says something similar when he writes: "Thus it is only as regards the essential innermost progress of its content and of its media of expression that we must call to mind the outline prescribed by its [art's] necessity."[11]

As might be expected, then, when we encounter the artist and the works discussed together for the first time, we also encounter a fully formed discourse for that discussion, the genre of the biography of the artist, in which the works and the artist are intertwined.[12] This genre will be discussed at length in the following chapter. We must assume that when we find the artist in these earliest texts that we are not at the beginnings of the formation of an idea about what is the artist and what is art.[13] These categories have already been constituted, if not in print, then absolutely in cultural practices. If we return to the origins of the genre of the biography of the artist in the fifteenth century, we will not find a beginning of the construction of the artist as we know it today but rather a preexisting idea of who and what the artist is. The futility of a search for the originary moment is thus established, although an investigation of the earliest discursive location in which the artist is represented will profitably be explored in chapter 2.

In the last chapter of this book I argue that because the connection between the artist and his work operates at a mythic level in our culture, all written accounts, such as biographies or art history dependent on these texts, have been seen as the "natural" expression of the artist's intentions. Discursively, however, the written accounts and the artist's intentions have been buried in the works of art: literally seen to reside there, in the case of artistic intention, or hidden in the discussion of the work of art, in the case of the written accounts. So Nahm was able to argue that "just and perceptive criticism attempts to find the ground for the products of art which we call works of fine art in the history, continuity, and identity of the self-same original mind which has its own unique and individual history."[14] The result of the internment of the texts is that their subject, the artist and the texts themselves, has been naturalized in the history of visual culture. To the extent that the artist in culture and the texts that represent him have not been examined critically, this remains a major epistemological issue. For our culture, knowing excludes the creator at the deepest of theoretical levels. The interpretative problem appears for the discipline of art history because texts cannot be analyzed if they are naturalized or buried. In this book I attempt to recover these texts from the methods of art historical discourse.

The naturalized position of the artist in the production, or in the practice, and the concurrent privileging of the object were ensured by the arguments regarding practice and the artist that arose in the eigh-

teenth century in the branch of philosophy known as Aesthetics, particularly in the writing of two of its founding members, Alexander Baumgarten and Immanuel Kant. Regarding the artist in eighteenth-century Aesthetics, Charles Dempsey expressed a complex situation in the following succinct terms:

> The notion first began to take coherent shape that creative activity—in other words that which governs the eternally mysterious leap from generic imitation to individual creation—was a function not simply of the trained intellect in the service of a native wit regulated by judgment, but was also fundamentally a function of individual and therefore variable psychological response, deriving not only from universal rule but also from individual sense perception. With this realization, given its first full formulation in the Aesthetics of Kant, the path to the modern perception of the artist and his creative role was blazed.[15]

The "individual sense perception" of the artist could be visible to the viewer in the work of art. Expressive claims for the work of art rest on this assumption. We shall see in the passage from Kant quoted below that in this regime, the artist possesses agency but only insofar as that agency is visible or can be seen in the work of art.[16]

Kant expressed his ideas about the splitting of artist and object in his *Critique of Judgment* (1790), the central philosophical text for the artist-object binary:

> We thus see (1) that genius is a talent for producing that for which no definite rule can be given; it is not a mere aptitude for what can be learned by a rule. Hence originality must be its first property. (2) But since it also can produce original nonsense, its products must be models, i.e., exemplary, and they consequently ought not to spring from imitation, but must serve as a standard or rule of judgment for others. (3) It cannot describe or indicate scientifically how it brings about its products, but it gives the rule just as nature does. Hence the author of a product for which he is indebted to his genius does not know himself how he has come by his ideas; and he has not the power to devise the like at pleasure or in accordance with a plan, and to communicate it to others in precepts that will enable them to produce similar products. (4) Nature, by the medium of genius, does not prescribe rules to science but to art, and to it only in so far as it is to be beautiful art.[17]

This passage pertains to every aspect of the definition of the absolute artist with which I began this introduction. We can easily see how Hegel incorporated it into his concept of art and the artist. We shall need to return to it again. With this philosophical basis, it is no won-

der that the artist, deprived of power, has remained extradiscursive in our culture generally, and in art history's *doxa* specifically.

Dempsey reminds us that Baumgarten coined the term *Aesthetics*, meaning "things perceived," knowing full well that it had already been distinguished by philosophers and theologians from "things known."[18] It is precisely here in eighteenth-century Aesthetics that we can locate the epistemological dilemma posed by the object-artist binary on its philosophical and theoretical levels. This brief account of the object-artist binary in terms of its place in the history of Aesthetics should be kept in mind when reading my chapter on Jacob Burckhardt's approach to cultural history, or *Kulturwissenschaft*, for it underpins his assumption that not only the artist but the political, the social, and the poetic can be understood through culture itself. For Burckhardt, an adherent to Kantian theory, this meant that culture can be known only through those things that are perceivable, that is, in objects, including architecture and performance, and in texts that describe objects, most especially biographies of artists. The chapter on Burckhardt attempts a historiographic critique of this assumption, which underlies all of German historicism devoted to the study of art. It is therefore a critique of the foundations of the discipline of art history itself.[19]

The inheritance of Kant and Hegel, together with the strength of German historicism, has resulted in the situation of the textually "lost" artist. An excellent expression of the Romantic strain of this situation can be found in E. T. A. Hoffmann's work:

> The genuine artist lives only for the work, which he understands as the composer understood it and which he now performs. He does not make his personality count in any way. All his thoughts and actions are directed towards bringing into being all the wonderful, enchanting pictures and impressions the composer sealed in his work with magical power.[20]

Just as the composer here is "sealed" into his music, so too the visual artist has been cut off from a critical assessment by being locked into the work of art, from whence only intentionality and genius, not an individual personality, can be discerned.

In the nineteenth century, the essentialist position toward the creator sometimes took extraordinarily literal turns. The *Bust of Bach* in Basel (figure 2) is an excellent example of this statement. The mu-

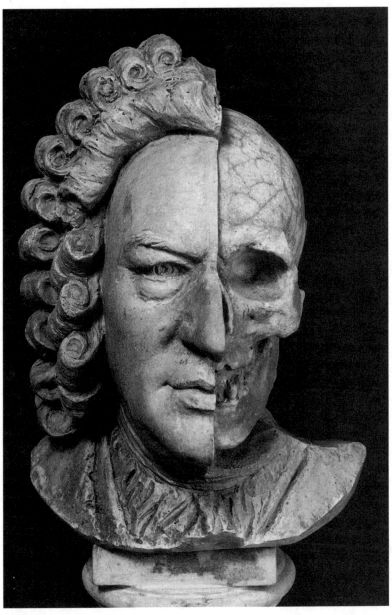

*Figure 2. Carl Seffner after Wilhelm His,* Reconstruction of the Bust of
Johann Sebastian Bach *(1894). (By permission of the Anatomisches Institut
der Universität Basel)*

seum's didactic display of the partially flayed and dissected head of Bach, based on the exhumed and decapitated remains of the man as well as on the documentation of contemporary photographs and a painted portrait, show the extremes to which science was put in the service of perpetuating the idea of the artist.[21] In the middle of the seventeenth century it was said of the Roman sculptor Gianlorenzo Bernini that he had the ability to make a marble bust appear as though it had all the color of life in its flesh.[22] In the display of the bust of Bach we are asked to consider how a knowledge of anatomy might aid not only in the illusion of reality but in the reconstruction of the lost "mind" of the genius. This archaeology of the body seeks a reconstruction of a reality, also a construction, "the artist."[23]

The naturalization of the cultural construction "artist" has produced two interrelated results for the interpretation of art history. First, there has been a lack of scrutiny of "naturalized" source materials, that is, the biographies of the artist; and second, the character types that are represented in and result from this literature have been naturalized in interpretation. I seek to address this situation, aware of the danger for the interpreter when the hidden becomes her center of interest, or when what has been taken for granted becomes the center of attention. If one accepts the major arguments of this book, the logical result will be the realization that doxological approaches to the discursive location of the artist—the representation of this figure in biography—have essentialized the cultural category "artist," because the category itself and its representations have been absolute, unexamined, and uninterpreted.[24] Hayden White, a major influence in this book, has stated the situation similarly by paraphrasing Nietzsche: "every discipline . . . is constituted by what it *forbids* its practitioners to do."[25] This book demonstrates that disciplinary taboos follow upon the heels of mythic cultural figures and, like other social taboos, result in suppression and repression.

My examination participates in a disciplinary critique that art historians began in the early 1970s, but it insists on the incorporation—indeed the centrality—of the discourse of art history in this critique.[26] The ongoing self-critique from within art history, while not dominant, has prepared the ground for many of the arguments presented here. An important caveat, however, is that the present argument challenges the "New Art History" whenever it attempts to abolish the discipline or the theory of art. If we are to extend the self-critique of art history

to the category "artist," then we must reexamine the foundations and the foundational texts on which the discipline itself is based, but we cannot deny their existence or their significance in the construction of past and present attitudes. Art history's *doxa* must no longer forbid alternative historical analyses of "the artist" within its domain. If accepted, my call to denaturalize the category "artist" will result in further deconstitution of the discipline. In a more constructive and less threatening formulation, I hope that it will contribute in a substantive way to its transformation.

It is time to underline again the observation already explicit in the title of this book, *The Absolute Artist*: there is an artist-object binary in the history of art as a discipline and as an epistemological endeavor. This binary as it pertains to one of its aspects, "the artist," deserves some comment here, at least from a historiographical point of view, although the fact that it cannot be the main focus of the book is a condition from which the major argument of the whole book results. Some of what follows may be construed as a statement of the obvious, but it bears stating because much of this book is an attempt to make the obvious less so.

Whereas the usual questions asked today by practitioners—the artists themselves—are concerned with identity, most questions asked by historians of art since the beginning of this century remain concerned with the object. This statement can be verified easily, perhaps even brutally (because it will not be a happy demonstration for many) in the recent call for session proposals for the 1996 annual meeting of the College Art Association of America. The wording of the call illustrates precisely my contention that the object continues to constitute the major concern of the discipline of art history in this century. It also articulates, in spite of itself, why this concern and focus are so problematic, both at the disciplinary and epistemological levels:

The theme *The Object and Its Limits* asks the central question: what is the art object? Or, to turn the wording around: what is the object of art history? Sessions might investigate: the museological practice of presenting and interpreting works of art; the kinds of knowledge gained from the scientific analysis of art objects through conservation; the value and limitations of connoisseurship; the possibilities of iconographical analysis; the relevance or irrelevance of critical theory to an understanding of art objects and their history; the boundary between art and other objects; the necessity of objects to our field of study; and the effects of new electronic technology on our appreciation and understanding of objects.[27]

In this list of possible approaches to the object, the word *history* only appears once, the word *political* not at all. The word *theory*, which might provide the bridge between the object and history or the political, and thereby enable epistemological considerations, occurs only once—and its relevance is questioned. Most certainly, this focus on the object, "the necessity of objects to our field of study," especially at the end of the twentieth century, allows art history to avoid its own history and the politics embedded in it.

Martin Jay has argued that the separation of the object from the corporeal—the body of the artist and the body of the depicted or imaged—and from the historical space that it inhabits ultimately derived from the invention of perspective, that is, "the perspectivalists' assumption of what was visible in the perceptual field: a homogeneous, regularly ordered space, there to be duplicated by the extension of a gridlike network of coordinates."[28] Jay suggests that the world created by "this uniform, infinite, isotropic space that differentiated the dominant modern world view from its various predecessors" enabled or was enabled by the emerging capitalist system that has flourished since the Renaissance.[29] Whether one agrees with Jay's contention regarding the centrality of the imposition and metaphor of perspective, its emergence in discourse and art theory at exactly the same moment as the genre of the biography of the artist indicates a similarity in effect on the issue of the subjectivity of the artist. In chapter 2 I discuss the issue of perspective and the significance of its appearance in the earliest biography of an artist, written in the last quarter of the fifteenth century. I anticipate that argument somewhat here by stating that the submersion of the artist in art history coincides with a regime of representation for the reification of the object, whether it be in space, as suggested by Jay, or in discourse, as in the biographies. The effect is not only an aesthetic one, resulting ultimately in "Aesthetics," but also political, as Jay suggests.

Accepting the already constituted artist makes the project of understanding the linguistic and narrative structure of the genre of the biography of the artist a most challenging one. In seeking a "description of the facts of the discourse," as Foucault called it in the *Archaeology of Knowledge*, there are many pitfalls. For example, in the exploration of the structure of the "artist anecdote" that I undertake in the final chapter of this book, we must be wary of accepting earlier philological models of literary analysis that found an originary moment in those

texts in which the "artist anecdote" appears, in discussions about the artist in ancient Greece, for example. In this light I urge wariness of the valuable but flawed studies in which the beginnings of the representation of the artist are thought to exist in "lost" papyri or missing dialogues.[30] Again, I would concur with Nietzsche, who recognized the futility of a search for origins in the epistemological endeavor: "The purpose of the 'law' is absolutely the last thing to employ in the history of the origin of law: on the contrary . . . the cause of the origin of a thing and its eventual utility, its actual employment and place in a system of purposes, lie worlds apart; whatever exists, having somehow come into being, is again and again reinterpreted to new ends, taken over, transformed, and redirected."[31]

The most subtle recent interpretations of early biography, for instance, of the *Lives* of saints, which predate the *Lives* of artists, have accepted the complexity of the genealogy of the genre of biographies. For example, Thomas Heffernan has written in his fine study of early "sacred biographies" that "texts have their beginnings not in the act of composition but in a complex series of anticipations."[32] Heffernan calls these anticipations "intersubjective" between the author, the audience, and the society of which they are a part. So, too, the earliest biographies of artists, emergent fully formed in a generic sense, in the fifteenth and sixteenth centuries in Tuscany must be seen as complex responses to a set of circumstances tied to Tuscany at that time: the Tuscan vernacular, the position of painters, sculptors, architects, humanists, goldsmiths, and so on in society, the technical advances made in a variety of media, and the conditions necessary for the expression of these in a discrete narrative form.

Conversely, as Foucault has argued, we must guard against "a wish that it should never be possible to assign, in the order of discourse, the irruption of a real event; that beyond any apparent beginning, there is always a secret origin—so secret and so fundamental that it can never be quite grasped in itself."[33] This "secret" origin of discourse operates manifestly in the biography of the artist, as the final chapter will show. The purpose of such secrecy, according to Foucault, is to "elude all historical determination." Foucault calls for a renunciation of "all those themes whose function is to ensure the infinite continuity of discourse and its secret presence to itself in the interplay of a constantly recurring absence."[34] The search for the origin of the artist would only continue to ensure the lack of a historically situated artist in a cultural

reality, the absolute artist. The absence that the absolute artist fills in all its narrative complexity, and repetitiveness, will be the place to which the work of this book eventually leads.[35]

If the concept of the artist exists at all in interpretations of the object by art history, he exists in the work of art, "sealed in his work with magical power," as Hoffmann wrote. A major argument made here is that the artist exists as the product of art historical methods used to explain the object in culture. The artist is a naturalized concept, existing in the object, with intentions signaled through a self-constructed persona for whom a primary trait is the possession of just those intentions capable of artistic realization, or "expression" invested in the work of art. Therefore, a genealogy of the artist intersects not only with the concepts of artist, art, and the biography of the artist but also with the question in contemporary cultural theory of how disciplines construct their own objects of study, their own methods, and, hence, their "discipline."

With a virtually exclusive focus on "the object," art history, particularly when addressing itself to art before 1848, or "modernity," has avoided many of the major developments of the past thirty years that have taken place in most other fields of the humanities and social sciences, where theory has questioned the limits of disciplinary discourses and formations. This book contains much theory, but at the same time not one theoretical approach. The complexity of the topic, "artist," warrants the eclecticism of the approach found in these pages and adumbrated in the endnotes. In seeking to bridge the gap all too present today in the humanities and social sciences between history and historical studies and theory and cultural studies, I have insisted on a synthetic method that will displease those on both sides of the divide. Against the conventions of most history writing, my story here does not unfold sequentially, or even always chronologically. There are repetitions and renegotiations of points or material already covered—justified, I like to think, by the complexity of the topic at hand. Against most theorists, I insist on the importance of grounding interpretation and philosophical explanation in the past in order to enhance their relevance and understanding for the present. To my mind, this practice of a "new historiography" is the only kind of approach that will allow an examination of the articulation amongst the very figures, such as the artist, discourses, such as biography, and institutions, such as art history, which have perpetuated history's inability to

absorb theory critically and theory's to absorb history usefully. This impasse must be seen to account for the lack of interest in or regard for either history or theory on the part of the general public. On the other hand, there is great interest in and regard for the artist. My use of both history and theory to discover the placement of the absolute artist in culture today speaks to my desire to make the activities of the interpreter actively participant in a political reality.

Finally, therefore, let me turn to a historiographical example of the political stakes that underlie the absolute artist. I use E. H. Gombrich here not only because his book *Art and Illusion* represents a logical extension of the concept of the artist posited by eighteenth-century Aesthetics, but also because at the same time it purports to be a rejection of German historicism, at least as Gombrich understood it.[36] Thus, unlike Burckhardt, who inherited the view of the artist found in Kant and incorporated it into a historicist framework, and Aby Warburg, who rejected the artist from the historicist framework, Gombrich embraced the view of the artist found in Kant while at the same time rejecting German historicism. Importantly, this did not result in another view of the artist or of the object, although some have argued that *Art and Illusion* provides just such new interpretations. On the contrary, it presents the final and most complete expression of a Romantic historicism in the service of Kantian aesthetics.

In *Art and Illusion* Gombrich rejects a historicism founded on a belief in the predictability of history in favor of an art history determined by the issues of style found in the works of art. For Gombrich, following Kant on genius, style resides ultimately in the hands of the individual maker. The evaluative system of judgment of the work of art, in summary its "style," resides in this assumption about the preeminence of the individual maker. Gombrich has said that his view of "the psychology of pictorial representation" was informed to a large degree by the positivism ("the priority of the scientific hypothesis") established in the work of Karl Popper.[37] Recently, he elaborated upon his intellectual debt to Popper in a series of interviews with Didier Eribon.[38] Popper's *The Poverty of Historicism*, published concurrently with the presentation of the Mellon lectures that later became *Art and Illusion*, prevailed in Gombrich's assessment of pictorial representation.[39]

While Gombrich embraces the agency of the maker, he will not also admit that the personality of the individual is determinant to style in the work of art, or at least he will not admit that the personality of the

artist can be determined from the work of art.[40] Herein lies the major contradiction in simultaneously allowing for individual agency, the priority of a valuative system known as style, and the category of Kant's genius-artist. Not surprisingly, given the taboo against personality, and although the term *psychology* appears in the subtitle of *Art and Illusion*, the methods of psychoanalysis are forbidden by Gombrich. They are rejected on empirical grounds because, according to Gombrich, they cannot convincingly demonstrate in either the artist or the work of art a verifiable linkage between art and life. As a method, psychoanalysis partakes of the predictability thesis of the kind of historicism shunned by Popper.

The results of the suppression of the methods of psychoanalysis by a discipline whose foundation rests on the ideal of the individual artist, inherited from Kant and Burckhardt, will be explored extensively in later chapters of this book. In radical terms, a logical outcome will be seen as one in which the appropriation of the suppression of "personality" by the makers themselves, because naturalized into the idea of the artist, effectively causes repressions, deformations, and obsession with the character, "artist," further reifying, if not fetishizing, the cultural concept.

*Art and Illusion* is a key text in the object-artist binary, at least in this century.[41] Carlo Ginzburg has argued persuasively that Gombrich sought a way around the category "maker" by positioning biography, and the biography of the artist in particular, as a completely alternative narrative in the history of art, one that in fact did not deserve to be recognized as history.[42] This is a position that Gombrich inherited from Warburg, as I argue in chapter 3. It should be noted that Gombrich's concentration on the object in history coincided temporally with New Criticism's similar privileging of the text over the author.[43] I will demonstrate that because the preeminent genre in which the artist has been textualized, the biography of the artist, has been minimized by those who have adopted Gombrich's view, the position of the artist remains one of critical negation. The result of an "absolute" status in culture is the absence of an individualized person in history.

Ginzburg does not say so, but Gombrich's diminishment of biography was highly artificial in that it did not represent the actual situation of how these texts had been used previously in art history. Gombrich did not want to make his work depend on direct artistic intentions or historical specificities, but only on the properties of the object, al-

though in practice his insights could not be generated fully without reference to such issues and materials. On all grounds, my work argues against positioning biography as an alternative, secondary, or unnecessary genre or narrative, just as it argues against the privileging of the discursive category "object" over "the artist" in the discipline. The alternative proposed here is to locate the biographies in their own reality, in discourse.

Important issues concerning Gombrich's rejection of psychoanalysis and the appropriation of Popper's view of historicism remain to be addressed. I have not covered all of them in this book. I suggest that there is a political stake to these issues. The definition or identification of that political reality is highly significant not only for the individual historians or interpreters of culture involved but for all the students for whom *Art and Illusion* has served as an introduction to art history and as a foundational text in the study of visual culture. Naming the political stakes involved is also extremely important in understanding the disciplinary formation of art history in this century when it continues to view *Art and Illusion* as a foundational text.

Some of the historical specifics of the politics are discussed in chapter 5, which deals with the diaspora of the Viennese Jewish art historians, Gombrich among them. Another aspect is clearly signaled in the dedication to Popper's book *The Poverty of Historicism*: "In memory of the countless men and women of all creeds or nations or races who fell victims to the fascist and communist belief in Inexorable Laws of Historical Destiny." Popper identifies historicism with theories of historical destiny. By dismissing the political extremes of fascism and communism, even by setting them up as polar opposites, Popper dismisses the possibilities that the methods of historicism held for other kinds of politically invested history. One of these was the acknowledgment of the importance of early narratives, such as biographies, in the subsequent interpretation of history.

Concerned with the representation of the subject and with the subjective, artists' biographies are always closely involved with the political, even as the form itself attempts to hide this engagement—perhaps more than any other kind of text used in the analysis of visual culture. Therefore, the suppression of those texts must be seen to possess a political dimension both for the discipline and for the culture. With Popper's dedication we should remember White's paraphrase of Nietzsche, that disciplines are constituted by what they forbid their practitioners to do.

Questions regarding the maker *have* been asked in other disciplines, such as psychoanalysis and literature. These discourses will be addressed in this book.

Contrary to the character of much art history writing, it will not long remain a secret that the self-consciousness of this author has contributed greatly to her political and historical consciousness in this book. This, too, is an aspect of the methods used and suggested here. It is also an aspect of my own identity as a woman, a historian, and a political being. Not a small part of my reality is the art history profession itself, something I do not wish to reject or destroy so much as place within a self-critical frame of the sort Barthes proposes in *Barthes on Barthes.* The nature of a paradigm shift has been well described by Thomas Kuhn, whose purpose in *The Structure of Scientific Revolutions* bears repeating here:

> History, if viewed as a repository for more than anecdote or chronology, could produce a decisive transformation in the image of science by which we are now possessed. That image has previously been drawn, even by scientists themselves, mainly from the study of finished scientific achievements as these are recorded in the classics and, more recently, in the textbooks from which each new scientific generation learns to practice its trade. . . . This essay attempts to show that we have been misled by them in fundamental ways. Its aim is a sketch of the quite different concept of science that can emerge from the historical record of the research activity itself.[44]

Just as critiques of the discipline of art history have been occurring elsewhere, the old and the new have continued to coexist within the same context.[45] Turf wars between academic disciplines are prevalent in academe today; in my experience this is particularly true concerning the terrain of the visual—visual anthropology, art history, studio practice, film studies, cultural studies, digital imaging. The revisions attempted in this book are not aimed at reviving old battles or establishing new binaries, new "disciplinings." Rather, my aim is to contribute to the advancement of the criticism of culture in the political reality of today.

# 1 / On the Threshold of Historiography: Biography, Artists, Genre

To write the body.
Neither the skin, nor the muscles, nor the bones, nor the nerves, but the rest: an awkward, fibrous, shaggy, raveled thing, a clown's coat.
ROLAND BARTHES, *Roland Barthes by Roland Barthes*

A coherent field of study, for the time being parceled out among semanticists and literary critics, sociolinguists and ethnolinguists, philosophers of language and psychologists, thus demands imperiously to be recognized; in it, poetics will give way to the theory of discourse and to the analysis of its genres.
TZVETAN TODOROV, *Genres in Discourse*

Like all history writing, this book mediates between individuals who existed in historical reality and texts that represent those individuals and that reality. This book insists more than most books concerned with history writing on the interplay between those individuals—their lives and ideas—and the texts that represent them for two reasons. First, this book specifies a certain subcategory of "genius" as its subject of investigation, the artist. Second, it foregrounds a certain kind or genre of text in which the emphasis is on the individual artist: the biography. In historical discourse the genre of the biography of the artist contains within it the autobiography of the artist, on which it depends just as much, but no more so, as it depends on a physical description of the artist.

19

## The Artist's Autobiography

First-person written or spoken accounts by the artist, whether in the form of the autobiography, memoir, or interview, have been considered to be particularly useful in understanding the artist and the work. These accounts appear with the beginnings of an art historical discourse, in fifteenth-century Italy. Whether it is the fifteenth-century *I Commentarii* by Lorenzo Ghiberti, or the sixteenth-century *Autobiography* by Benvenuto Cellini, or early interviews with Pablo Picasso reported in art magazines of his time, self-representations have always figured large in the discussion of artist and work in art history and criticism.[1] When Giorgio Vasari wrote the earliest series of artists' *Lives* (1550, 1568) in a commonly spoken language, the Tuscan vernacular, he wanted to use whatever he could find in the way of first-hand accounts by artists in his history. He wrote of his method in the preface:

> and having spent much time in seeking them out and used the greatest diligence in discovering the native city, the origin, and the actions of the craftsmen, and having with great labour drawn them from the tales of old men and from various records and writings, left by their heirs a prey to dust and food for worms; and having received from this both profit and pleasure, I have judged it expedient, nay rather, my duty, to make for them whatsoever memorial my weak talents and my small judgment may be able to make.[2]

In the more recent past, since the formation of the discipline of art history in the nineteenth century, autobiographical writings by artists have been used by the interpreters to discuss or discern intention as it appears to be evidenced in the work. They have used the autobiography and the interview, along with other "documents," to discern meaning in the work of art. Michael Baxandall's book *Patterns of Intention* has revealed how problematic this practice can be.[3] I would like to stress that this is particularly so when such motivations remain implicit in the interpretation or criticism, or when they are unexpressed by the interpreter. Because of Baxandall, it has become possible now to identify the dangers of impugning intention to the artist when interpreting a work of art more precisely, no matter if the source used to do so is autobiographical or "documentary."

Texts by practitioners, such as autobiographies and interviews, are sufficiently rare, and the desire for the expression of intentionality suf-

ficiently strong, that other self-representations of the artist, especially self-portraits and studio pictures, have been seen to be key in the interpretation of the artist and his work by art history.[4] When the maker asks the identity question through the presentation or depiction of his body—and this question is explicit in every self-portrait—the question assumes a historical specificity before it can become universalized under the idea "artist." Or, as Bernard Williams has argued, bodily identity is always a necessary condition of personal identity; in order for the artist to express his identity, the body's presence is of paramount importance.[5]

However, in self-portraiture the importance of the discursive context of the artistic identity cannot be completely avoided, for the way that any individual artist views himself must rely in some way(s) on the concept that the culture holds of the category "artist." Stephen Greenblatt has recognized the same to be true about certain Renaissance authors, and his term "self-fashioning," used to describe the complex textual representation of the authorial self, has gained some currency in contemporary literary studies.[6] We could say, in agreement with Greenblatt, that if Renaissance authors self-fashioned, so too did Renaissance artists, particularly in the area of the self-portrait— invented as a genre in this period—leading to the conclusion that such self-fashioning adheres to the genre of self-portraiture up to the present.[7] In 1934 Ernst Kris and Otto Kurz made a similar point about the appropriation of the artistic persona by the individual artist, something we could signal with the idea of the artist's self-construction, or with their term "enacted biography."[8] When the enactment of the construction of the artist is self-conscious, as it so often is, then the contingencies created in the apprehension of the "real" self emerge, sometimes in acute ways:

> One day, toward the end of a conversation I was having with the painter David Salle in his studio, on White Street, he looked at me and said, "has this ever happened to you? Have you ever thought that your real life hasn't begun yet?"
> I think I know what you mean."
> "You know—soon. Soon you'll start your real life."[9]

This book is not about the self-representation of the artist, the self-portrait, or the autobiographical text, but in truth these visual and textual genres should be read into my arguments here, although they often are not explicitly evident. It would be nonsensical not to admit

that the concept of the artist in culture and its appearance in various discursive contexts, particularly art history, have always been inflected by the makers themselves. They have been contributing to the idea of the artist that society holds as they have been appropriating aspects of it. The best recent work on biography and autobiography explicitly accepts the interdependence of the accounts by and about the artist.[10]

The inversions or perversions of artistic identity come up frequently as a theme in contemporary art practice. For example, Komar and Melamid, the name used by two artists from the former Soviet Union for one artistic identity, play extensively with the idea of the artist's self-construction (figure 3). They invented an eighteenth-century Russian artist, Apelles Ziablov, named after the most famous Greek painter; they appropriated the name of an unknown artist, Nikolai Buchumov, whose painting they found in a garbage dump in Moscow, in order to be able to exhibit works in a "realist" style. These identities signaled by names indicate the importance of the construction of the artist in a political context, not only in the former Soviet Union, where Komar and Melamid began, but also in the contemporary art world.[11] Their contributions to the concept "artist" aid the historian of visual culture in understanding its appearance in discourse.

Komar and Melamid did not invent the idea of the importance of naming in the identity of the artist, nor the perception of him held by society both as a person and a creator.[12] The 1568 version of Giorgio Vasari's *Life of Michelangelo* provides an excellent example of how pervasive this idea has been in the discourse on art, both in the auto-biographical and biographical contexts:

> There was born a son, then, in the Casentino, in the year 1474, under a fateful and happy star, from an excellent and noble mother, to Lodovico di Leonardo Buonarroti Simoni, a descendant, so it is said, of the most noble and most ancient family of the Counts of Canossa. To that Lodovico, I say, who was in that year Podestà of the township of Chiusi and Caprese, near the Sasso della Vernia, where S. Francis received the Stigmata, in the Diocese of Arezzo, a son was born on the 6th of March, a Sunday, about the eighth hour of the night, to which son he gave the name Michelagnolo, because, inspired by some influence from above, and giving it no more thought, he wished to suggest that he was something celestial and divine beyond the use of mortals.[13]

The possibilities of the appropriation or personalization of the concept "artist," often signaled by the emphasis on names and naming

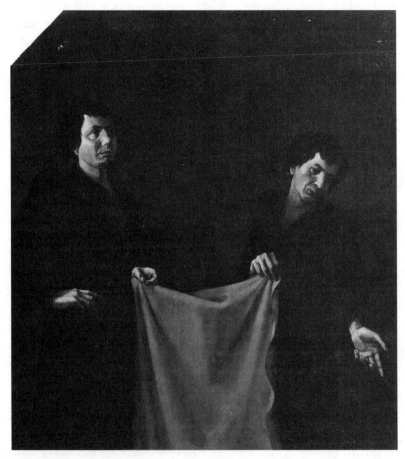

*Figure 3. Komar and Melamid,* Self-Portrait. *(By permission of the artists and Wadsworth Atheneum, Hartford, Connecticut)*

in the biographical and autobiographical contexts, call attention to the usefulness of this book for the practitioner. Vasari, Komar and Melamid, and countless others constantly challenge us in what they make with the question: What is the artist? While this book may provide some responses to this provocative and important question, articulated by artists since the early Renaissance, it is not directly about the world of making and the contemporary artist, although they cannot be imagined without the philosophical and theoretical assumptions explored here.

## The Genre of the Biography of the Artist

Most of the mediations by historians between individual artists and their lives have resulted in what is known in the discipline of art history as the "monograph of the artist," which I would call a professional genre. There have been mediations between the single biographical text or a group of biographical texts by one author and the representation of the contemporaneous reality represented by those texts, usually called "the historical context" or the period history. This book, on another hand, attempts something new: not only the mediation between the individual and texts that represent the individual but also, simultaneously, the investigation of historical mediation itself. Hayden White has called this level of historical analysis "diataxis."[14] This is accomplished through analysis of the biographical text, the historical interpretations in art history and related disciplines that rely on the textual genre of biography, sometimes naively, and the historical situations of the art historians who have examined or used biographies.

In this book, I attempt to work at two levels: the historiographic methods and actual historical situation of the historian, and the representation of the artist in the biographical texts. What are the interpretations of the artist that have appeared or resulted from these contexts? A restatement of my working assumptions pertains here: (1) what we know as history can only be known discursively; (2) the idea of "the artist" is already part of this discursive history; (3) historians who have addressed the image of the artist rely on this history often without adequate theorization to refer to what I call here the absolute artist in order to locate their historiographic tradition; and (4) I become implicated in the history as I interpret it.

These assumptions point to the centrality of discourse, writing, and genre, or of the impetus to view the discursive problem generically. A certain clarity can be established, I think, if I begin with a more personalized account of my motivation here by recalling that this book began with the textual question, How does the biography of the artist fit into the broader category, or genre, of biography in general? I first asked this question some years ago when I contemplated doing a scholarly and critical edition of a biography of the famous Roman sculptor Gianlorenzo Bernini (1598–1680) written by his son, Domenico Bernini, and published in 1713.[15] It was my intention in the introduction to put Domenico's text in the context of other biographies of artists written in Italy in the Early Modern period so that I could understand what the unique features of his contribution were not to the genre of biography but to the representation of his father, the artist Gianlorenzo Bernini, found there and in other texts, such as a diary, biographies, and art histories, to which the Domenico Bernini text was related.[16] It was clear to me that the enormous interpretative literature on the work of Gianlorenzo Bernini replicated the unusually rich lode of contemporary texts that had been produced during Bernini's lifetime, not only in number but also in the repetition of tropes, descriptions of works, and particular anecdotes.[17] Furthermore, I found that many of these tropes, types of descriptions, and anecdotes appeared in even earlier biographies of artists, such as those written by Vasari in the previous century. To clarify the contributions of Domenico, I thought to separate this text generically from the other texts about Bernini, such as the important diary by Paul Fréart de Chantelou, and, furthermore, to see what alliances it had with other early biographies of artists.

As it turned out, what I had been looking for—a systematic study of the genre of early vernacular biographies from its beginnings in Italy in the fourteenth century to the end of the seventeenth century when we find the biography by Domenico Bernini—did not exist. The major study of early history writing, Eric Cochrane's book *Historians and Historiography in the Italian Renaissance* (1981), calls biography a "lateral discipline."[18] His book lacks an extensive investigation of this important genre.

The closest approximation to a systematic study of the genre of the early biographies of artists remains the book by Julius von Schlosser, first published in 1924, called *Die Kunstliteratur* or, in its more recent

and complete Italian edition, *La letteratura artistica*.[19] Von Schlosser was the teacher of Ernst Kris and Otto Kurz, whose work I have acknowledged as fundamental for my study here. I will be exploring von Schlosser's significance in greater detail later in this book. Here, I want to concentrate on von Schlosser's view of the generic adumbration of the literature on art from the Renaissance to the eighteenth century, the subject of his study. The classical tradition in which he had been trained as an art historian together with the Germanic tradition of philology, which he used to analyze these texts, allowed von Schlosser to present a taxonomy of the literature on art of the Early Modern period. With this came a categorizing of the literature of art history into *kinds* of texts.

His book names the texts as the literature on art, *Die Kunstliteratur*, and separates it according to the subject matter of art and the artist from other kinds of texts written in the Early Modern period. Naturally, this means that biographies of artists are separated from other biographies, say of poets, written in this period. The literature of art history is thus decontextualized here. Furthermore, in the narrative part of von Schlosser's book (a large part of the text consists of extensively annotated bibliographic entries, an important aspect of taxonomic operations) selections according to kind are further refined: chronicles, descriptions of cities, theoretical treatises, technical treatises, autobiographies, and biographies, or *Lives*. Von Schlosser recognized from his own earlier work on *I Commentarii* by the fifteenth-century sculptor Lorenzo Ghiberti and from the work of his colleague Wolfgang Kallab on Vasari's *Lives* that although the various kinds of writing about artists had very different traditions and structures before the Early Modern period, there were particular aspects of biography, such as the artist anecdote, common to all such texts that determined subsequent interpretations of the artist and his work.

The important systematic work on the characteristics of the genres of writing about the artist and art that emerged in the Early Modern period in Italy begun by von Schlosser and Kallab early in this century was never carried forth. Von Schlosser's student E. H. Gombrich turned toward the object, not the text or the artist. His influential work serves as a prominent example of a pattern of rejection of the deeper implications of von Schlosser and Kallab's work. This rejection is homologous: the failure to continue von Schlosser's project of classifying and contextualizing the texts generically resulted in a lack of

commentary on the genre of the biography of the artist in the interpretative literature. Thus, my early desire to situate the *Life* of Gianlorenzo Bernini in a textual context was thwarted. There was no continuous tradition of the critical assessment of the biography of the artist on which to build.

Why is it that von Schlosser's project did not result in a comprehensive approach to the genre on which art history relied? Specifically, why did such a consideration of the most extensive and influential of those genres, the biography of the artist, *qua genre*, not follow? Why did the object persist, as in Gombrich? Much of this book seeks to answer these questions, which until now have often produced tautologies, such as the assumption of essential differences between the biography of the artist and the monograph of the artist.

## Genre Theory

The status of genre study itself, certainly inside the discipline of art history, but also in other disciplines that have tried to theorize it, has no doubt contributed to the difficulty of arriving at a satisfactory context in which to place the biography of the artist. Because the idea of genre is at the heart of my approach to the foundational biographies used here, and yet is also in itself problematic, the issue and the theory of genre warrant attention and, ultimately, a reformulation with the biography of the artist in mind.

It is worth stating that the theory of genre or the close attention to issues of genre has not been at the forefront of literary studies in the past thirty years or so. In one of the few exceptions to the last statement, Tzvetan Todorov makes it clear that this is because the issue of genre today will always appear to require a definition of "literature," a definition that he and others see as being constituted by "the discourse that, like my own, attempts to talk about literature" rather than by any idea of what literature is essentially or by nature.[20] If literature as a category is unclear, then how can genre be any more clear? If genre is a fixing of a form, it remains all the harder to contain when its overall terrain, literature, is itself accepted as an unfixed concept. The unfixing of the concept of literature *has* been at the front of poststructural approaches to literature and texts of the past thirty years.

Furthermore, when genre is approached as a way of constructing a literary history, it must be rejected in any modernist account of the

constitution of that history because the point of modern genres, such as the novel, was that they transgressed and redefined the very generic borders they inhabited.[21] Thus, Walter Benjamin could write of genre: "It is, moreover, precisely the more significant works, inasmuch as they are not the original and, so to speak, ideal embodiments of the genre, which fall outside the limits of genre. A major work will either establish the genre or abolish it; and the perfect work will do both."[22] In other words, the lesson of modernism from the moment of the Romantic novel onwards was that generic categories did not hold, nor did ideas about genre.

Russian Formalism, in fact, made a virtue of undoing conventions such as genre; *ostranenie* (literally "making strange"), or defamiliarization, became the essence of art. Victor Shklovsky explained: "Should the disordering of rhythm become a convention, it would be ineffective as a device for the roughening of language."[23] In Shklovsky's formulation there appears to be a necessary dialectic at work, but one that, again, like literature, floats. It unfixes genre that changes with *ostranenies*. To locate this observation in the post-Enlightenment discourse on the artist, we should return to the first two of Kant's points about the artist, quoted from his third *Critique*: "1) that genius is a talent for producing that for which no definite rule can be given; and 2) But since it also can produce original nonsense, its products must be models, i.e., exemplary, and they consequently ought not to spring from imitation, but must serve as a standard rule of judgment for others."[24] To accept the position theorized by Shklovsky and Todorov for literature, and genre, would be to deny the fixating qualities inherent in genius or any rule-producing agent or discourse. Therefore, their understanding of genre is useful to this project but in a way other than what either intended: as a historically determined category that can be employed for an interpretation dependent on it. This understanding of genre will allow us to explore what happens to the artist-genius when he is placed in a dynamic, genre-dependent context.

Jacques Derrida has used the idea of the breaking of generic rules or boundaries in order to hypothesize aspects of genre that are nonformal: "The question of the literary genre is not a formal one: it covers the motif of the law in general, of generation in the natural and symbolic senses, of birth in the natural and symbolic senses, of the generation difference, sexual difference between the feminine and mascu-

line genre/gender, of the hymen between the two, of a relationless rela-
tion between the two, of an identity and difference between the femi-
nine and masculine."[25] Derrida's understanding of genre as intimately
linked to issues of gender, not just etymologically but also structurally,
recalls the absolutism of the category "artist" in terms of being gen-
dered as male, and the biography of the artist in terms of the ways
it might discursively represent this gendering. This perception aids
in understanding the epistemological significance inherent in the cate-
gorizing of literature according to genres or rules. With a similar ap-
proach to the genre of autobiography, Philippe Lejeune has written:
"The job of the theory is not, therefore, to construct a classification of
genres, but to discover the laws of the functioning of the historical sys-
tem of genres."[26]

Derrida's invocation of natural and symbolic generation and birth
resonates with some of the observations that I will make later con-
cerning the genre of biography, life writing, or the life of the individ-
ual from birth to death. My point here, however, is this: if we accept
Todorov's assumption that the result of the contemplation of genre is
that "literature" rather than categories collapses *and* Derrida's posi-
tion that genre causes us to question the structure of individual texts
rather than the categories themselves, we begin to see how important
genre is to understanding biography. For this is a category of literature
that is known both as literature and as history.

We can accept biography as history only by understanding it generi-
cally and accepting literature as a contested and changing category. To
be precise, literary critics have long recognized the precarious position
of biography balanced between the expectation of the presentation of
a unitary life and personality "in his time" and the reality of a narra-
tive structure dependent on conventions and rhetorical strategies that
present the life "over time."[27] The tension of the simultaneity of the
diachronic and synchronic in biography together with the concept of
the artist inherent in every artist's biography would seem to make the
genre of the biography of the artist ideal for a poststructuralist generic
critique.

The multivalent power of genre in the discussion of discourse was
not lost in earlier times, particularly among Greek and Latin writers,
where the concept of genre originated, but in what discursive context
did it appear? Francis Cairns has argued convincingly that all generic

categories in ancient literature, whether in rhetoric or poetics, "origi-nate in important, recurrent, real-life situations."[28] Furthermore, he has shown that the categorization of the genres, or the "laws" of genre as Derrida would have it, operated efficiently and extensively both in poetry and in rhetoric. This is important when considering a genre such as biography that has aspects of both poetry and rhetoric imbedded in its very structure. In fact we should expect that a further generic refinement, the biography of the artist, which did not appear until the Early Modern period, would be a place in which the generic laws of poetry and rhetoric would merge most seamlessly and unob-trusively. I address the poetic aspects of the genre of the biography in the last chapter of this book when I tie it to the notion of the myth and the representation of the imaginary itself. It seems sensible to me to think that in these complex and undefined areas of myth and imagina-tion that engulf the cultural representation of the artist a genre such as the biography of the artist would necessarily have to include rhetorics and poetics.

I want to complicate the issue of genre even further here by refer-ring to its use in film criticism. I choose film because it is a field inti-mately concerned with the visual and the discursive, like art history. It is also concerned, especially in its infancy and more recently in the documentary, with the representation of a life. It is worthwhile re-membering here that one of the earliest movie projectors was known as the "Biograph." Once again, I must stress that this way of under-standing genre in the visual context comes out of a regard for "the ob-ject" (the film) rather than for "the artist" (the director). Genre criti-cism in the realm of "the object" is familiar to art historians who have studied the seventeenth and eighteenth centuries, when the French Academy introduced "the hierarchy of the genres," or ranking of the representational arts according to subject matter with history painting at the top. In film history the tradition of viewing the medium generi-cally no doubt arises in response to like categorization by kind in other, earlier visual media such as painting and nineteenth-century photography.[29] However, like art history, film studies and criticism also concern themselves with the maker, or the director, or the *auteur* as he or she has been variously called, as well as with the object or film. In fact it is the temporal convergence of *auteur* theories and the reeval-uation of film genres that interests me here, for it replicates to some extent the situation of the object-artist binary in art history without the

attendant interpretative impasse that has occurred in terms of the artist, the impasse that this book seeks to rectify.

Bill Nichols summarizes this important convergence in the history of film criticism this way:

> One of the most debated frontiers lies between genre and *auteur* criticism. . . . The debate across this frontier often deals specifically with the question of a priori meaning, because such a notion can be a restriction for the *auteur* critic, whereas a "repertoire of (ambiguous) stock situations" (to use Richard Collins' phrase) allows room for a director's personal expression.[30]

Put succinctly, *auteur* theory enthroned the director-creator as it attempted to define all genre according to formal ideals:

> However, auteur criticism is quite distinct from genre criticism. Genre criticism of the Western, for example, presupposes an ideal form for the genre. Directors may deviate from this form, but only at their own peril. The late Robert Warshow's celebrated essay on the Western described how a variety of directors failed to achieve Warshow's idealized archetype of the genre. By contrast, auteur criticism of the Western treats the genre as one more condition of creation.[31]

Here, in one of the most extreme theorizations of the *auteur* at the expense of genre, subject matter is subsumed under the category of the creator. These are ideas about the director that can be related to the formulation of the artist put forth by German Romanticism and embodied in the great composers, such as Beethoven, and the great artists, such as Michelangelo and Leonardo. Furthermore, the formal ideals regarding film genres that this approach presupposes in order to have them subsumed by the *auteur* do not pertain in a poststructuralist theory of genre according to Todorov and Derrida, as I have illustrated earlier. For here, the idea of genre is infinitely flexible and used as a way of understanding structure rather than form. As Nichols suggests, there can be no a priori meaning for either the genre or the *auteur* if both of these categories are understood to be nonuniversal or unessential. This is the state in poststructuralist approaches to film theory that have overthrown the *auteur* in favor of the centrality of language (a semiotics of film) or the spectator (theories of psychoanalysis in film). In both of these kinds of approaches, the analysis of discourse—the visual as a discursive field—prevails. Art historians can learn from the lessons of *auteur* theory in film studies.

## The Structure of the Biography of the Artist

Domenico Bernini's biography was one of many biographies of the artist published in Italy in the Early Modern period. All of these biographies differ in their specifics, but all of them have many aspects in common. These have not been outlined in their discursive form heretofore, but they can, in fact, be represented schematically, as I illustrate in the "Schematic structure of the artist's biography" (figure 1).[32] Briefly, we can consider the descriptive level of the biography of the artist to be the life of the artist represented mimetically, that is, in chronological order, as a life is lived from birth to death. Structurally, however, the life is represented in something that could be called "biographical time." The arrangement of the biographical text signifies the importance of time itself in the narrative of a life. Here we should keep in mind Bernard Williams's observation that the body is a precondition of individual identity. In biography the biological body and its time join with a chronological time imposed by narrative. Thomas Luckmann has put it this way in his consideration of biography and historical time:

> It is not surprising that categories in this set (one might call them biographical schemes) bear a closer resemblance to the diachronic interactional categories that differentiate aims and projects, define beginnings and ends, and coordinate interlocking phases of action than to the synchronic categories that measure duration (and provide a spatialized taxonomy for it). Both interactional categories and biographical schemes serve to order sequences of action in time. But there is a substantial difference in the temporal span on which the ordering occurs. Interactional categories integrate sequences of action within the individually recurrent and short stretches of daily life; biographical schemes integrate sequences of (temporally already preordered) action within an overarching, individually *non*current "long" sequence, the entire course of an individual's life.[33]

The events in the life may usually be represented chronologically, but their importance to the individual or their weight in historical reality is not as pertinent as their preordered arrangement, because the events are represented discursively in the form of narrative. This is a major difference between the generic structure of biography and autobiographical genres, where the individuals represented can impose themselves more directly into the manipulation of conventions.

In the case of the artist, an account of the life in chronological order

is interwoven with descriptions of the works and the body and character of the artist, along with subjects attendant on the production of the works of art, such as the artist's schooling, his patronage by men of wealth, power, and status in the society, and his technical skills. Each of these is a prominent aspect of the biography of the artist.

Because the life and the works are interwoven in the biography of the artist, certain parts or chronological sections of the life of the artist are given precedence textually in the biographies. This precedence can be seen simply in the amount of narrative space, particularly in the use of anecdote and descriptive passages, given to a subject or topic. I explain the theoretical function of anecdote in the biography of the artist in the last chapter of this book. Here, as can be seen in my "Schematic structure of the artist's biography" (figure 1), I want to stress that the narrative force of the entire biography rests basically on two things: (1) anecdotes about what the artist has been purported to have done in his historical reality, including issues of physical appearance, dress, and interaction with other individuals, most especially patrons and other artists, and (2) the description of the works of art.

The importance of establishing a word "picture" of the actual works of art made by the artist resulted in complex literary strategies for description that can be found in the biographies of artists. For example, Svetlana Alpers and Mark Jarzombek have explored the significance of the revival of ancient *ekphrasis* for use in the descriptions of works of art in the Renaissance period.[34] In ancient rhetoric, *ekphrasis* meant "a self-contained description, often on a commonplace subject, which could be inserted at a fitting place in a discourse. It . . . could deal with persons, events, times, places, etc."[35] *Ekphrasis*, in fact, was an ideal rhetorical form for insertion into the chronological narrative structure of biography because it was designed for inserting a description without interrupting the flow of narrative. The extended descriptions by Giovanni Pietro Bellori of the paintings by Annibale Carracci in the Farnese Palace that are found in Bellori's biography of the painter are excellent examples of how this form can function in the larger narrative.[36] This kind of description established the standard form, that is, the generic conventions, for the description of the work of art that is still found in much contemporary art history, particularly the exhibition catalogue entry.

In terms of the overall structure of the biography, the beginning and the end of the life are the chronological moments when the text ex-

pands or possesses the additional force of elaboration in terms of anecdote and description. This is appropriate given the importance of beginnings and endings in all narratives, most especially in those that imply a historical reality. I have examined this textual phenomenon in terms of the artist's old age and the attendant notion of old-age style in an earlier article.[37] The moment of the artist's birth, including pre-figurations of his birth and his naming, are topics that are found elaborated upon in the beginning of the artist's *Life*. In another article I have established that these topics are appropriated for artists' *Lives* from similar topics in the structure of the Early Modern biographies of poets.[38] More recently, Victoria Kirkham has shown how important these prefigurative moments are in the texts of early biographies of poets, upon which, I have argued, the early biographies of artists are based.[39]

Let me turn again to an example of the importance of one aspect of the early part of the biography of the artist, his naming, in order to demonstrate how this trope operates in the biographies of artists not only in the Early Modern period but later as well. Some time ago, Saul Kripke explored the issue of names and naming in terms of identity theory.[40] As he demonstrated, the use of names is an enormously important one in culture for it refers both to the body and to its place in history, or how it is individualized in history. In our cultural tradition we receive a given name as a given or natural part of "the self." The name is emblematic of "the self." If the body is essential to the personal identity of the individual, as Bernard Williams argued, a name is essential to the representation of the body and the identity in historical discourse. Hence, the naming of the genius in general in historical discourse is already emblematic of what is already given, that is, "genius." We should not forget the importance of naming the artist in other kinds of art historical discourse too, such as connoisseurship, attribution, and the definition of personal style.

I have already explored the naming of Michelangelo, when I spoke about the self-representation of the artist at the beginning of this chapter. We can profitably compare that occurrence of naming as represented in Vasari's biography with the naming of the painter Lionel, the main character in Martin Scorsese's film *Life Lessons*.[41] Vasari said that Michelangelo's naming after the archangel came about because he and his work were considered divine. Vasari speaks of a "compelling impulse" that prevailed when Signor Lodovico Buonarroti

named his son Michelagnolo, an idea that is supposed to have oc-
curred "near a spot where S. Francis received the Stigmata."[42] Not
only is the giving of the name by the human father prefigured by the
giving of the stigmata, or mark, by the divine Father, but also the re-
ceivers of those miracles are related: the artist becomes identified with
a saint, or an archangel, from his very birth.[43] In like manner, the
name Lionel immediately associates the film's hero with the leonine
traits of strength and virility, both artistic and sexual, important in the
film's narrative about love and art. In the original screenplay by
Richard Price, the artist is called "John" (his last line is "What's your
name?. . . I'm John Dobie."), and whether the change was intentional
or not, the trope of renaming is also common in artist's biographies.[44]

The importance of names and naming in the early biographies
raises the related issue of the body or the physical presence of the
artist. In the film, the sheer physicality of Lionel, played by Nick
Nolte, is felt in almost every frame, except when we are overwhelmed
by the scale and presence of his canvases, which he assaults with
pigment-laden brushes, painting in real time to the rock music of the
early 1970s. Through the physical action of his painting, Lionel pro-
jects himself onto the canvas, and one result is a mocking self-portrait
that appears amidst the otherwise abstract forms. Similarly, contem-
poraries of Michelangelo adduced self-portraits in his works, particu-
larly his late works. The figure of Nicodemus in the sculpture group of
the *Florentine Pietà* is an excellent example of this common theme in
early biography.[45] It insists on an intimate and visible connection be-
tween the individual artist and his work. Such is the power of the
body of the artist, and of these texts, that although no reliable portrait
of Michelangelo is known to exist, art historians have insisted that
self-portrayal is central to the meaning of these images.[46]

Quite literally in the art historical discourse, then, the "giveness" of
the name speaks. The constructedness of the name in the discourse on
the Nicodemus, for example, cannot be questioned, only recognized
as a mark of the "act" of the sculpture itself. Names and naming in
the biographies of artists and the discourse of art history become per-
formative of the process of art making itself. Thus, at the end of the
biography of the artist, when the performance ends in death, it is the
body, rather than the name of the artist, that becomes emphasized.

Michelangelo's body looms large in the second edition of Vasari's
biography (1568). A third of this version of the *Life* is devoted to a de-

scription of the events that occurred after the artist's death, when the Medici court and the Florentine Academy of Design arranged to have the artist's body transported secretly from Rome to Florence in order to bury their native son in Tuscan soil and with a ceremony theretofore considered appropriate only for princes.

Some days after Michelangelo's death and many days before the actual burial, his corpse, in a sealed coffin, was carried from the Customs House in Florence to the church of Santa Croce accompanied by many artists and curious citizens. Vasari reports that a custom's official "(as he afterwards confessed) desiring to see in death one whom he had not seen in life, or had seen at such an early age that he had lost all memory of him, then resolved to have the coffin opened."[47] Vasari goes on to report the appearance of the body, something also "confirmed" by other early witnesses:

> When he and all the rest of us present thought to find the body already marred and putrefied, because Michelangnolo had been dead twenty-five days and twenty-two in the coffin, we found it so perfect in every part, and so free from any noisome odour, that we were ready to believe that it was rather at rest in a sweet and most peaceful sleep; and, besides that the features of the face were exactly as in life (except that there was something of the colour of death), it had no member that was marred or revealed by any corruption, and the head and cheeks were not otherwise to the touch than as if he had passed away but a few hours before.[48]

The idea that the artist is both divinely endowed with talent, as argued by Kant, and inspired in his work is embodied here in a corpse that did not stink. This body is not like other bodies; this is the body of the absolute artist.

A comparable fetishization of the body of the artist occurs in the last scene of *Life Lessons*:

> ANGLE to Lionel, at the makeshift bar . . . He reaches for a glass of wine. Abruptly, the bar server, a young, attractive woman in a man's white shirt and bow tie, an employee of the gallery, puts a hand on his arm and then withdraws it just as quickly.
> LIONEL: What was that?
> WOMAN: I wanted to touch you . . . for good luck.
> LIONEL: For me?
> WOMAN: For me. (smiling winningly, shyly) Maybe some of it'll rub off.
> LIONEL: (warming) Are you an artist?
> WOMAN: *You're* an artist . . . I'm a painter . . . I mean, I'm trying . . . I'm not saying . . .[49]

Whether in the text of a biography of Michelangelo or in *Life Lessons*, "the artist" has a cultural presence that heretofore has seemed beyond speech or discourse. That is the myth that will be explored in the final chapter of this book. It is time to bring back the stench and sweetness of the bodies of the artists, of their histories, of the writing about them, and of their political realities. Let me conclude by examining the expectations that the genre of biography, especially the biography of the artist, elicits from us. These expectations have to do with the representation and location of the real and with the social contract that the genre of the biography embodies for our culture. For, in our historical reality as readers, expectations are the counterparts to generic conventions.

## The Social Context of the Form

It is well to begin here with the term *biography*, which contains within it two Greek roots: *bíos*, meaning a human course of life or manner of living distinct to human society; and *graphos*, meaning writing or written. The term *biography*, therefore, describes writing about a life distinctly human, relating to society at large and different from other life forms. From the Greek use of *bíos*, it is clear that a relationship existed between how one conducted one's life and the products of that life.[50] We therefore include in the term *biography* considerations of a way of living over a period of time determined by society to be distinctly human and inclusive of the moral and material productions of the life.

Significantly, however, the term *biography* did not come into general usage until the late seventeenth or early eighteenth century, when it first appeared in English.[51] The earlier term in English for the form was *life*; in Italian and Latin the term was *vita*. Thus, the meanings key in the name *biography* emerge with the political and social dimensions of literary criticism and its formation in the context of academic institutions.[52] Indeed, even before the emergence of the term *biography*, the earlier *Lives* of famous writers and artists were often written with an academic institution in mind: Giorgio Vasari's relationship to the Accademia del Disegno in Florence figures large in his series of *Lives*; Giovanni Bellori's *Lives* were addressed, in part, to the French Academy; Boswell's *Life* of Johnson has the Royal Academy governing aspects of its discourse.

The use of the term *biography* in the eighteenth century is also coincident with the classification and separation of various life forms by science, a result of the scientific revolution of the preceding century. Sarah Franklin has argued that this was the result of both "a horizontal ordering strategy to classify diverse life forms into taxonomies of kind or type" and "a vertical ranking of the value of these life forms based on their proximity to the divine.[53] The latter ranking had prevailed during the Renaissance period along with the "purposive," or entelechic, view of life theorized by Aristotle.[54] Here the "attainment of a predetermined endpoint is seen as the purpose of life . . . a purpose that is contained in itself, independent of any external causal agent."[55] "Life itself," a term Franklin borrows from Foucault's *Archaeology of Knowledge*, did not appear as a concept until after the Darwinian theories of evolution.

Thus, we must be careful to note that the use of the term *biography* emerges during a period of the reclassification of the natural world by science taxonomically, while at the same time life maintained its earlier immutable (teleological) status. This is the status theorized by eighteenth-century Aesthetics for the artist: for example, as Kant wrote: "It [genius] cannot describe or indicate scientifically how it brings about its products, but it gives the rule just as nature does."[56] The term *biography* admits of an awareness of the separation of human life from other life, but it also adheres to universalist positions about life coming from both the Aristotelian and Judeo-Christian traditions. The immutable position theorized for the artist in the eighteenth century by Aesthetics was assured by the form "biography" not yet incorporative of later evolutionary life schemes. As we shall see in the next chapter, this was the form that prevailed in the nineteenth century, as the discipline of art history emerged from the German historicist discourse on art. This discourse, when it discussed art and artists, had as its foundation the biographies of artists.

To further ascertain the assumptions inherent in the rhetorical structure of the biography of the artist, it remains to discuss the genre of *Life* writing before the eighteenth century. There has been a lively discussion outside of art history, mainly from literary scholars, on the nature of early biography.[57] We may accept that both medieval hagiography and classical *Lives* of philosophers, poets, and writers furnished the models that the Renaissance biographers used when they wrote their *Lives* of poets and painters. Explicit, then, in all Re-

naissance biography is the issue of the model, or exemplar. Timothy Hampton has shown how central "the question of exemplarity" is to "the understanding of the self in terms of narrative."[58] Not only does exemplarity press at all aspects of the social integration of the individual or type narrativized, but, as Hampton argues, it also inserts the body of the hero into history.[59] This is evident most clearly in the genre of biography.

In an important article on the body in the narrative of biography, Michael Holquist has argued that in ancient encomiums of statesmen and warriors, "every effort was devoted to molding the specific details of a man's existence into the contours of such a normative paradigm."[60] He notes that the ancient encomium established "a chronotype for historical persons that had previously been reserved for mythic heroes."[61] Arnoldo Momigliano established how essential the ideal of the hero, such as Heracles, Theseus, and Oedipus, was to the earliest examples of biography, although he infers the existence of these biographies from fragments only. Using these examples, Momigliano erected the thesis that "biography was never considered as history in the classical world," that is, that the exemplarity of biography, its desire to represent a paragon, precluded its admittance to a more reasoned history whose main subject was the discussion of political events of all kinds.[62]

Recently, Momigliano's model of the development of biography has been criticized by Bruno Gentili and Giovanni Cerri.[63] They assert that Momigliano's positing of a separate and early genre of biography allowed him to argue that biography and history writing had always been considered as separate from each other in the Greek tradition, a position with which they seriously disagree.[64] They find ample evidence to the contrary in ancient Greek writing on the project of history itself. The idea that biography and history are one and the same endeavor, or that history partakes in many ways of the biographical models such as encomiums and funeral orations, is not, according to Gentili and Cerri, a modern one. On this point, Gentili and Cerri quote Dionysius of Halicarnassus:

> The most characteristic element of his historiography, which is not developed with equal care and effectiveness in any of the other historians either past or present . . . is not only to see and to say what is evident to everyone in various political events, but also to seek the hidden motives of the actions and of the man who accomplished them and the passions

which move the soul, which are not easy to discern in the majority of men, and to unveil the secrets of an apparent virtue and of a vice concealed and ignored.[65]

We may relate these observations to our consideration of the earliest *Lives* of the artists in the Italian context. There, too, authors were aware of the aspects of history and the normalization of paradigms in the society:

> I have striven not only to say what these craftsmen have done, but also in treating of them, to distinguish the better from the good, and the best from the better, and to note with no small diligence the methods, the feelings, the manners, the characteristics, and the fantasies of the painters and sculptors; seeking with the greatest diligence in my power to make known, to those who do not know this for themselves, the causes and origins of the various manners and of that amelioration and that deterioration of the arts which have come to pass at diverse times and through diverse persons.[66]

Hampton has argued convincingly that the ideality of exemplarity in history writing so indicative of early Renaissance humanism had changed by the middle of the sixteenth century to one of uneasiness in the universality of ancient exemplars. Vasari's (1568) admission of the duality of his project as history writing and the praise of heroic artists indicates what Hampton has called an erosion of "the moral idealism of much of humanist ideology" about history writing.[67] We can say, then, that because the biography of the artist emerged as a genre just at the time when this erosion of faith in exemplarity was occurring that anxiety about exemplarity was contained in the form itself.

One of the distinctive characteristics of the genre from Antonio Manetti's *Life of Brunelleschi* (ca. 1575–82) to Vasari's *Lives* to the seventeenth-century biographies by Bellori, Filippo Baldinucci, and others is the emphasis on the rivalry and competition between artists that often took the form of acrimonious and less than exemplary behavior on their part. Yet, these behaviors are conventional, even in the most exemplary of artists. We can therefore assume that embodied within the heroic artist are aspects of an unconventional heroism. Indeed, it is precisely this sort of unconventional cultural hero that we often encounter in contemporary representations of the artist. Here is an acute example of the relationship of the content of the form to our understanding of the concept "artist" today. These assumptions about

the artist inherent in the form, biography, adhere in history writing too, as the following chapters demonstrate.

According to Holquist, the normative paradigm not only establishes in society the idea of men as heroes but also provides a model for the later narrative form, the biography, in which the "praxis" and "ethos" of individual lives are combined with a "tendency to rub smooth the rough edges of particularity in the life."[68] In the Renaissance *Lives* of artists, this "rubbing smooth" of praxis and ethos can be considered quite literally as the conjoining of the description of what the artist does or makes with discussion of his moral and ethical behavior as a professional craftsman and as an individual. I have argued elsewhere that this conjoining of life and works in the genre of the biography of the artist distinguishes it from all other early *Life* writing.[69] As I noted earlier, the work of art and the behavior of the artist emerge as distinctly identifiable elements in the narrative of the early *Lives* of artists: the description and the anecdote.

These rhetorical elements make the *Life* of the artist easy to identify. They are also what led to a dissatisfaction on the part of art critics with the form by the end of the eighteenth century. At that time, just as Kant was writing his *Third Critique* and the term *biography* was emerging in discourse, Luigi Lanzi, the Italian antiquarian and art critic, expressed the problem of biography for history writing in this way:

> When detached histories become so numerous that they can neither be easily collected nor perused, the public interest requires a writer capable of arranging and embodying them in the form of a general historical narrative; not, indeed, by minute details, but by selecting from each that which appears most interesting and instructive.[70]

Lanzi goes on to disparage all of the early Italian biographies of artists for their regional prejudices, their stylistic excessiveness, and most especially their focus on the personality as well as the works. Lanzi calls for a Renaissance art history without biography, like the historicizing and developmental view of Greek art offered by his contemporary Johann Joachim Winckelmann. The rhetoric of this art history would possess an aesthetic dimension as visible as that perceived by Kant to be present in the art object. This is the assessment of the situation that Burckhardt inherited when he began his *Civilization of the Renaissance in Italy*. The ways that Burckhardt selected and used

the early biographies are of primary importance if we are to understand the fate of the representation of the artist found in these biographies in nineteenth- and twentieth-century history writing. First, however, we shall see how the core of the "absolute artist" came to Burckhardt from the earliest Italian biographies.

# 2 / The Artist in Nature: Renaissance Biography

Since it may be of utility to those who may hereafter be inclined to give a very full and perfect history of every thing relating to Italian painting, let us view with indulgence those who employed themselves in compiling lives so copious. . . . At the same time, regard should be paid to that respectable class of readers, who, in a history of painting, would rather contemplate the artist than the man; who are less solicitous to become acquainted with the character of a single painter, whose insulated history cannot prove instructive, than with the genius, the method, the invention, and the style of a great number of artists, with their characteristics, their merits, and their rank, the result of which is a history of the whole of art.

LUIGI LANZI, *The History of Painting in Italy*

In this chapter the consideration of certain topics found in the biographical tradition results in interpretations about the artist, particular works of art, and texts that intersect with others already generated by an object-oriented art history. The argument proceeds from the position that the structure of the texts and the use made by history writers of the earliest biographies of artists are intertwined. I take Antonio Manetti's *Life* of Filippo Brunelleschi to be the first text in the genre of the biography of the artist because it can be characterized by models, topics, tropes, and structure that pertain uniquely to the genre. In this light, the precedent models for the biography of the artist that can be found in the vernacular *Lives* of Tuscan poets are

particularly telling, for Manetti's biography did not appear until well after the middle of the fifteenth century, a full century later than the first of the vernacular *Lives* of poets, Boccaccio's *Life* of Dante, usually dated circa 1350.[1] The *Life* of Brunelleschi contains virtually all of the elements that can be associated with the better-known biographies by Vasari of a century later. Given the linguistic and literary characteristics of the genre, its models, and the role of the artist in society in the Early Modern period, the investigation of the topics found in the biographies of artists must range across the entire period of the Renaissance (ca. 1350–ca. 1580). The material drawn from the contemporary texts and interpretations of them made in the fields of literary studies, Italian history, and Renaissance studies are all taken to be part of the discursive and disciplinary dimensions of the artist in culture.

## An Autochthonous Art

The quattrocento arguments about the preeminence of the modern Tuscan vernacular in literature and the modern Tuscan *arte naturale* founded on perfect measure (*misura*) both rely on the concept of an autochthonous literature or art. In both the linguistic and the visual fields, this term refers to a style without lineage, self-generated and springing directly from the earth. It is worth exploring this concept theoretically as a preliminary way of understanding the correspondences in Renaissance art, literature, and history created by the autochthonous aesthetic. In agreement with Wilhelm Dilthey, we could say that what is at stake in discussions in these fields is exactly what constitutes a "native" Italian style, or, in the words of Dilthey, what is the "origin and character" of Renaissance culture?[2]

The term *autochthonous* is Greek and commonly used to refer to the Chthonic gods, that is, the gods of the underworld, from the earth rather than the heavens. It is associated in its originary use with the *Spartoi* (or seeds), who were said to have sprung from the soil of their native land, without parentage. These men had no childhood; they emerged fully developed into adulthood. Therefore, they have no *bíos*, the Greek term that means life as human lived experience and that forms the prefix of the word biography. For the history of art, the tension between a narrative of origins simultaneously structured by the genre of biography and the claims of autochthonic expression or style

is apparent. The role of the maker or artist, privileged by the literary form biography, will always be denied by one of the arguments central to *these* biographies, that the art in essential ways lacks human origins and lineage. We can begin to understand how this tension inherent in the texts themselves has resulted in a narrative that relies on myth as much as history to construct the artist in culture.

In the Athenian context, the myth of autochthony concerns the boy Erichthonios, adopted son of Athena. Hephaestus desired and pursued Athena, the virgin goddess, who saved herself from his embraces. The sperm of the god fell to earth (Ge), making her fertile. Ge subsequently gave up Erichthonios to Athena, who recognized him as "the son of blessed gods, [born] of sacred soil" (Euripides, *Medea*, 824–26). Thus, in ancient Greece the myths of autochthony have to do with origins, family and citizenship, and the *polis* (Sparta or Athens). In her study of Athenian politics, Nicole Loraux has surmised that autochthony provides the *topos* or location for the merging of myth, what she calls the imaginary, and history, what she calls the political.[3] In other words, claims about or discussions of autochthony furnish an ideology of origins.

The same could be said of Hubert Damisch's recent exploration of the "origin of perspective." Through his reading of the biographies of Brunelleschi by Manetti and Vasari, he posits the invention of perspective as the origin myth for painting and the beginning of art history.[4] Similarly, we shall see that Jacob Burckhardt, basing his autochthonic argument on the vernacular texts of the period, proposes the invention of the period concept "the Renaissance" for the history of art.

With this understanding of autochthony, we could say that like myth and history, it relies on a linguistic rather than a familial or genetic identity. Because it is linguistic, it is also in the main geographically determined, if only because linguistic groups in a noncolonial situation rely on community contact for communication and the survival of language. Community comes not only with the landscape but also with the territory, that is, with the state. This is the political aspect of Athenian autochthony with which Loraux deals.

This concept of the political function and operation of autochthony, whether in ancient Greece or quattrocento Florence, pertains only in the premodern setting. It predates the formation of the modern nation-state, across whose porous borders colonizing and immigrant groups may enter speaking their own languages and bringing their

own customs and artifacts. For example, recent scholars of Latin American literature have realized the importance of understanding the role of autochthony in the context of contemporary Latin American literature and the politics of nationhood.[5] In this light, Jorge Luis Borges argues in "The Argentine Writer and Tradition" *against* the necessity for an autochthonous tradition for Argentinean (and implicitly Latin American) literature. He sees autochthonic arguments as essentially a European preoccupation about literary origins that do not allow for the political and cultural realities of modern Latin America.[6] Identity in these contexts can be understood as "hybrid," a term taken from more recent thinking about cultural identity, particularly postcolonial, that is, non-European.[7] In the autochthonous narrative, like the birth of Erichthonios, the origins and traditions of a culture emerge from the native land through divine or nonhuman agency. A cultural autochthony, unlike a cultural hybridity, makes the native the norm, not allowing for differentiation in a positive sense, but only in the sense where "the other" remains separate and different *from* the rest of society. These characteristics become instantly problematic once they are at play in the modern nation-state, resulting in discrimination, racism, and genocide. They are, however, coexistent with earlier forms of statehood, such as the civic humanism of the Renaissance city-state Florence, as understood by Hans Baron and others.

Baron argues that the issues of origin in the vernacular language raised by the debates known as the *questione della lingua* can be related directly to the civic humanism of Florentine politics. In the Renaissance context autochthony concerns the contribution that poetry in the native language of Tuscany made to the new order. It concerns as well the contribution that the visual arts, particularly painting based on nature indigenous to Tuscany, made to the new order. The parallels between the two were made again early in this century by Julius von Schlosser, as we shall see in a later chapter.

Both linguistic and visual debates resulted in chauvinistic claims made for the literature and art of Florence and Tuscany. For example, Carlo Dionisotti has argued that the claims of the superiority of the Tuscan language made by Cristoforo Landino on behalf of Dante in 1478 were provoked by the arguments in praise of the Bolognese dialect in the preface written by Martino Paolo Nidobeato for a new edition (1478) of Jacopo della Lana's commentary on the *Divine Comedy*.[8] Such chauvinistic claims are familiar to art historians when

they appear in related discourses about art, such as the *Disegno* versus *Colore* controversies that pitted Florence against Venice in discussions of art theory in the sixteenth century. If the autochthonic arguments underlying the debates that Dilthey said were about the "origin and character" of Renaissance culture are less familiar, it is because the biographies containing these arguments have been undertheorized.

The theoretical point can be demonstrated by juxtaposing a passage from the earliest *Life* of a poet, Giovanni Boccaccio's *Vita di Dante* (written ca. 1350), with a passage from Giorgio Vasari's *Life* of Giotto (2d ed. published in 1568). In order to be perfectly clear, I include the Italian and the English translation together.

> Questi fu quel Dante, del quale è il presente sermone; questi fu quel Dante, che a' nostri seculi fu conceduto di speziale grazia da Dio; questi fu quel Dante, il qual primo doveva al ritorno delle muse, sbandite d'Italia, aprir la via. Per costui la chiarezza del fiorentino idioma è dimostrata; per costui ogni bellezza di volgar parlare sotto debiti numeri è regolata; per costui la morta poesì meritamente si può dir suscitata: le quali cose, debitament guardate, lui niuno altro nome che Dante potere degnamente avere avuto dimostreranno.[9]

> This was that Dante of whom the present discourse treats. This was that Dante given to our age by the special grace of God. This was that Dante who was the first to open the way for the return of the Muses, banished from Italy. By him the glory of the Florentine idiom has been made manifest; by him all the beauties of the vulgar tongue have been set to fitting numbers; by him dead poesy may truly be said to have been revived. A due consideration of these things will show that he could rightly have had no other name than Dante.[10]

In the opening sentence of his *Life* of Giotto, written some two hundred years later, Vasari wrote:

> Quell'obbligo stesso che hanno gli artefici pittori alla natura, la quale serve continuamente per esempio a coloro che, cavando il buono dalle parti di lei migliori e più belle, di contraffarla ed imitarla s'ingegnano sempre; avere, per mio credere, si deve a Giotto, pittore fiorentino: perciocchè, essendo stati sotterrati tanti anni dalle rovine delle guerre i modi delle buone pitture e i dintorni di quelle, egli solo, ancora che nato fra artefici inetti, per dono di Dio, quella che era per mala via, risuscitò ed a late forma ridusse, che si potette chiamar buona. E veramente fu miracolo grandissimo, che quella età è grossa ed inetta avesse forza d'operare in Giotto si dottamente, che il disegno, del quale poca o niuna cognizione avevano gli uomini di que'tempi, mediante lui ritornasse del tutto in vita.[11]

That very obligation which the craftsmen of painting owe to nature, who serves continually as model to those who are ever wresting the good from her best and most beautiful features and striving to counterfeit and to imitate her, should be owed, in my belief, to Giotto, painter of Florence, for the reason that, after the methods of good paintings and their outlines had lain buried for so many years under the ruins of the wars, he alone, although born among inept craftsmen, by the gift of God revived that art, which had come to a grievous pass, and brought it to such a form as could be called good. And truly it was a very great miracle that that age, gross and inept, should have had strength to work in Giotto in a fashion so masterly, that design, whereof the men of those times had little or no knowledge, was restored completely to life by means of him.[12]

Both texts speak about the "founders" or originators of the new order, the one in poetry, the other in painting. These texts are separated in time from each other by over two centuries, but their subjects, Dante Alghieri (1265–1321) and Giotto di Bondone (1276–1337), were contemporaries. Dante figures prominently throughout Vasari's *Life* of Giotto. Vasari consistently draws attention to the precedent of Dante and to his own knowledge of the literature on Dante, Boccaccio's *Life*, for instance.[13] The authority of Dante and the collective accretion of the Florentine biographies of Dante that had proliferated up to Vasari's time lend weight to Vasari's claims for Giotto.[14] They also authorize his own biographical project, a history of modern art from its origins to the present.

In both passages the new order of poetry and painting is distinctly Christian. Whether by "the special grace of God" in the case of Dante, or "the gift of God" in the case of Giotto, the origin and originator are the issue. The resurrection of art after an unspecified period of death was due in both cases to the subject of the respective biography: Boccaccio's "Muses, banished from Italy" and "dead poesy," and Vasari's "the methods of good paintings and their outlines had lain buried for so many years under the ruins of the wars." The fact that Boccaccio's *Life* of Dante relies on the model of earlier *Lives* of Virgil does not concern Vasari in his use of it in his *Life* of Giotto, although the use of "parallel lives" in the tradition of biography clearly has roots that go back to the beginning of the genre.[15]

However Christian the new poetry and painting may have been for both Boccaccio and Vasari, they were also Florentine: "the glory of the Florentine idiom" used by Dante, and "Giotto, painter of Florence."

Both poet and painter are designated Florentines by their biographers, both of whom themselves were Florentines. Their *Lives* were intended primarily for a Florentine audience.[16] In both cases modern poetry and painting would not have been possible without the civic and religious ambiance of Florence.

By Vasari's time the use of Florence and of the Florentine language in the praise of poetry had become commonplace. The language of the two texts under discussion supports this assertion. In 1350, Boccaccio had to qualify "the Florentine idiom" with the noun "glory," whereas Vasari can simply state, "Giotto, painter of Florence." Much was implied by this simplicity, including the fact that the praise of Florence and of her poets and painters had emerged within the genre of biography itself, specifically, in the *Lives* of the Three Crowns of Florence: Dante, Petrarch, and Boccaccio.[17] In these texts, the city of Florence and the language of her citizens assume a significance that is both literal and figurative. On the literal level, the poet, the biographer, and the reader are of Florence and speak and write the Florentine vernacular. On the figurative level, the city of Florence is the political and social entity that is represented by the engagement of the poet with the vernacular language. In many of these early *Lives*, most particularly in that by Boccaccio, the poet becomes the spokesperson for and representative of the city and her citizens, though not necessarily of her government. Indeed, the subject of exile is central to Boccaccio's biography of the poet.

By the quattrocento, however, the situation had changed to include the poet and the painter as active participants in the government of the *polis*. The famous fresco by Domenico di Michelino in the Cathedral of Santa Maria del Fiore in Florence portrays Dante surveying the city of Florence, with its landmarks clearly indicated and, significantly, its walled perimeter encircling a teeming mass of citizens (figure 4). Such a representation of the city and her citizens is clearly based on the earlier trecento frescoes of *Good and Bad Government* by Ambrogio Lorenzetti in the Palazzo Pubblico in Siena. In that fresco cycle, the polis and her citizens are represented along with the personifications of the Virtues, based on medieval prototypes, which are entailed in good governance (figure 5). In the later Florentine fresco, Dante assumes the position of one or more of the personified Virtues.

Martin Kemp has recently argued that depictions such as Loren-

STRAVIT QVEANIMO CVNCTA POETA SVO DOCTVS ADEST DANTES SVA QVEM FLOR
MORS SAEVA NOCERE POETAE OVEM VIVVM VIRTVS CARMEN IMAGO

*Figure 4. Detail, fresco by Domenico di Michelino,* Dante Surveying the City of Florence, *Florence, Cathedral of Santa Maria del Fiore. (By permission of Alinari/Art Resource, New York)*

Figure 5. Detail, fresco by Ambrogio Lorenzetti, Good and Bad Government, Siena, Palazzo Pub-
blico. (By permission of Alinari/Art Resource, New York)

zetti's "were dependent upon actual spaces in cities and the manner of their use."[18] If this view of the cityscape is correct, then we could say that the poet was as integral to the representation of the civic life of the city as the representation of the civic life of Florence was to Dante's poem. The position of the poet in the culture and politics of the city is as manifest here in the quattrocento image in the cathedral in Florence as it is in the earlier text the *Life* of Dante by Boccaccio, where it is prominently featured.

Claims to a special kind of political representation on the artist's part were made by Vasari, who insists on such a position for the artists of Giotto's era as well. Arguments linking the superiority of Dante's vernacular with the political expansion of the Florentine state had been made in the fifteenth century by Lorenzo de' Medici in his *Commento* to Dante.[19] It has been established that Vasari's book owes a great deal to the early commentaries on Dante.[20] Vasari's own project to write a history of art had to do with ensuring the cultural hegemony of Florence under the Medici, as the prefaces to the two editions of his book demonstrate (cited earlier). According to Vasari, the representation of the poet Dante in a literal political context, in the palace of the Podestà in Florence, was due ultimately to Giotto, who by virtue of his ability to "portray living people from the best of nature" painted the portrait of Dante in that seat of government.[21] The existence of additional passages such as this one in the *Life* of Giotto supports Vasari's contentions regarding the political position of the painter. The relationships described between Giotto and Dante allow Vasari to elaborate on the association between poet and painter.

Vasari's own portrait of Dante, in the group portrait at the Minneapolis Institute of Arts (figure 6), supports this linkage of the language of poetry, polis, and painting in the biographical context.[22] Here, the "Three Crowns of Florence" are joined by Guido Cavalcanti (ca. 1255–1300), Cino da Pistoia (1270–1336), and Guittone d'Arezzo (ca. 1230–1294). All of these Tuscan poets were invoked in the debates about the *questione della lingua* that took place during Vasari's time in the Florentine Academy and that affected his view of the history of Tuscan art.[23]

Furthermore, like Dante's, Giotto's association with the city and her citizens and politics existed in the very fabric of the city itself, that is, in her monuments, for he was perhaps best known in the quattrocento as the architect of one of Florence's landmarks, the bell tower of the

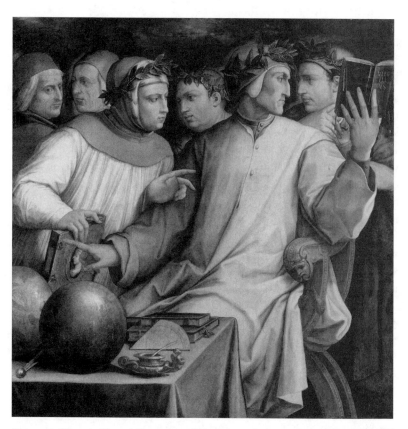

*Figure 6. Giorgio Vasari,* Portraits of Six Tuscan Poets, *1543. (By permission of the Minneapolis Institute of Arts)*

Cathedral of Santa Maria del Fiore.[24] In Vasari's biography, it is through this project that Giotto is specifically linked to the Commune and to Florentine citizenship.[25] Making Giotto the painter of Florence through analogy with Dante the poet of painting reveals the depth of the argument of *ut pictura poesis*, the equation of painting with poetry, in Vasari's Florentine chauvinism. In the words of Vasari, how did he bring "it to such a form as could be called good"?

If we return to the passage in Boccaccio's *Life* of Dante, we will see how the argument for an autochthonous style emerges. According to Boccaccio, "by him [Dante] all the beauties of the vulgar tongue have been set to fitting numbers." First, this statement refers to the language in which Dante wrote his poetry. Even as early as Boccaccio's time, the Tuscan vernacular was a language whose beauty was understood to be self-evident: "all the beauties of the vulgar tongue." Dante's appropriation of the *dolce stil nuovo* and Provencal troubadour poetry together with his own use of language in the *Divine Comedy* enriched and changed forever the language of Italian poetry.

Second, the phrase "setting the vulgar tongue to fitting numbers" marks the association between language and measurement. The numbering or measurement of language results, of course, in poetry. The rhythm or meter of Dante's poetry is still considered one of its most signal characteristics. Boccaccio's praise of the vernacular is distinctive because the grounds of his praise rest on the language's correspondence to "fitting numbers." There is ample evidence from the Renaissance period and from poetics in particular that the use of the terms and meanings of numbers and measure were interchangeable. For example, in *Hamlet*, II, 2, 119, when Hamlet complains, "I am ill at these numbers," he means the rhymed verses that are being spoken. An excellent example of the interchangeability of numbers and poetry can be found on the title page of Robert Herrick's collected poems, *His Noble Numbers: or, His Pious Pieces* (1648).[26]

Boccaccio's views of Dante's contributions to the possibilities that poetry held rely ultimately on Dante's own writing, particularly in the *Convivio*, the *De vulgari eloquentia* and the *Epistle to Can Grande della Scala*.[27] Boccaccio's claim that Dante began a new style has both a Renaissance precedent and a classical one in Horace's *Ars Poetica*. The assertion that its distinguishing characteristic was a vernacular set to a true and just measurement belongs to the classical source. This is the model of interest here because it helps us to understand Vasari's

use of similar terminology in his *Life* of Giotto. It will also be of use in understanding the claims that the biographer Antonio Manetti made for Brunelleschi.

Horace precedes his discussion of the measurement or meter of poetry with the idea of a revival of language and poetry, the same kind of juxtaposition of revival and measure that Boccaccio makes in the passage that we have been glossing. Ben Jonson's translation (1640) of Horace reads:

> Much phrase that now is dead, shall be reviv'd;
> And much shall dye, that now is nobly liv'd,
> If Custome please; at whose disposing will
> The power, and rule of speaking resteth still.
> The gests of Kings great Captains and sad Warres,
> What number best can fit, Homer declares.
> In Verse unequall match'd, first sowre Laments,
> After, mens wishes, crown'd in their events,
> Were also clos'd: But, who the man should be,
> That first sent forth the dapper Elegie,
> All the Grammarians strive; and yet in Court
> Before the Judge, it brings, and waites report.[28]

Boccaccio's argument on behalf of Dante's poetry is distinctly new because it makes the switch from an argument concerning classical language to the vernacular seamlessly and thereby infuses the contribution of Dante's poetry with a Florentine chauvinism, enforcing what I have called the autochthonous bias while at the same time downplaying the classical referent.[29] Explicit in Horace and evident in Boccaccio's own theory of mimesis is that the measurability of poetry occurs through imitation, the imitation of fitting numbers by the language of the poetry, that is, the vernacular in Boccaccio. This last point relates these issues of mimesis to the Renaissance use of the Horatian doctrine *ut pictura poesis*.

Rensselaer Lee and others have demonstrated that the issues of imitation embedded in the classical sources on poetics, primarily Aristotle's *Poetics* and Horace's *Ars Poetica*, are central to all discussions of the comparison between poetry and painting that took place in Renaissance art theory.[30] The particularities of the authority of these classical texts for the Renaissance writers who followed Boccaccio need not concern us here. It is unnecessary to posit Aristotle as an intervention in Vasari's view of Giotto, because he relied primarily on the pas-

sage in Boccaccio's *Life of Dante*. Lee insists: "Again these comparisons were in their place legitimate and illuminating, but when they were appropriated by the Renaissance enthusiasts who sought for painting the honors long accorded poetry, their original context was not always remembered."[31] By the middle of the sixteenth century, the classical reference had been absorbed by the vernacular tradition. Boccaccio's view of Dante's poetry and Vasari's view of painting, like Burckhardt's view of Renaissance culture, rested on the distinctly modern assumption that "the Renaissance is primarily Italian, in origin and character, and it is only secondarily a culture of Classical Antiquity."[32]

## The Question of Language

There are further historical reasons concerning Boccaccio's text that allow us to understand better Vasari's statement that Giotto was "wresting the good from" the "best and most beautiful features" of nature. When Boccaccio's claims for vernacular poetry are seen in light of the subsequent claims made for and against it by later biographers of Dante, the significance of Vasari's assertions regarding Giotto can be contextualized.

Some fifty years after Boccaccio's biography, Leonardo Bruni wrote that Dante did not belong to the highest rank "of those who become poets through an inner abstraction of the soul," but rather to a group of poets who "create their poetry by means of knowledge and study, by discipline, art, and forethought."[33] Bruni makes an overt appeal to the classification of poets found in the then recently discovered *Poetics* of Aristotle.[34] According to Bruni, the rank of poets to which Dante belonged "acquired the knowledge which he was to adorn and unfold in his poetry" through "the study of philosophy, theology, astrology, arithmetic, and geometry, the reading of history, the meditation on many and various books, and by watching and fatigue in his studies."[35]

Bruni goes on to speak about the *volgare* versus Latin, regarding the latter as better while at the same time admitting that Dante's vernacular style in poetry was "*eccellentissimo sopra ogni altro*":

> But if I were asked why Dante elected to write in the vulgar tongue rather than in Latin and the literary style, I should give the true answer that Dante knew he was far better fitted for this riming style in the vernacular than for the Latin or literary style. And certainly he has gracefully expressed in vernacular rime many things which he had neither the

knowledge nor the power to set forth in the Latin tongue and in heroic verse. The proof lies in his eclogues, written in hexameters, which, good though they be, I have often seen surpassed. For the truth is that our poet's strength lay in vernacular rime, wherein he has no peer. But in Latin verse and in prose he barely reached mediocrity.[36]

In Bruni's discussion of Dante's poetic language there is no recourse to the topic of his Florentine citizenship, nor does he make Dante an originator of a modern style. As a historian of Florence (*Historia Florentina* was written in 1404), Bruni would have known the chauvinist claims for language that Boccaccio had made through the association of the vernacular and Florence in his *Life* of Dante. For Bruni to make similar claims, he would have had to have thought very differently about the status of the vernacular. As Hans Baron has argued, he would have had to have thought very differently about Florence's civic humanism.[37] Bruni's assessment of Dante's contribution is anti-autochthonous, as are other assessments of Dante's poetry that are found in the quattrocento. Virtually all of these anti-autochthonous writers rely on the Aristotelian rather than the Horatian view of poetry.

The important rebuttal to the early humanist attitudes toward the language and poetry of Dante such as those found in Bruni is Cristoforo Landino's *Commentary* on the *Divine Comedy* of 1481, which includes in its preface a biography of the poet. This text is an important intervention not only in the critical fortunes of Dante but also in the history of *Life* writing in the Renaissance. It employs the genre of biography to discuss the political and cultural arguments implied in the *questione della lingua* and joins it with a commentary on poetry. In both of these aspects Landino revives and amplifies Boccaccio's arguments about language. Landino not only changed the critical fortunes of Dante, a point long recognized by Dante scholars, he also established the topics and terms of discussion to be used in writing about contemporary art, particularly in the biographies of artists, where life and a commentary on the works are combined.[38]

Landino's influence on the *Lives* of artists begins even earlier than Vasari, with Manetti's biography of Brunelleschi. The fact that Manetti collaborated with Landino on his Dante *Commentary* underlines the importance of Landino's text, especially its revival of Boccaccio's *Vita*, for the history of art. Manetti's work with Landino concerned that section of the preface to the 1481 edition titled "Sito, forma, e misura dello 'nferno e statura de' giganti e de Lucifero."[39] Manetti's designs

for Hell, illustrating the measurements and design of Dante's *Inferno*, were famous in the next century, for they appeared in other editions of Dante as well. In their (and Landino's) emphasis on measurement and the representation of the built environment they should be seen as important to the discussion of Brunelleschi's perspective demonstrations, key aspects of Manetti's biography of the artist. This point is supported by a reference in Vasari (1568) to Brunelleschi's interest in Dante's use of the Florentine geography and buildings: "He also gave much attention at this time to the works of Dante, which he understood very well with regard to the places described and their proportions, and he would avail himself of them in his conversations, quoting them often in making comparisons."[40] This passage occurs in Vasari's *Life* of Brunelleschi directly after his references to the perspective demonstration panels. Manetti's illustrations to Landino's Dante clearly had their roots in Brunelleschi's own commentary on environmental subjects in Dante that took place early in the century. These aspects of Manetti's biography will be pursued further when I discuss the textual descriptions of the panels, but first let us return to the issue of autochthonous style.

The implications of my conclusions regarding the differences between Boccaccio's and Landino's appraisals of Dante on the one hand and the other early humanists on the other are of paramount interest. Vasari in his treatment of Giotto returned, whether consciously or unconsciously, to appraisals of poetry, specifically the poetry of Dante, that stressed the autochthonic aspect of Dante's work; that is, in the middle of the cinquecento he returned to a trecento rather than a quattrocento view of poetry and of Dante. In so doing, he implicitly, at least in his appraisal of Giotto, eschewed the *Poetics* in favor of the *Ars Poetica*. Furthermore, in the passage that I have been glossing, he explicitly embraced the political or civic importance of Giotto's painting in ways similar to Boccaccio's view of the importance of Florence for Dante's poetry. After all, as I noted earlier, this might be called a historicist move on Vasari's part given that Giotto and Dante were of the same generation. At the historiographical level of my argument, when Jacob Burckhardt turned to the origin and character of the Renaissance, he based his views on the ideas and arguments that are found in texts, like the *Life of Dante* by Boccaccio, in which an autochthonous aesthetic prevails, rather than on later texts, like Bruni's biography, in which a classicizing aesthetic prevails. We shall see the

effect of this historicist aesthetic regarding the texts of the Renaissance in greater detail in the next chapter.

Judging from Boccaccio's biography and from the later one by Landino, these were times in Florentine history when interpretations of contemporary literature, especially poetry, could be made relatively free of the precedent of antiquity and when the language of the poetry and the poet himself could be easily linked to the political landscape: the Commune in Boccaccio's time and the state increasingly, but not always securely, under Medici control in Landino's time. Poetry, the biographies, the person of Dante himself could be used to support the political views of the commentator and his circle. This situation is not dissimilar from the one in which Vasari found himself at the famous dinner party that led to the genesis of the *Lives* of the artists: art, the biographies, and the artists themselves could be used to support the ruling Florentine regime.[41]

## Ut Pictor Poeta

In the passage from the *Life of Giotto* we have seen how crucial the earlier Boccaccian text is for Vasari's construction of his interpretation of the art and life of Giotto. The final part of the passage from Vasari's biography of Giotto that remains to be investigated is the one that names the artist's contribution to the modern style, the parallel to the passage in Boccaccio that speaks about "setting" the vernacular to "fitting numbers" in order to resurrect dead poesy.

If we continue with the textual correspondences followed thus far, the "setting" of the vernacular "to fitting numbers" that Dante accomplished can be equated as a textual correspondence with Giotto's "wresting the good from" the "best and most beautiful features" of nature. But what does this mean when we are confronted with the actual paintings of the Renaissance? Much of the problem here lies in the discrepancies between the written word and the painted picture that have determined the kinds of terminologies and narratives used to write about art since Greek times.[42]

If we accept, however, that the concept of *ut pictura poesis* prevails in Early Modern texts, (and arguably at least until the beginning of the twentieth century in all art theory), then we can recognize that all comparisons made between the spoken and the visual arts are based on issues of imitation. It will help to recall that Boccaccio's praise of

Giotto's contribution to the art of painting, made in *Decameron*, VI, 5, was key to Vasari's view of the artist.[43] Boccaccio praised Giotto's ability to paint so accurate a likeness of things that men mistook his paintings for reality. Lee cites that passage from Boccaccio's *Decameron* as proof that "the concept of literal imitation had occurred already in the Trecento, and was the natural accompaniment during the Quattrocento of a realistic point of view and practice among those artists who were striving strenuously to capture the perfect illusion of visible nature."[44]

From here we can elucidate the Vasari-Boccaccio comparison further, especially as it relates to the artist. This is the crux of the argument: the "perfect illusion of visible nature" in painting corresponds to the theory of autochthonism that underlies Boccaccio's praise of Dante's use of the vernacular in poetry. Taken at its most literal, "visible nature" is whatever the artist and his audience could see around them in Tuscany circa 1300.[45] But how can we understand Vasari's "the perfect illusion of visible nature" in terms of the actual painting practice of the time?

One way to proceed is to look for this claim or the language that embodies it in a related text and context: the earliest biography of an artist, Manetti's *Life of Brunelleschi*, written in Florence sometime after 1482.[46] This text could be said to present an ideal mediation between Boccaccio's *Life of Dante* and Vasari's *Life of Giotto* for more than just the obvious fact that it was written at almost exactly the halfway point between the Boccaccio and Vasari *Lives*. Brunelleschi is considered by Manetti, just as Dante was by Boccaccio and Giotto by Vasari, to have been an originator or founder: "He originated the rule that is essential to whatever has been accomplished since his time in that area. . . . Through industry and intelligence he either rediscovered or invented it." ["E da luj e nato la regola, che è la inportanza di tutto quello che di ciò se fatto da quel tempo in qua."][47] The language in the original Italian is important because the word for "rule," *la regola*, recalls Boccaccio's use of the same word, in its verb form *regolare*, in his discussion of Dante's contribution to poetry: "per costui ogni bellezza di volgar parlare sotto debiti numeri è regolata."

That rule that Brunelleschi invented is perspective. Manetti wrote of perspective that "it forms part of that science which, in effect, consists of setting down properly and rationally the reductions and enlargements of near and distant objects as perceived by the eye of man:

buildings, plains, mountains, places of every sort and location, with figures and objects in correct proportion to the distance in which they are shown."[48] Perspective allowed painters to achieve "the perfect illusion of visible nature," that is, everything visible, in their painting. Manetti's language here, the list of what nature provides for the eye to see and the hand to represent, is encyclopedic and can be used to gloss Vasari's statement that painters "are ever wresting the good from her best and most beautiful features and striving to counterfeit and to imitate her."[49]

In practice, this is not only the idealized and singular subject "nature," as it is usually spoken of by critics such as Lee when they speak of imitation, but also the buildings of Florence and the surroundings of Florence, including the figures and objects that filled those urban and rural spaces. The paintings depicting idealized urban views that have been associated with the invention of perspective and the Manetti text by most art historians present just such an understanding of the theory of autochthonous imitation in practice.[50] For example, in the panel in Urbino (figure 7) the buildings are based on Florentine examples of late medieval and Renaissance architectural design. The obviousness of the use of perspective allows the viewer to make a visual correspondence between the reference to the real in the buildings depicted and the reference to the theoretical in the perspective used to accomplish the imitation. The primary objects of imitation, the purpose for employing mathematical perspective in the first place, were the city, the figures, and monuments occupying that urban space.

With this science of measurement the artist was able to achieve a perfect imitation of his own surroundings in painting. This literal way of understanding how the painter represented his surroundings recalls the role of measure in Boccaccio's phrase "the beauties of the vulgar tongue have been set to fitting numbers" and its claims based on autochthony. Manetti insisted that we understand the invention in practical terms by including in that portion of the biography that immediately follows the quotations cited earlier elaborate descriptions of two paintings by Brunelleschi whose purpose was to demonstrate the ability of the rule of perspective in the perfect representation of nature. The paintings depicted "buildings . . . with figures and objects in correct proportion to the distance in which they are shown." If they were extant today, they would provide excellent examples of the autochthonous aesthetic in Florentine painting.

Figure 7. *So-called* Urbino Panel, *Urbino, National Gallery of the Marches. (By permission of Alinari/Art Resource, New York)*

## Brunelleschi's Demonstration Panels

Because my argument here concerns the uses that art history has made of Renaissance texts in understanding the role of the artist as much as it does the panels themselves, the reasons for the enormous status of these panels in the discipline require review.[51] They are (1) the perceived importance of the invention of scientific perspective in the practice and development of Renaissance, particularly quattrocento, painting; (2) the fact that discussions of perspective figure prominently in the earliest Renaissance treatise on painting, Leon Battista Alberti's *Della Pittura* (ca. 1435), which was dedicated to Brunelleschi and which may have been predated by Brunelleschi's perspective discoveries and the panels; (3) the fact that the author of the panels is the subject of the first major biography of a Renaissance artist and that this biography includes relatively lengthy descriptions of these paintings; (4) the fact that Vasari may have used the panels themselves and/or Manetti's biography and its descriptions of the panels in his conception of the development of painting in the period known as the Early Renaissance, that is, from Giotto to Leonardo; and (5) because these paintings exist only in literary description—as "lost" major monuments in the history of art—they have become mystified in ways that have yet to be explored by art history.[52] For example, it has been suggested that Vasari actually saw Brunelleschi's demonstration paintings because his description of the buildings in the panel that depicted the Palazzo della Signoria differs from Manetti's, but it could have been the case that Vasari was simply amplifying the description found in Manetti based on his own knowledge of the surroundings that had changed relatively little from Brunelleschi's and Manetti's day.[53]

The descriptions of the demonstration panels are very detailed, but they have proven difficult if not impossible to satisfactorily reconstruct, to which the multiplicity and variety of the diagrams illustrating the books referred to in this chapter attest. I will not be adding to this literature of visual reconstruction. Rather, I want to concentrate on Brunelleschi's use of "scientific perspective," as Kemp understands it to mean, based on mathematical principles and measurement. These terms recall Boccaccio's assessment of Dante's contribution to poetry, that is, his meter, measure, or versification of the vernacular.

In this light we can expand on Kemp's suggestion concerning the broader cultural significance of the panels: "there is little doubt that

Brunelleschi's measured representation of these two revered buildings was deeply locked into the system of political, religious and intellectual values shared by those who exercised the greatest influence [sic] on Florentine civic life in this period."⁵⁴ This civic or cultural level of the panels is married in the text to the theoretical discussion of perspective.

Manetti's description of the panels reveals his absorption in the subject matter: the center of the city of Florence and the buildings that when their various functions are taken together represent the religious, economic, and political life of the city. Marvin Trachtenberg has recently written at length about the significance of the monuments described in the second panel, especially with reference to the iconic status that the Palazzo del Podestà had in the life of the city.⁵⁵ His views on urban life in downtown Florence in the early Renaissance resonate with the issues of autochthony in language, art, and politics raised here. However, concerning both panels, the only representation of them that exists is a textual one. The close reading that follows here, therefore, seeks to understand them as textual representations. Thus, for instance, when a building is named in the textual description, it is not understood to be a place marker for an ideal viewing point related only and empirically to an actual perspectival measurement but rather to resonate with the cultural embeddedness that the experiment, the panels, and Manetti's text propose.

In the third decade of the quattrocento, the supposed date of Brunelleschi's panels, the artist, according to the description, chose to represent in the first panel the religious center of the city, that is, the baptistery of San Giovanni as seen from the cathedral church of Santa Maria del Fiori; and in the second panel the civic and political center of the city, that is, the government palace known as the Palazzo della Signoria or the Palazzo Vecchio. We have seen that these are the same areas of Florentine life to which both Boccaccio and Vasari referred when they sought to describe respectively the singularity of Dante and Giotto. Manetti's descriptions follow here:

> He made a representation of the exterior of San Giovanni in Florence, encompassing as much of that temple as can be seen at a glance from the outside. In order to paint it it seems that he stationed himself some three *braccia* inside the central portal of Santa Maria del Fiore. He painted it with such care and delicacy and with such great precision in the black and white colors of the marble that no miniaturist could have done it

better. In the foreground he painted that part of the piazza encompassed by the eye, that is to say, from the side facing the Misericordia up to the arch and corner of the sheep [market], and from the side with the column of the miracle of St. Zenobius up to the corner of the straw [market], and all that is seen in that area for some distance. And he placed burnished silver where the sky had to be represented, that is to say, where the buildings of the painting were free in the air, so that the real air and atmosphere were reflected in it, and thus the clouds seen in the silver are carried along by the wind as it blows . . . he made a hole in the painted panel at that point in the temple of San Giovanni which is directly opposite the eye of anyone stationed inside the central portal of Santa Maria del Fiore, for the purpose of painting it. . . . With the aforementioned elements of the burnished silver, the piazza, the viewpoint, etc., the spectator felt he saw the actual scene when he looked at the painting. I have had it in my hands and seen it many times in my days and can testify to it.

He made a perspective of the piazza of the Palazzo dei Signori in Florence together with all that is in front of it and around it that is encompassed by the eye when one stands outside the piazza, or better, along the front of the church of San Romolo beyond the Canto dei Calimala Francesca, which opens into that piazza a few feet toward Orto San Michele. From that position two entire facades—the west and the north—of the Palazzo dei Signori can be seen. It is marvelous to see, with all the objects the eye absorbs in that place, what appears. . . . And where in the San Giovanni panel he had placed burnished silver, here he cut away the panel in the area above the buildings represented, and took it to a spot in which he could observe it with the natural atmosphere above the buildings.[56]

The first of the two descriptions by Manetti centers on the religious life of the city. From within the central portals of the Cathedral of Santa Maria del Fiore, Brunelleschi positioned himself for an ideal view of the baptistery, dedicated to St. John the Baptist, the patron saint of the Florentines. The preeminence of these two buildings in the religious life of the city was stressed by Bruni in his *Laudatio Florentinae Urbis* (*Panegyric to the City of Florence*), written in the first decade of the quattrocento:

Therefore, our Almighty and Everlasting God, in whose churches and at whose altars your Florentines worship most devoutly; and you, Most Holy Mother, to whom this city has erected a great temple of fine and glimmering marble, where you are at once mother and purest virgin tending your most sweet son; and you, John the Baptist, whom this city has adopted as its patron saint—all of you, defend this most beautiful and distinguished city from every adversity and from every evil.[57]

The other buildings mentioned in Manetti's description are significant in Florentine religious life and society as well. The Misericordia, a charity foundation, was a building opposite the campanile and was dedicated to St. Sebastian. Its presence in the precinct of the cathedral and in the description by Manetti of Brunelleschi's panel reminds the reader of the importance of such charities for the citizens of the city who donated a significant amount of their income to them. The column of St. Zenobius honored the first Bishop of Florence in the vicinity of his seat. The straw market and the sheep market, also mentioned in this description, insert commerce, specifically agricultural commerce, into the religious milieu and remind the reader that commerce enables the functioning of all the fabrics mentioned here.

Joining the explicit allusions to the religious and commercial life of the city that this description and Brunelleschi's panels embodied are implicit references to the artistic heritage of the city and the architect. The Cathedral of Santa Maria del Fiore was erected by Arnolfo di Cambio in 1302. The campanile was designed by Giotto in the following decades. The Misericordia was built in 1330, and the column of St. Zenobius in 1384. This urban space represented a trecento building boom in which the most prominent architects of the century preceding had contributed their most important monuments. Brunelleschi began his cupola for the cathedral (1420–36) just before the supposed date of the panels that Manetti describes.

By representing his perspective view of the cathedral precinct (without the cathedral itself), Brunelleschi literally positioned himself in the company of the greatest architects of Florence's past. He could be said to have appropriated not only his own architectural heritage by representing it but also to have inserted himself into the pantheon of trecento builders who changed the face of the city forever.

Manetti, the architect, builder, and historian, could not have been unaware of the significance of Brunelleschi's self-representation in this demonstration panel. Manetti had worked with Brunelleschi on the cathedral, and following his death, after a hiatus in which Michelozzo was in charge, Manetti was appointed *capomaestro* of the lantern in 1452.[58] His biography of Brunelleschi contains a lengthy defense of his own and Brunelleschi's program in the building of the cathedral. Indeed, the construction of his own text, written some fifty years after the event of the panels shows a self-consciousness about the architect's role in the history of the cultural life of the city. Art historian Leopold Ettlinger has argued persuasively that in fourteenth-century Italy ar-

chitecture was the earliest of the visual media to become associated with the term for art (*arte*) instead of being understood as a vocation (*mestiere*).[59] Parallel to this new justification of architecture, Manetti inserts painting into the category of art by focusing on Brunelleschi's demonstration panels. Thus, the concept of "the artist" emerges concurrently with the elevation of the media, architecture and painting, and their originator, Brunelleschi.

The description of Brunelleschi's second panel brings into play the civic aspect of Florentine history in the representation of culture through texts and images. This aspect of the subject matter of the second panel is enhanced by reading in Vasari's *Life of Brunelleschi* that the architect was elected to the Signoria in May and June of 1423: "Filippo exercised that office and also other magisterial functions that he obtained in his city, wherein he ever bore himself with most profound talent."[60] Brunelleschi was a member of the government of the city whose seat he was soon to represent in the second panel. Vasari writes that earlier Brunelleschi had worked in the Palazzo della Signoria as designer: "In the Palace that was the habitation of the Signoria, he arranged and distributed all those rooms wherein the officials of the Monte had their office, and he made doors and windows there in the manner copied from the ancient, which was then little used, for architecture was very rude in Tuscany."[61]

Manetti's description of the second demonstration panel emphasizes that the view encompassed the piazza as well as "two entire facades" of the Palazzo dei Signori. Once again, Brunelleschi had positioned himself in front of a church, San Romolo, in order to obtain the ideal view of the piazza and palazzo inferred by Manetti. In order to enlarge the piazza, the church of San Romolo was demolished in 1356 and subsequently rebuilt. The other major monument besides the Palazzo dei Signori that is mentioned in this description, the Or San Michele or the guild hall of Florence, had also been built in the trecento, in 1336. The building history of the palazzo and piazza spanned the entire trecento. Thus, like the buildings mentioned in the description of the first panel, this site represents a history of the urban architecture of Florence that directly preceded Brunelleschi's own day.

Furthermore, like the first description, this one inserts the commercial into the major subject matter of the panel, in this case the civic life of the city, represented by the palazzo and Or San Michele. The Canto di Calimala Francesca was the important wool exchange and could be said to represent Florence's commercial hegemony abroad. Thus, the

foreign affairs and the domestic politics of the city are "encompassed by the eye when one stands outside the piazza," or when one viewed Brunelleschi's representation of the piazza, or when one read Manetti's description of Brunelleschi's representation.

The compendium of Florentine life that these two panels and the texts describe is similar to the extended description of the city found in Bruni's contemporaneous *Panegyric to the City of Florence*. Here as well, the cultural and artistic heritage of the city, along with many references to its famous buildings, is evoked in the context of a civic pride based on religious foundations. Furthermore, in this text the vernacular language and the literature written in that language are directly and concretely tied to the civic and spiritual aspects of culture. The last two paragraphs of Bruni's text are the strongest arguments that can be made in support of the foregoing assertions regarding Brunelleschi's panels and Manetti's descriptions and the autochthonous aesthetic that inheres in the language of those texts:

> Now what shall I say of the persuasiveness of their speech and the elegance of their discourse? Indeed, in this category the Florentines are the unquestioned leaders. All of Italy believes that this city alone possesses the clearest and purest speech. All who wish to speak well and correctly follow the example of the Florentine manner of speech, for this city possesses men who are so expert in their use of the common vernacular language that all others seem like children compared to them. The study of literature—and I don't mean simply mercantile and vile writings but that which is especially worthy of free men—which always flourishes among every great people, grows in this city in full vigor.
>
> Therefore, what ornament does this city lack? What category of endeavor is not fully worthy of praises and grandeur? What about the quality of forebears? Why are they not the descendants of the Roman people? What about glory? Florence has done and daily continues to do great deeds of honor and virtue both at home and abroad. What about the splendor of the architecture, the buildings, the cleanliness, the wealth, the great population, the healthfulness and pleasantness of the site? What more can a city desire? Nothing at all. What, therefore, should we say now? What remains to be done? Nothing other than to venerate God on account of His great beneficence and to offer our prayers to God. Therefore, our Almighty and Everlasting God, in whose churches and at whose altars your Florentines worship most devoutly; and you, Most Holy Mother, to whom this city has erected a great temple of fine and glimmering marble.[62]

Trachtenberg has argued that the Palazzo della Signoria and the adjacent piazza held iconic significance for the citizens of Florence: "Un-

like any other Florentine square, the enormous void of the Piazza della Signoria was itself a monument, a telling symbol of the power and sovereignty of the community."[63] Other scholars express a similar opinion. For example, in tracing the history of the palazzo and the site from the late 1200s to circa 1400, Nicolai Rubenstein concludes that the entire complex, but especially the western section with the Loggia, "had become more properly the Piazza of the Signoria, and of the people."[64] The western view was most probably the one that Brunelleschi chose to represent. According to Trachtenberg, the reasons for so doing were dictated by his fascination with "its geometric construction and . . . by the illusion of a space that looks square although it is not, and with a site that seems precisely balanced, even symmetrical, though it is asymmetrical."[65] Similar reasons, those of geometry and proportion, have been given by Samuel Edgerton for Brunelleschi's choice of the baptistery in his first demonstration panel.[66] We have seen here that a reading of Manetti's descriptions in light of other passages drawn from biographies, such as Boccaccio's and Vasari's, and in light of Bruni's *Panegyric to the City of Florence* shows Brunelleschi's "choice" to have been further complicated by issues of history, language, and the place of the artist and art in the life of the city. In the biography by Manetti, civic life is played out between the symbolic poles of religion and government with painting, or the *invenzione* of the artist, intervening in the representation of both. Vasari's entire biographical project, especially the first edition of his *Vite*, supports this observation concerning the role of the artist.

Painting what one sees and using the vernacular in poetry in and of themselves do not constitute the contributions of the respective arts and artists spoken of here. Rather, painting according to perspective and poetry according to number or meter are the real contributions of Brunelleschi and Dante. These contributions are distinctly entwined with a dense matrix of interrelated topics that can be called distinctly indigenous to Florence, her citizens, and artists. As we recall this autochthony, let us turn to the subject of mimesis with the descriptions of the panels in mind.

## Mimesis and Culture

Brunelleschi's purpose in his demonstration panels was, in the words of Vasari on Giotto, the "counterfeiting and imitation of nature." The lengthy and complex descriptions, particularly of the first panel, leave

no doubt that such an understanding of the imitation of nature could be termed totalizing in the extreme. Brunelleschi imitates culture (the *polis*) naturalized by perspective. Perspective as a means to an end can be said to be the practical application of the theory of imitation. This is why Brunelleschi's invention of perspective was seen to be so important by his contemporaries, like Alberti, who dedicated his book on painting (1435) to the inventor of the perspective theory described therein. When Manetti described the demonstration panels, he stressed that "whoever could have imparted it [scientific perspective] to him had been dead for centuries and no written records about it have been discovered, or if they have been, have not been comprehended."[67]

In Brunelleschi's panels, or at least in Manetti's descriptions of them, this goal of painting can be said to have been literalized to an extreme not possible within the confines of the mathematics of the science of perspective, if we understand those in terms of Alberti's book on the subject, *On Painting*, or in Kemp's words, in terms of "codification and the written record."[68] We could say that the theoretical, mathematical boundaries of the science of perspective were transgressed by Brunelleschi, the reason being that science was incapable of allowing the literal view of nature that was painting's goal.

The last parts of the descriptions in Manetti are symmetrically placed in the text at the end of each description of the separate but contiguous cityscapes. The two systems or methods that Brunelleschi devised so that "the spectator felt he saw the actual scene when he looked at the painting," in the case of the view of the baptistery, or so that "he could observe it with the natural atmosphere above the buildings," in the case of the view of the Palazzo della Signoria, have little to do with the mathematics of perspective. Instead, by means of burnished silver, mirror effects, and drilled holes in the first panel and a skyline cut out of the wood in the second panel, Brunelleschi reverted to more basic tricks of illusion that did not rely strictly on mathematical methods. In both cases the desire for a literal representation of "*l'aria naturale*," as Manetti termed it, compelled the artist to eschew science in favor of illusion and craft.

In the first panel, the mimesis is achieved through reflection on burnished silver: "the real air and atmosphere were reflected in it, and thus the clouds seen in the silver are carried along by the wind as it blows." In the second panel, mimesis itself is replaced by the literal insertion of sky above the cut-out skyline. Manetti makes the point that

in the second panel the illusion of reality was more difficult to achieve because the panel was larger due to the size of the piazza that contained "those many diverse objects." Thus, in the second panel, Brunelleschi could not be served by his complicated system of holes and reflections but rather only by the actual insertion of nature itself revealed in the cut-out section at the top of the panel.

We might infer from this that the ambitions of the artist to represent a scene of such difficulty in as exact an imitation of its reality as possible outstripped not only the science of perspective and the illusions that mirrors could provide but also representation itself. Brunelleschi abandons not only perspective, allied with science by interpreters since Alberti, but also representation, allied with imitation, in order to achieve a situated realism. This realism is part of a representational scheme, the panels, but one that is exactly situated in Florence. The mirrors and cut-out attest to, rather than imitate, the represented reality in perspective when that representation, that is, the panel, is itself placed or located in Florence. Here is an autochthonism of remarkable ingenuity, and a reason for the canonical status of Brunelleschi's panels in the history of art.

What the viewer of this panel saw above the representation of the civic center of the city was nothing more or less than "l'aria naturale" of Florence, a literal insertion of indigenous nature into a system of visual representation. In the scope of its artistic ambition, it is analogous to the claims that Boccaccio made for Dante regarding the insertion of the vernacular into the language of poetry. The biographers, Manetti and Vasari, and art historians following them emphasize the panels as literal demonstrations of the theory that they embody, betraying the strength of the autochthonous aesthetic in representation and its history since the time of Boccaccio.

We shall see in the following chapter that the aesthetic of mimesis operative in the Renaissance biographies replicates in Burckhardt's assessment of the entire Renaissance culture. It is the same view of the contribution of Dante to the project of modernity that Erich Auerbach expressed in his influential book on literary history, *Mimesis*.[69] This view of Dante was made possible not only by the texts from the time of the Renaissance itself but also by the idea of Renaissance *culture* as it was formulated first and imitatively by Burckhardt in *The Civilization of the Renaissance in Italy*. Auerbach's thesis concerning Dante's originary status in the understanding of a modern conception of mi-

mesis represents one of the most prominent views of Western culture in which autochthonous elements or characteristics determine and override other considerations. Historiographically, this perception of culture resides in the German historicism of *Kulturwissenschaft*, and Burckhardt and Auerbach are two of its most brilliant exponents. They both located the origin of this culture in the literary criticism of the trecento where Florentine nature and life were represented in the poetry of Dante and in the biography of Dante by Boccaccio.[70] Thus have these literary foundations and their usage in history writing determined our view of both literary and visual culture. In between Boccaccio and Burckhardt, Dante and Auerbach, lies the birth of the nation-state and other reasons for autochthonic arguments that lie beyond the scope of this book.

# 3 / The Artist in Culture: *Kulturwissenschaft* from Burckhardt to Warburg

Not until art history can show . . . that it sees the work of art in a few more dimensions than it has done so far will our activity again attract the interest of scholars and of the general public.

ABY WARBURG[1]

When the complexities involved in the construction of the image of the artist in Western culture from the Early Modern period (ca. 1350) to the present are viewed historiographically, their interpretation requires at the outset two kinds of investigations. First, the determinants for our present image of the artist that are found in texts from this early period require identification and contextualization. Second, the traces and usage made of these structures and their contents in the later writing on the Renaissance period by historians and early art historians call for historicization on the discursive and disciplinary levels. Such a genealogy implicates some key aspects of early Italian art theory in the subsequent construction of the artist in culture. By demonstrating how theoretical discussions such as those concerned with poetry and painting and native style, to name two major topics discussed in the previous chapter, adhered in their textual usage to the later conception of the role of the artist in culture, I aim to include the discipline and the discourse of art history in my interpretation of Renaissance theory and texts about the artist.

It is well known that the issue of the artist's image was raised explic-

itly for the first time in the *Lives*, or biographies, of artists that began to appear in Italy in the middle of the fourteenth century. From the first, these early *Lives* provided the textual instantiation of the work of art *and* the person of the artist. For example, in the dedicatory letter to Cosimo de' Medici written by Giorgio Vasari for the 1550 edition of his *Lives of the Most Famous Painters, Sculptors and Architects*, the author defined his project in terms that conflate the individual craftsman and the works of art:

> I think that you cannot but take pleasure in this labour which I have undertaken, of writing down the lives (*le vite*), the works (*i lavori*), the manners (*le maniere*), and the circumstances (*le condizioni*) of all those who, finding the arts already dead, first revived them, then step by step nourished and adorned them, and finally brought them to that height of beauty and majesty whereon they stand at the present day.[2]

In the Romantic period, the idea of seeing the artist's life in conjunction with his work became infused with thinking about genius, which had begun in the early eighteenth century with the writing on art of Johann Winckelmann and, slightly later, in the aesthetics of Kant.[3] The situation of the artist whose origins can be identified as textual and located specifically in the early biographies of artists but whose genius is universal is one that we have come to accept as the norm in our culture. As a cultural norm, or what we expect of the artist and art, it has naturally been addressed by the artists of modernism, who often concerned themselves with questioning cultural norms, self-representation, and the limits of art.

Art historians Linda Nochlin, Timothy J. Clark, Michael Fried, and others have located the beginning of this critique of a cultural norm in the middle of the nineteenth century. The artists Gustave Courbet and Edouard Manet and the later Impressionists took the definition of the artist in society to be a central subject of their painting. The art historians have argued that this exploration of the figure of the artist constitutes a major signal of the birth of modernism in art.[4] The approaches of these artists in their paintings to the issue of the artist in society reveal that the questioning of the imbrication of artist and work took place around the subject and subject matter of history painting and self-portraiture. The resultant redefinition of these genres soon became a major concern in the critical writing on art of the same period.[5]

With the literal marriage of the written and the visual in cubism and the work of Marcel Duchamp and the Dada artists, the construction of the image of the artist in culture and by texts has remained a central focus of art in this century.[6] In pop art and the many movements of postmodernism, works by artists such as Andy Warhol, Cindy Sherman, and Barbara Kruger question the subject of the artist and the work of art in culture.

For example, an examination of the topic of the construction of the artist in culture in conjunction with the work of art in texts and visual media can be found in Bruce Nauman's installation piece *Clown Torture* of 1987 (figure 8). *Clown Torture* consists of two twenty-inch color monitors, two twenty-five-inch color monitors, four speakers, two video projectors, and four videotapes. The clown speaks at himself mirrored in projections on two opposite walls and in the two pairs of stacked monitors placed frontally on pedestals. Images of the clown exposed on a toilet, attempting to balance goldfish bowls, and tortured and interrogated appear on the various screens. The clown could be the artist, made up and filmed by himself, the clown. This allusion to self-portraiture employs the artist-as-clown trope, a familiar pose of the twentieth-century artist as social outcast and commentator, conveyed most notably in painting by Pablo Picasso and in film by Federico Fellini. Nauman portrays the physical and emotional pains of the self-reflective artist in a repetitive loop of video and sound bites. Artist-as-clown demonstrates the torture of being the object of art: the clown is artist, the oppositional video screens are artists, the voices are the artists'. This desire to seize control of the system of construction through a dual subversion of the medium of video performance and the genre of self-portraiture enhances the position of the artist in this system of object display and subject objectification. Through self-objectification and self-mortification, Nauman critiques the museum as a system of display, the performance piece as engagement, and the role of the artist in culture. This painful exercise leaves us with the conclusion that today the inseparability of maker and production provokes anxiety.

In history writing, rather than art practice, the discussion regarding the artist has proceeded differently, although the initial imbrication of artist and art occurred in the context of history writing, as we have seen in the example taken from Vasari, often called the first art historian. Martin Kemp has pointed out that

*Figure 8. Bruce Nauman,* Clown Torture, *1987, video installation (detail), Collection Lannan Foundation, Los Angeles. (By permission)*

the cult of the individual artist, as an individual with a recognizable creative personality worthy of biographical attention, may fairly be regarded as one of the signal characteristics of Renaissance art. The assessment of individual artists plays a prominent, even dominant role in the later literature on the period, taking its cue from the new genre of biographies of artists that arose in the Renaissance itself.[7]

Whereas Kemp's insight that our ideas of both the artist and the period known as the Renaissance are implicated in the genre of biography may be familiar to some, the interpretations generated when this view is pursued discursively, as indeed Kemp suggests it should, are not. Assumptions regarding the artist and work of art appropriated from the biographical literature have determined art history's view of these subjects and also of itself. This chapter will explore that determinism. The effects of the early biographical texts have been felt in discursive and disciplinary fields. This chapter argues that the deployment of the early texts about the artist has determined key interpretations of the idea of the Renaissance and the methods used to understand the idea of a period concept in the history of culture. The earliest biographies of the artist and those texts that follow in their tradition reveal that the myth and the history of art and the artist intertwine in compelling and complex ways.

## History, Science, and Culture

Art historians have maintained that the definition of the image of the artist by modernist artists took place overtly in art practice in the mid-nineteenth century and the early twentieth century. The other place in which the question of the image of the artist arose—however implicitly—at exactly these same moments was in every area of academic discourse touched by the German historicist project of *Kulturwissenschaft*. This difficult term and the concepts that it embodies occur in the areas of the humanities and social sciences that were concerned with the image of the artist. This includes the disciplines of literature, philosophy, history, anthropology, psychoanalysis, and art history. *Kulturwissenschaft* is central to the problem of understanding the historical dimensions or background of the cultural construction of the artist because it provides a way to explore the history of the image of the artist in all of these fields. By ranging across these disciplines and examining a variety of discourses in which the cultural construction or understanding of the artist emerged, we can fix upon, hopefully

with some degree of satisfaction concerning the breadth and complexity of the problem, the outlines of the cultural construction of the artist in the academy and in popular thought throughout this century. The issue of the cultural construction and history of the image of the artist, then, at least when it is viewed from a historiographical point of view, is not merely present for art history but for all of the social sciences, for humanities, and for society at large as well. A brief background discussion of the term *Kulturwissenschaft* will be followed by a consideration of two historians, Jacob Burckhardt and Aby Warburg. Their interpretations of the Renaissance remain influential in art history today.

Translated into English, the term *Wissenschaft* literally means "science." In a combinatory usage with other terms such as *Kultur*, it therefore connotes the inheritance of the Enlightenment's belief in science as truth with the idea of scholarship as science. The use of the term in historical studies from the middle of the nineteenth century onwards is part and parcel of the empirical or "realist" method of history writing initiated by Leopold van Ranke at the beginning of that century. Arguably, this method of history writing held sway until poststructuralism's critique of the value of all truth-bearing approaches for history writing began in the early 1970s.

Hayden White has shown that although Ranke's idea of history was itself a reaction against "the methods of the Romantic art, Positivist science, and Idealistic philosophy of his own time," it nonetheless must "still claim that title of a 'science' with which Ranke recognized it must be endowed if it was to be permitted to claim an authority greater than that of subjective opinion."[8] White's point is important, and it is twofold. If we accept, as most historiographers have done, that Ranke's approach to history founded "a large school of historians who are in fundamental agreement on common standards of objectivity," then we must also agree that the inheritance of the Enlightenment's belief in the basic "truth" of science and scientific method underlies the project of history writing for much of the nineteenth and twentieth centuries.[9] We can understand Burckhardt's positivism in exactly this way. It is not, as Ernst Cassirer wrote, a collection of facts and evidence but an essential belief that history will furnish us with knowledge as truth.[10] In addition, although Ranke "rejected a Romantic approach to history in the name of objectivity," his own writing of history relied on narrative. As White saw, the essential aspects

of narrative, such as archetypal myth or plot structure, are therefore common to any approach (including the Romantic one) that uses this form.[11]

Simply put, in Ranke and other historicists we encounter the contradiction in a history writing conceived of simultaneously as narrative and objective fact telling. As we shall see, this contradiction must be kept in mind when historians, such as Burckhardt, consider the "primary literature," such as the biography of the artist, of a period in history, such as the Renaissance. For, in all cases, the contradiction adheres when objectivity is believed to belong to the historian who brings it to bear on the uncovering and interpretation of the written sources. To understand the function of *Wissenschaft* in the term *Kulturwissenschaft*, we must accept that it carries Enlightenment values colored by a dominant practice of history writing unable to acknowledge an essential contradiction intrinsic to its own procedures.

Other, and perhaps more complex, issues adhere to the term *Kultur*. In English usage *culture* or *civilization* encompasses the fine arts and literature but also every product of civilization, such as language, history, myth, and indeed all so-called cultural artifacts. *Kultur* can be understood not only in this most general sense but also in a more particular sense in which, for instance, nationalistic, native, or ethnic traditions inform its use. It has often been pointed out that the first use of the term *culture* in English occurred in the field of anthropology and specifically in a theoretical context in reference to so-called primitive culture.[12] In English usage today, all of these senses are connoted when the term appears as the name of a new field of social history called cultural studies.[13] Raymond Williams, whose work is central to this new field, wrote that "the very fact that it [culture] was important in two areas that are often thought of as separate—*art* and *society*—posed new questions and suggested new kinds of connections."[14] Historically, the term *Kultur* or *culture* has been ubiquitous and loaded. Thomas Mann's famous attempt in 1918 to disentangle it from the metapolitical level where earlier formulations of German nationalism and ethnicity had placed it can be understood as emblematic of the ideological difficulties encountered in its usage.[15] Nonetheless, *Kulturwissenschaft* remained a dominant approach to visual culture, especially art history, in German-speaking countries at this very time.[16]

If there are any doubts about this last observation, they should be laid to rest by the simple reminder that Warburg's library in Hamburg,

Die kulturwissenschaftlich Bibliothek Warburg, envisioned by its founder as early as 1903, became a public institute in the early 1920s when it was allied with the newly founded Hamburg University (1920).[17] Edgar Wind has described Warburg's concept of culture and *Kulturwissenschaft* as central to understanding "artistic vision" as just another, albeit important, "function" of culture: "One should rather ask the twofold question: what do these other cultural functions (religion and poetry, myth and science, society and the state) mean for the pictorial imagination; and what does the image mean for these other functions?"[18] Where does the artist fit in this formulation of the functions of culture and the practice of history as *Kulturwissenschaft*? Both Wind and E. H. Gombrich agree that Warburg's *Kulturwissenschaft* was based on an approach to and a tradition of writing about Renaissance art and artists that went back to the middle of the nineteenth century and the book *The Civilization of the Renaissance in Italy* (*Die Cultur der Renaissance in Italien*, 1860) by Burckhardt, the Swiss historian and student of Ranke.[19]

Renaissance writers and artists themselves insisted that they were rejecting the Middle Ages, but it was not until Burckhardt's book that the concept of a Renaissance in culture emerged as a major tenant of German historicist thought and inflected the newly emergent discipline of art history. It is fair to say that although Burckhardt's other studies of the Renaissance, *Renaissance in Italien* (1867) and the *Cicerone* (1855), address key aspects of Renaissance art and monuments, neither of them deals with the issue of the definition of a period culture in the social and political dimensions of *Civilization*. Nor has either of them had anywhere near the influence, especially among non-German speakers, as *Civilization* has.

Furthermore, the notion of what constitutes a Renaissance, particularly the emphasis on the individual, so important to the construction of the artist in the culture, occurs in *Civilization*. It is from this book and its use of sources regarding the individual, that is, the biographies, that art history appropriated its use of the sources—sources used by Burckhardt himself as the basis of his view of the artist. Peter Murray has said that Burckhardt's book on architecture provides a "typological account" because it "breaks decisively with the kind of architectural history based on biography, which began in Italy with the *Vita di Brunellesco* and was perfected by Vasari."[20] The structure of *Civilization* is also typological, but it should not be inferred from this that bi-

ography *in its form*, or as a genre, does not determine key aspects of Burckhardt's book, most particularly the way in which it determines the typologies of Burckhardt's Renaissance. While the typological *account* may differ from the chronological one found in biography, including Vasari, this does not mean that Burckhardt eschewed all of the other conventions and aspects, such as the emphasis on the individual heroic figure, of the genre of biography. Biographies constituted the majority of Burckhardt's sources. Therefore, Burckhardt's approach to the artist in *Civilization* especially in his conception of culture and the Renaissance is essential to our discussion.

## Culture as Concept

The most lasting contribution of Burckhardt's book has been the definition of the period concept Renaissance.[21] Burckhardt's belief that the "cult of the individual artist . . . may fairly be regarded as one of the signal characteristics of Renaissance art," as cited earlier, was an important corollary to this view. Again, Cassirer recognized the importance of this elevation of the individual and a belief in his agency as central to Burckhardt's view not only of the Renaissance but of all of history: "What Burckhardt foresaw and what he feared was the ever increasing ascendancy of the 'collective' spirit over individual judgment."[22] Indeed, according to Cassirer, it was in the individual in history that Burckhardt found his truth: "Burckhardt finds permanence and truth in quite a different sphere. He does not seek it in eternal essences, in things in themselves or Platonic ideas."[23] His field— the field of a historian, not a metaphysician, as Cassirer saw—is man's empirical existence. Burckhardt's view that the essential truth lay in history, particularly the history of the individual as it was to be found in the literature of an age, was compelling to art historians interested in the application of *Kulturwissenschaft* to the history of the visual arts.

Gertrude Bing, Warburg's biographer, recognized that the basis of his adherence to Burckhardt's view of the Renaissance lay in his appropriation of the method of using particular facts gleaned from a variety of Renaissance sources, most of them biographical, as the means of interpreting culture. Significantly, Bing saw Warburg's use of Burckhardt's term "*la Vita*" to be emblematic of their common method regarding their approach to the contemporary sources in the elucidation

of the art of the period: "The historian cannot consider any sphere of existence too low, too obscure or too ephemeral not to be able to furnish evidence."[24] As we shall see, the *Vita*, or biography of the artist, provided just the sort of evidence Burckhardt and Warburg required for their period concept.

The preeminence of Burckhardt in art history was overdetermined by the author, as he himself admits on the first page and as scholars since his time have consistently noted. His "intention to fill up the gaps" in the understanding of this period by simply writing a book on the art of the Renaissance was thwarted because, as he wrote, "the most serious difficulty of the history of civilization (*Cultur*) [is] that a great intellectual process must be broken up into single, and often into what seem arbitrary, categories in order to be in any way intelligible."[25] Burckhardt delineates the subject matter of his book with the titles of the sections under which he groups his chapters: "The State as a Work of Art," "The Development of the Individual," "The Revival of Antiquity," "The Discovery of the World and of Man," "Society and Festivals," and "Morality and Religion." These correspond to what Murray called the "typological account."

Literary texts, almost all of them in the vernacular, or *volgare*, and the largest number of them biographies, constituted the sources from the period that Burckhardt used as the basis for his categorization of the main aspects of the culture. According to Burckhardt, the sources were the documentary evidence *in* history, the same function that sources had in Ranke's "realistic" historiography. Cassirer writes that "to him the world of human doings and human sufferings is no mere fugitive shadow; it is, on the contrary, the very core of reality."[26] Burckhardt's sources are biographies of poets, such as Dante, politicians, such as Lorenzo de' Medici, and artists, such as Leon Battista Alberti.

In Burckhardt's formulation, culture operates in a virtually seamless way and at two levels: in his historical method and in the choice and application he made of the texts he used to explain his subject, the Renaissance. Like Ranke, Burckhardt was caught in the contradiction inherent in the conception of history writing as narrative and an essential belief in the objectivity that the historian could bring to bear on the uncovering and interpretation of the written sources from the period of his investigation. In Burckhardt this contradiction could be said to be operating metastatically between the narrative and objec-

tive levels of his enterprise. It is most evident in his conception of culture, specifically in his idea of the Renaissance.

The titles of Burckhardt's sections indicate that he was intent "on exploring culture as manifested in action, writing, and art" in order to define "the root patterns of orientation and motivation" that constituted a particular society at a particular time and place.[27] For Burckhardt, the time and place was Italy in the years circa 1300 to circa 1525. The term that he used to label this culture, society, and period was "the Renaissance," a period concept that had already been developed to some extent by Jules Michelet in the last volume of his *History of France* (1833–44, 6 vols.). Michelet's study of France in the Middle Ages culminated in a discussion of the fourteenth and fifteenth centuries, the Renaissance, as he called it. Michelet saw this period as a decline in the moral and political values of the late Middle Ages because of the demise of the communes and the democratic political and social ideals that he believed they embodied.[28] Burckhardt knew and used Michelet's work, as Werner Kaegi established in his biography of the Swiss historian.[29] Burckhardt's Renaissance, however, was more than simply a term used to designate a chronological period that came after the Middle Ages and against which the ideals of the earlier period could be contrasted and extolled, a fair characterization of the term as used by Michelet. Like Michelet, Burckhardt viewed the Renaissance as a radical break with the earlier period of the Middle Ages and a break that ushered in modernity.[30] For Burckhardt, however, this period of the ushering in of modernity, the Renaissance, stood out because the life of the spirit, so dominant in the Middle Ages, was manifested for the first time since antiquity in a life in action. In the actions of individual men, according to Burckhardt, the spirit of the age revealed itself.

Thus, Burckhardt's idea of the Renaissance is bound up not only with a concept of individuality but also with his conception of culture. For Burckhardt, culture can be seen as the repository of the spirit and actions of men. The concept of the Renaissance depends on the methods he used to interpret cultural history. Essential to the concept of the Renaissance and the interpretation of the period's individuals and literary and artistic artifacts was the method of recuperation.

It has often been noted that Burckhardt spends as much time considering the precedents for the Renaissance as he does on the years 1400 to 1600, commonly considered the chronological boundaries of

the period.[31] In order for Burckhardt to delineate the Renaissance and the idea of its culture, he had to recuperate a past that preceded the subject of his investigation of the past. This double recuperation, whether by Michelet or Burckhardt, must be seen as essentially Romantic because it incorporates nostalgia into the very notion of the period concept Renaissance. Warburg appropriated this method of understanding the past and Renaissance culture in his later version of *Kulturwissenschaft*.

According to Warburg's view of Renaissance art, one of the signal characteristics of the period, the use of the antique, could be understood through the process of recuperation. In this interpretation the recuperation of the ideal past occurred through the visual *forms* of the past, classical antiquity. As Gombrich has explained, "The special problem of *Kulturwissenschaft* that Warburg had singled out as his principal concern was that of '*das Nachleben der Antike*,' literally 'the after-life of classical antiquity.'"[32] Wind said that Warburg's investigation of the "revival of pre-existing forms," that is, antiquity in the Renaissance, provided him with "concrete evidence of the operation of 'social memory.'"[33] In this Romantic approach, not only is culture recuperable, but the recuperation itself is a double one. With Burckhardt's entry into the Renaissance via the Middle Ages, recuperation occurs before the period culture can be conceptualized. In Warburg, recuperation itself is posited as part of the procedures of the age under examination, as in the *Nachleben*. Furthermore, the historian's own method mirrors the recuperative act. In both historians, a romanticized view of the past results because of the methods employed to understand a period culture.[34]

In summary, Ranke gave history writing a method for substantiating a belief that the past could be recuperated objectively. Burckhardt used this as a means of separating one period from another, thereby establishing one period's unique culture. The possibility of identifying the "root patterns and orientation" of a culture is the result. Similarly, Warburg thought that by recuperating the way that classical antiquity, in particular, was used in the art of the Renaissance period he could identify the "root patterns and orientation" that were distinctive to a society. An extreme but nonetheless useful way of thinking about this procedural level of the enterprise of *Kulturwissenschaft* would be to say that if all the historical specificities of the period under investigation were removed, what would always remain would be "root pat-

terns and orientation," or culture itself, always essentially recuperable. This optimistic and Romantic view of cultural history remains problematic, as Karl Löwith saw: Burckhardt's "ultimate belief in the eternal value of 'culture' and of its 'continuity' is rather a problem than a solution" for historians.[35] The contradiction of Ranke's legacy lies in the term *culture* and its usage in the operations of *Kulturwissenschaft*.

## Renaissance Writing in Burckhardt and Warburg

We can understand the implications for the construction of the image of the artist in culture by investigating more closely the use Burckhardt makes of Renaissance texts. One might begin such an investigation with the external historical evidence of Kaegi's biography of Burckhardt, which documents the extensive details of Burckhardt's research in Italy and Zurich during the 1850s.[36] That research involved excerpting virtually all of the available Italian vernacular biographies, both published and in manuscript. Considering Burckhardt's emphasis on the individual and his actions as denotations of the period's culture, we should not be surprised to find Burckhardt's obsession with the genre of biography. For example, in the earliest notes for *Civilization* Burckhardt concentrated on the biographies and writings of Dante and Leon Battista Alberti. These men became central figures in his interpretation of Renaissance man in general and, therefore, in his formulation of Renaissance individualism.

Burckhardt adduces the genre of the biography as a prime indication of the Renaissance contribution to culture, as he says at the beginning of the fifth chapter: "Outside the sphere of poetry also the Italians were the first of all European nations who displayed any remarkable power and inclination accurately to describe man as shown in history, according to his inward and outward characteristics."[37] Echoing Burckhardt, Gombrich has seen the reliance on the vernacular biographies of Vespasiano de' Bisticci, Vasari, and others as evidence of "the magic touch with which he turned these selected extracts into signs of the times."[38]

Another approach to understanding Burckhardt's use of texts is to ask how Burckhardt reads the earliest biography of an artist. In *The Civilization of the Renaissance in Italy*, he used both Manetti's and Vasari's *Lives* of Brunelleschi. With his interest in festivals as indicators of the Renaissance spirit, Burckhardt looks at the performances

of legendary plays that took place in the piazzas of the towns of Italy and in which by "artificial means figures were made to rise and float in the air."[39] Brunelleschi appears as an inventor of the "marvelous apparatus" for the feast of the Annunciation in the Piazza S. Felice in Florence, "consisting of a heavenly globe surrounded by two circles of angels, out of which Gabriel flew down in a machine shaped like an almond."[40]

This passage in Burckhardt encapsulates the major themes found in Manetti's *Life* of Brunelleschi. As discussed in the previous chapter, these were (1) his powers of invention, such as when he is given credit for the invention of perspective; (2) his production of the marvelous, such as when he astounds other artists with his demonstrations of perspective, or artists and the public alike with his techniques for completing the dome of the cathedral in Florence; and (3) his public activity as an artist, which made him a visible figure in the civic and cultural life of Florence, not only with designs for public *feste* but also as a member of government. Of these, Brunelleschi's *invenzione* and his invention of perspective inform most strongly the later tradition of the discourse on art and its history.

This statement can be corroborated by the attention given to perspective and Brunelleschi in two recent and important books that deal with the European visual tradition from the Renaissance to the present: Martin Kemp's *The Science of Art* (1990) and Hubert Damisch's *The Origin of Perspective* (1987; recently translated into English).[41] Damisch writes:

> Tradition holds that Brunelleschi was one of the founding fathers of the Renaissance, one of the heroes of its narrative of origins, and makes him out to be the inventor of a method, if not of a form of representation, by means of which this same Renaissance summed up its key principles, making itself visible, rendering its composite matrix accessible in the guise of *paintings* (Though one sees immediately that the terms "tradition," "invention," "representation," "principle," and even "painting" call for critical scrutiny, and that questions concerning them cannot be separated from those raised by the very notion of "Renaissance").[42]

Unlike Damisch, Kemp's ideas about perspective are determined by post-Enlightenment scientific models. He understands the invention of perspective as a milestone in the imposition of a rational order on the chaotic world of the early Renaissance. It is a necessary first step toward the possibility of the invention of science itself. Damisch, on

the other hand, regards the invention of perspective as a metaphor for history and representation itself. In spite of these important differences, and perhaps because of their equally important concurrences, both authors give priority to the biographical literature, most especially Manetti's *Life* of Brunelleschi, in their investigation of the problem in the Renaissance. If, as indicated in the discussion of Burckhardt and culture, the biographical literature has been undertheorized in terms of history writing, so too have the traditions that adhere to the invention and the representations of perspective, including the concept of the Renaissance. My interpretation in the previous chapter of the textual representation of the so-called demonstration panels by Brunelleschi supports these contentions.

Burckhardt's characterization of the civilization of the Renaissance in Italy relied on texts that were as concerned with individual personalities as they were with the works that those personalities produced. His Romantic strain was naturally attracted to the idea of the individual genius, a concept central to all German historicism of the nineteenth century.[43] In a letter containing a "map of the discipline of art history," as Gombrich has called it, Warburg recognized the reliance of art historians on this primary literature that he criticized. He said that "our ordinary, enthusiastic, biographically orientated history of art" comes from Renaissance biographies by Vasari and others, resulting in a reliance on individual genius and "hero-worship" that he saw as particularly "peculiar to the propertied classes, the collector and his circle."[44] Warburg located Burckhardt in his list of "enthusiastic art historians," specifically in the category of "Morally heroic, reconstructing on historical foundations—Burckhardt (his parody: Gobineau)." To this first group of "enthusiastic art historians," Warburg opposed a second group who "made it its aim to investigate the sociological conditions, the universally existing inhibitions against which the heroic individual has to assert himself." He located himself here, in the subcategory of "*Stilgeschichte*": "Restricting conditions due to the nature of man's expressive movements."

Gombrich has suggested that with Warburg's separation of "*Panegyrische Kunstgeschichte*," or "enthusiastic art history," and "*Stilgeschichte*" a certain ambivalence existed toward the founder of *Kulturwissenschaft*, Burckhardt.[45] Some of this ambivalence must be related to a flaw in the logic of Warburg's own list rather than to Warburg's neurosis, as Gombrich asserts.[46] Warburg thought he was examining

the "sociological conditions" of art, unlike Burckhardt. Yet for both historians, an a priori "heroic individual" exists and reacts to the conditions of the time because the texts on which their interpretations of culture were based were the same.[47]

## Dilthey's Critique

Up to this point we have examined Burckhardt's use of the biographies of artists in the construction of the image of the artist in his scheme of culture by reverting to external evidence provided by Kaegi and to internal, or textual, evidence in *The Civilization of the Renaissance in Italy*. The contemporary reviews of the book provide another way to understand Burckhardt's use of sources. Such an opportunity appears especially pertinent when the critique is furnished by a contemporary of Burckhardt whose own work addressed issues of art, biography, and history writing. This is the case for Wilhelm Dilthey (1833–1911), whose little-noticed review of Burckhardt's book appeared in 1862, two years after its publication.[48] The impact on art history of Dilthey's approach to cultural history, particularly on Erwin Panofsky, has been recognized by Michael Ann Holly.[49] In fact, Dilthey intervenes in the dialogic relationship already established in this chapter between Burckhardt's and Warburg's ideas about cultural history.

The historian Hajo Holborn has argued that the review of Burckhardt's book represents Dilthey's preliminary thinking about the project of *Kulturwissenschaft*, which resulted in his formulation of the term and concept of *Geisteswissenschaften* in his book of 1883, *Einleitung in die Geisteswissenschaften*.[50] For Dilthey, the father of the hermeneutic theory of history writing, the two concepts were interchangeable and were used to support a history conceived of both as social science and as relative, at least as it pertains to the task of interpretation.[51]

Regarding Dilthey's approach to Burckhardt's book and its sources, we should remember that his own magnum opus, a work that occupied him for much of his productive life and that was still incomplete at his death, was his *Life of Schleiermacher*. Dilthey aimed in this book at a historicized psychological reconstruction of the *life* of a scholar and historian; in other words, he tried to write a new kind of historical, perhaps a hermeneutic, biography. In it Dilthey attempts to encompass personality and intellect, literary and historical interpretation, a history of an individual, and an intellectual history. For

Dilthey, the individual becomes historicized by and through psychological reconstruction, that is, through biography itself. As we shall see in the next chapter, Dilthey's life writing as history writing resonates with Freud's project to write a history of an artist through a psychoanalytical biography of Leonardo da Vinci. Dilthey's exhaustive "psychological reconstruction" of his subject could be seen as the elaboration of the "restricting conditions" that Warburg sought to describe in the representations of "the nature of man's expressive movements" embodied in Renaissance art. The *Life of Schleiermacher* could be said to be the "cult of the individual artist" taken to its most extreme elaboration.

Dilthey began his review of Burckhardt's book by reminding the reader that Ranke's earlier project "to write about Italy's historians, the interlocking of the Italian states with the European politics of the sixteenth century, and the Popes" resulted in a new awareness of "the political acumen of this nation, its eye for the life of the individual and for the real driving forces of political action."[52] From the outset, Dilthey had the reader understand that both Burckhardt's view of the role of the individual in the politics and history of the Italian states and his use of primary source material owed everything to his predecessor and teacher Ranke. Dilthey knew that Ranke's interest in Italian history was centered on the Counter Reformation and its aftermath and on politicians and historians. Burckhardt's emphasis, on the other hand, was on "every period from Dante to the Counter Reformation" and on how the literature and art of this period, rather than Ranke's "texts by Italian legations and historians," formed the basis of the political reality.[53] The result was one that Cassirer explained in this way: "Burckhardt even went so far as to declare that a powerful political life and a truly cultural life are, after all, incompatible with each other. A people cannot hope to be culturally significant and politically significant at the same time.[54]

The differences in period and source material between Ranke and Burckhardt were due, according to Dilthey, to factors "determined by his [Burckhardt's] social and political context."[55] Dilthey contended that Burckhardt "lived hoping that some day Italy would consolidate and become freed from the French influence."[56] According to Dilthey, the result of this liberal political standpoint was that "he intends to show that THE RENAISSANCE IS PRIMARILY ITALIAN, IN ORIGIN AND CHARACTER, AND IT IS ONLY SECONDARILY A

CULTURE OF CLASSICAL ANTIQUITY."[57] Dilthey's use of majuscules for emphasis in this passage impresses upon the reader the significance of maintaining that the Renaissance was primarily Italian.

I will make two comments here regarding Dilthey's perceptions of Burckhardt's book because they reinforce the point that I made earlier about the two levels of Burckhardt's enterprise that operate metastatically in the text itself. The first is to recall that Michelet's influence on *The Civilization of the Renaissance in Italy* had to do with conceiving of the Renaissance period as separated from the Middle Ages by virtue of its political structures, which were seen by Michelet to be a fall from the liberties and freedoms enjoyed by the communes. Dilthey recognized that Ranke's focus had been on the period of the Counter Reformation and "the ascendancy of the Spanish-Hapsburg power," or the formation of the early modern monarchy, based on the shared power of king and church. This left a breach right at "the apex of Italian culture," as Dilthey termed it, precisely in the fourteenth and fifteenth centuries.[58] With his interpretation of this period, Burckhardt provided an alternative to the lacuna in the prevailing historiography of the political development of Europe with Renaissance culture itself.

Second, if we accept Dilthey's perception that Burckhardt wanted to show that Renaissance culture was primarily Italian, we can understand the political dimensions present in the choice of the primary sources on which Burckhardt based his interpretation of the Renaissance. The issue of the Italian language is extremely important here because the majority of the texts that Burckhardt used as sources are in the vernacular. The question of whether to use Latin or the vernacular in poetry and history writing alike had been contested vigorously by the humanists in the very period that Burckhardt investigated. We have seen that this situation pertained in the early biographies of poets and artists. Hans Baron argued some time ago that the theoretical issues embedded in the discussion of the use of the vernacular in poetry and history writing, known in the Renaissance as the *questione della lingua*, were fraught with political and ideological significance.[59] The biographies of poets and artists and the commentaries on early Italian poetry that Burckhardt used are filled with the rhetoric of this debate over the merits of the use of the vernacular versus Latin.[60] If Dilthey pegs Burckhardt's intentions correctly, "that the Renaissance is primarily Italian, in origin and character," then, as the reviewer also recognized, it must be said that this is an argument that repeats an impor-

tant aspect of the texts that the author used as his sources.[61] Thus, Burckhardt's own narrative and his source material converge in the "culture" of the Italian vernacular, creating, as we shall see, important implications for the assessment of the visual arts of this period.

Regarding visual culture, Dilthey saw also that "Burckhardt's text must be considered the basis of a history of Renaissance figurative arts," for "even the study of the plastic arts, the most original product of the Italian Renaissance" led Burckhardt to conclude that "the Renaissance was primarily Italian."[62] Dilthey called the indigenous Italian art of the period the "most original product of the Italian Renaissance." According to Dilthey, art was therefore equated with or said to surpass poetry in the vernacular in Burckhardt's recuperation of the idea of a Renaissance culture and his assessment of its contributions. If Latin could be superseded by the vernacular in poetry, then modern Italian art could supersede that of antiquity, and, according to Burckhardt, the argument that the art of the Renaissance was due to a native expression rather than to a survival of antiquity could hold sway. In this sense, Burckhardt recuperates the discussion of "native style" that we saw in the early biographies of artists.

Burckhardt's insistence on the equation of the contribution of poetry and painting, and of poets and painters, to Renaissance culture relies completely on two interrelated topics that are found in the Renaissance biographies themselves. The first, the equivalency posited between the art of poetry and the art of painting, can, in its broadest elaboration, be extended to include the comparison between the authority of the poet and that of the painter. These sorts of comparisons are familiar to all readers in the literature of the period. We have seen already that Burckhardt incorporates this extension of *ut pictura poesis* in the use he makes of the biographies of poets and painters to support his interpretation of the meaning of poetry and the visual arts in Renaissance culture.

The second topic concerns the literary and the visual in the biographies as well. For this reason it may at times be found with discussions of the authority of poetry and painting in those texts. When Burckhardt discusses this topic, however, it assumes a dimension that is overtly historiographical, unlike its appearance in the Renaissance texts, where its appearance is often implicit or concealed. The view found in the texts and in Burckhardt that the contemporary or new "culture" resulted from an essential native tendency or impetus that

could be termed autochthonous has special relevance for any arguments made about the visual arts in the historiography of art history. In agreement with Dilthey, we could say that what is at stake in these discussions is exactly what constitutes an indigenous Italian style, or in Dilthey's words, what is the "origin and character" of Renaissance culture.

Put another way, the contribution that the poetry of the period made to the new order, as it was perceived in the Renaissance, had to do with the native language of Tuscany, especially Florence. So too, the contribution that the visual arts, particularly painting, made had to do with forms that were based on nature, but a nature that was indigenous to Tuscany, especially Florence. The early twentieth-century Viennese art historian Julius von Schlosser recognized that this idea of a new Tuscan art based on nature could be found in the earliest writing on art of the quattrocento, if not earlier. Importantly for the argument here, he finds it expressed in Tuscan poetry itself, that is in the famous lines on Giotto found in Boccaccio's *Decameron* (VI, 5). Equally importantly for the arguments here, he ocates "this concept, completely worked out into a historical construct" in the *Commentarii* of Lorenzo Ghiberti and the early biography of Brunelleschi by Manetti.[63]

Von Schlosser's points about Renaissance texts and concepts regarding the visual arts support and delineate more fully Dilthey's earlier (1862) position on Burckhardt. Our investigations in the previous chapter of the literature itself and in this chapter of the historians' use of it force the conclusion that when texts are used as source material, they determine the resultant interpretation, not in an uninflected sense but in a highly politicized manner.

Here it is worth quoting the conclusion of Dilthey's review of *Civilization* at some length:

> To repeat: Burckhardt's real intention lies in the proof, satisfyingly and irrefutably constructed through a wealth of details, that the Renaissance in Italy grew spontaneously from the character and the realities of Italy; that Antiquity only helped the rapid and powerful growth of what was already present. His main intent lies in the representation of the reasons and the interior connections of this spontaneous appearance which is being followed here in the truest historical sense for the first time in all its complications. If we tried to trace the ways in which the roots of Renaissance thinking are being demonstrated through the character of the Italian states, how it influenced science and art, as well as private life,

how Antiquity furthered and colored the whole development, we would have to copy the book.[64]

Dilthey observes that Burckhardt's reliance on the "wealth of details" constructed by the Renaissance determined the major points of his interpretation. This interpretation, like Brunelleschi's insertion of silver in the wood of the demonstration panel, mirrors the sources in profound ways: its autochthonous agenda had meaning for Manetti in the fourteenth century, another for Vasari in the sixteenth century, and still another for Burckhardt in Zurich and Basel in the nineteenth century. The historical literature cited here confirms that the impact of the autochthonous aesthetic continues today. It can be located textually and historically, if not visually, at all of these moments, yet its import for our understanding of the artist in culture outweighs any one of its particular historical instantiations.

The account of the artist and the works known as the biography of the artist has proven to be constitutive of itself in highly significant ways for history writing. Perhaps this is because the genre mediates so well between the imaginary and the real, between the myth and the history, between the artist and the object. *Kulturwissenschaft* took as its goal the interpretation of culture, not the individuals who contributed to that culture. Warburg rejected an art history based on the preexisting image of the artist because it could only represent the artist as hero. Yet the tradition traced out here in detail has been accepted as a given, including what it said about the artist or hero, because sources have been naturalized in interpretation. The nineteenth- and twentieth-century conception of the artist remains pegged to the fourteenth- and fifteenth-century concept on which it is uncritically based. However, the denial of the constructedness of the image of the artist in the methods of Burckhardt's and German historicism's cultural history can take on still other forms in the writing on art. In the next chapter we will examine what happens in the discourse when the artist surfaces as the overt subject of study.

# 4 / The Artist in History:
# The Viennese School of Art History

Thus, the *Handbook of the Sources* became the history of the historiography and theory of art from antiquity to the end of the 1700s: "conceived of with a philosophical spirit and therefore necessarily transformed, as it moved closer to more recent times, into a history of our discipline." OTTO KURZ AND JULIUS VON SCHLOSSER

The short book *Legend, Myth, and Magic in the Image of the Artist: A Historical Experiment*, written jointly by Ernst Kris (1900–57) and Otto Kurz (1908–75) and published in 1934 in Vienna, provides the first and only theory of the figure of the artist in culture.[1] Kris and Kurz base their understanding of the artist on the textual representation of the artist found in biography. They use two forms of analysis to understand this textual representation of the artist: literary and psychoanalytical.

In their literary approach, the texts of the past, especially biography, do not serve only or mainly as historical sources on which to base the reconstruction of a period's culture, as they did in Burckhardt's history. Instead, the discourse, structure, and value of these texts are recognized as dominant not only to the shape of the genre but also to the use made of them in historical interpretation. The Viennese School of art history, especially Julius von Schlosser (1866–1938), the teacher of both Kris and Kurz, actively sought to differentiate itself from the German art history known as *Kulturwissenschaft*.[2] Kris and Kurz's

analysis of biography relies on a philological approach associated with von Schlosser's teacher, Franz Wickhoff (1853–1909). Wickhoff "developed the idea of systematically organizing not only primary sources [documents], but secondary sources too, which was an important step for the Viennese School—though this was already a long tradition in Italy. . . . This set off over the next twenty years a great fever of interpretations of secondary sources, including biographies and studies."[3]

According to Kurz, the philological approach meant understanding the "formal" aspects of the texts "in the sense of a grammatical history."[4] Kris and Kurz use the philological method to interpret the texts generically. In this regime of interpretation Kris and Kurz, following von Schlosser, establish the category of the biography of the artist as separate from both other kinds of biography and art writing.[5]

Having established the biography of the artist as a separate genre, Kris and Kurz brought the methods of psychoanalysis, particularly its approach to the historical artist, to bear on the textual representation of the artist found in the biographies. Following his training in art history and preceding his collaboration with Kurz, Kris studied psychoanalysis with Sigmund Freud.[6] However, as we shall see, it was in Freud's early writing on the historical artist, most particularly the essay on Leonardo da Vinci (1910), that Kris and Kurz found a compatibility with their view of biography gained from their study of the literature on art. In this area of the historical, literary, and psychoanalytical representation of the artist, Freud's younger collaborator in the research on the historical artist, Otto Rank, must be given his due. His writing on the subject of the artist will be examined along with Freud's in the next chapter.

Kris and Kurz combined early psychoanalytic approaches to the historical artist with the philological approach of the Viennese School of art history toward the early literature on art, particularly biography, in order to achieve a theory of the artist. Thus, the Viennese schools of both art history and psychoanalysis were brought to bear on the subject of the artist in culture, a unique intellectual "experiment," as the authors termed it in the title of their book.

In the preface to the 1979 edition of *Legend, Myth, and Magic,* Ernst Gombrich, Kurz's research assistant at the time the book was written, stressed the importance of the linkage between art history and psychoanalysis: "we must not lose sight of the main aim of the

book—the establishment of links between the legend about the artist and certain invariant traits of the human psyche which psychoanalysis had begun to discern."[7] A summary of the book's main arguments, however, reveals that the exact nature of the contribution of Kris and Kurz was more complicated than Gombrich suggests.

## The Typology of the Biography of the Artist

In their book Kris and Kurz argue that the image of the artist in culture—not only in the Italian Renaissance context, with which they are most familiar, but in all of culture—rested exactly on the structure of the biography of the artist. They state in their introduction:

> The material that forms the subject of this inquiry has been selected according to historical criteria. It does not rely on a multitude of diverse details, facts and assertions about the artist's life history. Rather, it is homogeneous in character. Our primary source is how the artist was judged by contemporaries and posterity—the biography of the artist in the true sense of the word. At the very core of this stands the legend about the artist.[8]

Here, Kris and Kurz contend that the textual representation or the judgment of the artist by others, that is, the biography, simultaneously surrounds and provides the "core" of the legend of the artist. The biography is a textual instantiation of the legend, or image, of the artist. On this assumption rests their ability to argue that the image of the artist *and* the biography of the artist have exactly similar typologies:

> We believe that we can demonstrate the recurrence of certain preconceptions about artists in all their biographies. These preconceptions have a common root and can be traced back to the beginnings of historiography. Despite all modifications and transformations they have retained some of their meaning right up to the most recent past; only their origin has been lost to sight and must be painstakingly recovered."[9]

The "preconceptions" about which Kris and Kurz speak have to do with the heroization of the artist. The authors see this as evidence of the status given the artist by his contemporary society. Having situated the artist as hero, they turn to the biographical texts, where they find stereotypical themes indicative of heroic or "legendary" status in society. These include evidence of early promise or precocity, including the presence of portents or harbingers of genius; extreme virtuosity without labored effort in the artistic media; extreme or unusual

spirituality and wisdom evidenced in late works; and magical influ-
ences ascribed to artistic production. Kris and Kurz examine all of
these in their book.

Kris and Kurz recognized that the major contribution of *Legend,
Myth, and Magic* lay in the argument that the stereotypical themes
they identify are embodied structurally in the genre of biography it-
self. They identify the anecdote as the structural node of the biogra-
phy of the artist. They viewed the "artist anecdote" as instantly recog-
nizable because it was reflective of the legend of the artist already held
by a culture. They called this structural element "the primitive cell" of
the genre in that it bears the "fixed biographical themes" so character-
istic of the biographies of artists.[10] Therefore, the anecdote functions
as the basis of the typology of the genre. In their view, typology is not
carried only generically but also at a discrete narrative level, in the
form of the anecdote itself. We shall pursue the implications of this
view for present art history writing in the last chapter of this book.

Importantly for Kris and Kurz, the anecdote does not function only
at the narrative level but also operates at the symbolic level. Accord-
ing to them, the anecdote "contains the image of the artist which the
historian had in mind."[11] With their theory, the artist finds full expres-
sion in the culture because he can be seen as having been represented
both narratively and symbolically, both in texts and already as legend
or image.

A similar symbolic level of another genre of text, the folktale or
fairy tale, was theorized in a famous study by Vladimir Propp pub-
lished in Russian in 1928.[12] Propp's *Morphology of the Folktale* re-
mained virtually unknown in Europe and America until the 1960s,
when it became key in the thinking about myth undertaken by Claude
Lévi-Strauss. There is no evidence that the Viennese School of art his-
tory knew Propp, although the conjunction of dates of publication be-
tween his book and that of Kris and Kurz raises suspicions. Be that as
it may, it is worth calling attention to Propp's theorization, particu-
larly as both views of narrative address the symbolic by attempting a
typology of the whole through an examination of the smallest narra-
tive unit, called by Propp "the motif."

In Kris and Kurz "artist anecdotes" are narrative units, their "prim-
itive cell" of the genre. Propp's famous contribution, as his first Eng-
lish editor put it, is that

he defines the motifs in terms of their function, that is, in terms of what the dramatis personae do, independently of by whom and in what way the function is fulfilled. He states the number of these functions obligatory for the fairy tale and classifies them according to their significance and position in the course of the narrative. Their sequence is finally the basis of his typology within the genre.[13]

Kris and Kurz resist an examination of the function of the anecdotes associated with characters in biography other than the artist. They do not confine themselves to one example or school of the genre, as Propp does in his examination only of Russian folktales. Kris and Kurz suggest a theory for the structure of biographies of artists throughout history and in all places. This is a universal approach, not tied particularly to national schools or literatures but to Literature and History. Kris and Kurz identify the genre and the variations in the form of the artist anecdote, rather than, like Propp, understanding the operation of the motif—sequential or otherwise—narratively. To borrow a term from linguistics, the analytic schema of Kris and Kurz could be called "paradigmatic," analogous to Lévi-Strauss's view of myth.[14] In contrast, Propp's method has been called "syntagmatic."[15] The basis of the structuralist position, whether in Lévi-Strauss or Kris and Kurz, is to seek the origin or root of myth—the deep structure underneath the surface of the text. In Kris and Kurz this led to a search for the origins of the image of the artist. The search for origins was engendered by the approach to the literature on art inherited from their teacher, Julius von Schlosser.

## A Concept of the Artist

With the publication of *Legend, Myth, and Magic*, the idea of the artist in culture arises as a concept in historical consciousness for the first time. Importantly, this concept referred to the representation of "artist," not to the erection of a particular artist or the artist in history at a particular time or place. In this way, the idea of the artist, indeed, the term *artist*, could be removed from the empirical constraints imposed by "reality" factors such as those claims of exact historical representation of the sort we find in German historicism, as in Burckhardt, for example. There the representation of the individual artist in biography was taken to be truthful enough both in its general and particular characteristics to be used as empirical evidence in the interpretation of a period and its cultural artifacts. Kris and Kurz, relying

on von Schlosser, brought to the forefront the nature and function of the texts, biographies, previously seen as true, transparent windows onto art and its history. They saw that the texts also constructed art, history, and, particularly, the artist. The figure of the artist could be viewed as constructed because it appeared as a historical and symbolic representation in an identifiable literary genre. The concept of the artist was born.

Since 1934, the irony for art history regarding the interpretation of the artist has resided in the fact that despite having made this distinctive contribution to the field, the work of Kris and Kurz has not been received as a signal achievement. The reasons for this reception, or lack of reception, are worth exploring further for they indicate the fissures in the construction of the artist in culture, particularly in the disciplines of art history and Freudian psychoanalysis. An investigation into the view of the artist in Kris and Kurz results in the exploration of denial, suppression, and deferral in the project of art-history writing itself.

The genealogy of the text by Kris and Kurz here and in the following chapter locates these avoidance mechanisms in a situated history of the discipline so as to understand what has been at stake for art history in a critical examination of the artist in culture. A good deal of poststructuralist thinking about history, particularly the work of Michel Foucault, Michel de Certeau, and Hayden White, can be invoked to suggest how some self-consciousness about a discipline's theoretical assumptions leads to consideration of the deep structure of academic institutions and practices.[16] In the case of the theory of the artist, this is particularly relevant because both textual and historical investigations into the concept of the artist occurred in Vienna from about 1905 to 1934. These were critical years in the formation of the new disciplines of both art history and psychoanalysis. They were also crucial years in the formation of the Jewish identity of a group of art historians and psychoanalysts. The inference to be drawn here is that the investigation of the artist by both the discourse of art history and psychoanalysis is not coincidental but historically, indeed, interpretively, and institutionally determined.

The concept of the artist is central to both art history and psychoanalysis in the early years of the twentieth century. Thus, a history of the artist in these disciplines also provides an examination of the interconnectedness of psychoanalysis and art history. The fate of a critical

approach to the artist in culture is the fate of intellectual and discipli-
nary alliances forged in Vienna at the beginning of the century. If a
neglect of these alliances has resulted in disciplinary suppressions and
repression by certain key individuals, a genealogy of the approaches
to the artist made by Kris and Kurz, von Schlosser, Rank, and Freud
allows us to imagine again the potential of a transformative critique
emerging from within the discipline of art history itself regarding its
own project. In this chapter the Viennese School of art history's liter-
ary approach as employed by Kris and Kurz will be examined. This
will be followed in the next chapter by an examination of the ap-
proach to the historical artist in early psychoanalysis. The chapter will
conclude by inserting these two approaches and their proponents in
the disciplinary formation of art history.

## Julius von Schlosser

The concept of the artist found in Kris and Kurz nests in earlier ap-
proaches to the artist directly precedent to theirs. Their teacher, Julius
von Schlosser, had been responsible for organizing the early Italian
literature on art into a chronological order where issues pertinent to
literary analysis, according to a philological approach, such as genre
and rhetoric, were expanded. This important project, *Die Kunstliter-
atur: Ein Handbuch zur quellenkinde der neureren Kunstgeschichte*,
was published in 1924, just as Kris was finishing and Kurz was begin-
ning study with von Schlosser.[17] However, von Schlosser's approach in
*Die Kunstliteratur* can be found as early as 1910 with his first publica-
tion on the Italian Renaissance sculptor Lorenzo Ghiberti, on whom
von Schlosser did work for the rest of his life.[18]

The focus on the biography of the individual artist in von Schlosser's
work on Ghiberti determined his idea of literature on art and affected
the work of his students as well. Philosophically, Benedetto Croce's
aesthetics informed von Schlosser in the early research on Ghiberti
and in *Die Kunstliteratur*, as he and his commentators admitted many
times.[19] In the *Aesthetics* (1903), Croce argued that historical ab-
solutes proved the existence of a determinable and developmental his-
torical process, a belief founded on his view of the actions, the life and
work, of the individual artist.[20] In this view change occurs because
change is historically determined: the artist is the agent of change; the
work of art the representation—or symbolic field—of change.

Following Croce, von Schlosser found in the early discourse on art from the Tuscan humanist context justification for assuming a consistency in the history of writing on art and the artist.[21] Von Schlosser singled out the biography of the individual artist as the exemplum of art historical writing. He considered the modern monograph of the artist as the linguistic heir to this tradition. He characterized *Die Kunstliteratur* as

> an index organized according to the linguistics (*linguistica*) of the visual arts. . . . not biological therefore, nor sociological, nor even grammatically historical of the type intuited by A. Riegl and insinuated also in the *History of art without the names of artists* of Wölfflin; nor a *History of art as history of the spirit* (which is fundamentally a tautology) which was conceived of by M. Dvorak in the shadow of Dilthey: but simply a history of language, which is in itself history of the culture, not by exterior parallels and correspondences, too often used in *Histories of the spirit*, but because it is in itself philosophy, that is, history of the conception of the world.[22]

Von Schlosser sought to differentiate himself and this school from the German art historical project of *Kulturwissenschaft* begun by Burckhardt, although the centrality of biography and the Renaissance period to both projects remains a similarity. Motivated by issues of textuality, von Schlosser's work differs significantly from his fellow Viennese Alois Riegl, whose work focused on issues of style embedded in the art object or visual motif.[23] On the other hand, like Riegl, who held apart the object and motif from more historical or contextualized considerations, von Schlosser maintains his subject, the artist, in an ideal and absolute position, a location dictated by the very texts he employs.

Von Schlosser's work provided the textual location and a philosophical justification for the position of the artist necessary to Kris and Kurz's concept of the artist in culture. In addition, much of von Schlosser's work raises a question basic to any discourse on visual culture, such as art history, that constructs the maker as essential to an understanding of the artifact or object. Can the biography of the artist be held in a privileged and isolated status from the other written sources without profound consequences for the institutional nature of the discipline and the tenets of its more basic beliefs concerning history and art?

This question cannot be answered adequately without looking more

closely at the arguments found in von Schlosser concerning the structure of the biography of the artist that later informed those of *Legend, Myth, and Magic*. The genealogy of the assumptions specific to the interpretation of art history engendered by von Schlosser's privileging of the artist and biography are worth exploring at some length because the prerequisites operative in Kris and Kurz's view of the artist in culture depend on these assumptions. The importance of origins for the artifacts and the history about them emerges as central to the Viennese School's view of art-history writing. I will argue that von Schlosser's consideration of the individual artist as both maker *and* writer determined the foregrounding of the play of origins in the historiography. With von Schlosser we see how historiography determines the history of the discipline, as Kurz observed in the passage quoted at the beginning of this chapter. We also see how it constructs the story of art: defining the limitations of its textual and visual fields, and creating period styles, national schools, and points of origin from which the story can unfold or to which it must return.

In *Die Kunstliteratur* of 1924 von Schlosser criticized a discipline unaware of and unable to classify its most basic source materials, particularly the biographies of artists.[24] He praised only his deceased colleague Wolfgang Kallab, whose book on Vasari had been published in 1908, just two years before von Schlosser's first publication on Lorenzo Ghiberti, an artist of the greatest significance for both scholars.[25] Kallab's influence at exactly the time of von Schlosser's first work on Ghiberti is significant because it is arguably causal of the approach to the literature on art pursued by von Schlosser for the rest of his life.[26] The sophistication as an interpreter of texts that von Schlosser had after Kallab does not obtain in his earlier books on Carolingian art and the sources on the art of the Middle Ages.

Kallab's main interest is to establish what we would call today the "truth value" of Vasari's history by surveying the writer's use of sources: documents, inscriptions, oral traditions, and, most prominently, biographies.[27] In Kallab's words, with his study he aims "to weigh the question whether the form in which Vasari used the material did not, at the same time, require an alteration of the facts [or information]."[28] He finds the anecdote to be "the form" that carries the factual material from the earlier sources to Vasari. On this basis, Kallab posits Antonio Manetti's *Life of Brunelleschi* (ca. 1478–85) and Lorenzo Ghiberti's *Commentarii* (ca. 1448), both containing anecdotes repeated in Vasari, as essential to the facticity of Vasari's text.[29]

Von Schlosser took the understanding of Kallab's essential narrative form one step further, positing the anecdote as an autonomous element, persisting across texts and affecting meaning in distinct ways. Under this regime, the biography of the artist was privileged as a source because it contained many such anecdotes. This species of biography could only be identified by this kind of anecdote, something von Schlosser called the "Florentine artist anecdote" (*"der Florentiner Künstleranekdote"*). Von Schlosser considered these artist anecdotes to be "the actual" or "the real biographical characteristic" (*"das praktisch-biographische Element"*).[30] These are the "artist anecdotes" that Kris and Kurz later called the "primitive cell" of the biography of the artist.

It follows from this view of the anecdote that the more anecdotes the text contained, the more meaningful it became. Problematically for von Schlosser, Kallab's earliest exemplary text, Ghiberti's *Commentarii*, contained only two anecdotes in the second book, which consists of abbreviated accounts of some Florentine artists. Von Schlosser therefore concludes that another element is needed. He asserts that Ghiberti's "empirical style" of history writing combines with the artist anecdote to signal the birth of modern art history.[31]

Von Schlosser locates the basis of the origin of art history in an essential narrative form, in a text he considered to be biographical, in an author also an artist, and in a style of writing considered to be truthful. In *La letteratura artistica* he wrote:

> One of the most essential manifestations of the Renaissance resides in the reawakening [*ridestarsi*] of the historical sense, which the Middle Ages did not know or, in any case, knew in a different way. We must therefore place at the origin [*alla sommità*] not the most significant theorist, L. B. Alberti, but the venerated figure of the ancestor, in the true sense of the word, of the historical-artistic literature: the great sculptor in bronze, Lorenzo Ghiberti (1378–1455); not the least because he arose directly [*provenendo direttamente*] out of the workshop of a Giottesque painter of the previous century, thereby conjoining in his person the new era with the old one, and in his celebrated second Commentario he began his autobiography with the genealogy of the fourteenth-century artists.[32]

The picture here is neatly tripartite: co-temporality among works of art, the person of the artist/author, and texts marks the origin of art history. With Ghiberti, co-temporality occurs intratextually as well; the genres of autobiography and biography make up the second book of the *Commentarii*. Thus, the autobiography of Ghiberti affixes ge-

nealogically to his past and present fellow artists via the genre of the biography. In support of textual or historical origins, von Schlosser authorizes Ghiberti as the first art historian, calling him *"der erste Moderne Geschichteschreiber der Bildkunst."*[33]

Significantly, Ghiberti's *Commentarii* also consists of three parts, or books: a history of ancient art based on the model of Pliny, a series of short biographical notices of modern artists beginning with Giotto and including Ghiberti's autobiography, and some investigations into the theoretical aspects of art. In its tripartite construction the Ghibertian text fulfills the Schlosserian program for a modern history of art: references to a continuity with the "sources," or written narratives; an awareness of the importance of individual character in the new Renaissance style, evidenced by the series of biographical notices (which begin with Giotto) combined with a self-awareness of one's own place in the development of art and history (available in Ghiberti's autobiography); and evidence of art theories and principles underlying the images and artifacts. The structure of Ghiberti's text provides a simulacrum for von Schlosser's program for a history of art. More profoundly, these structural elements are the true content of the narrative of the history of art inasmuch as they determine meaning, according to von Schlosser's view of literary analysis.

Like Kallab, in formulating the outlines of what a history of art looks like, von Schlosser moves backwards from the later, more fully realized biographies by Vasari of 1568 and 1550 and from Manetti's lengthy biography of Brunelleschi (ca. 1478–85), both of which I discussed in the previous chapters. Von Schlosser settles on the *Commentarii* (ca. 1448). The significance of this method of genealogical argument for Renaissance art history can be demonstrated by comparing Vasari's *Lives* of Ghiberti and Brunelleschi.

In Vasari's series of *Lives*, the biography of Ghiberti precedes that of Brunelleschi. In the Ghiberti *Life*, Vasari sets up the theme of rivalry overcome between Ghiberti and Brunelleschi in the first paragraph when he speaks of the competition for the baptistery doors. The theme continues in the subsequent text of Brunelleschi's *Life*. First, Vasari on Ghiberti:

> But since it is seldom that talent is not persecuted by envy, men must continue to the best of their power, by means of the utmost excellence, to assure it of victory, or at least to make it stout and strong to sustain the attacks of that enemy; even as Lorenzo di Cione Ghiberti, otherwise

called Di Bartoluccio, was enabled to do both by his won merits and by fortune. This man well deserved the honour of being placed before themselves by the sculptor Donato and by the architect and sculptor Filippo Brunelleschi, both excellent craftsmen, since they recognized, in truth, although instinct perchance constrained them to do the contrary, that Lorenzo was a better master of casting than they were.[34]

Second, Vasari on Brunelleschi:

And so with good reasons they persuaded the Consul to allot the work to Lorenzo, showing that thus both the public and the private interest would be best served; and this was indeed the true goodness of friendship, excellence without envy, and a sound judgment in the knowledge of their own selves, whereby they deserved more praise than if they had executed the work to perfection. Happy spirits! who, while they were assisting one another, took delight in praising the labours of others. . . . The Consuls besought Filippo to undertake the work in company with Lorenzo, but he refused, being minded rather to be first in an art of his own than an equal or a second in that work.[35]

The competition between the two (and others) concerned the major commissions of early quattrocento Florence: the reliefs of the baptistery doors and the architecture of the cupola of the cathedral. We have already seen in the last chapter how important these monuments were in Manetti's discussion of Brunelleschi's perspective demonstration panels. Here, these monuments take on another significance. The arguments made in Vasari about the originary status of Ghiberti and Brunelleschi in the initiating moments of the Florentine Renaissance implicate not only the two artists in rivalry but also the two mediums of sculpture and architecture in the debates about the superiority of mediums, called in Vasari's day the *Paragone*.[36]

If we compare Manetti's biography of Brunelleschi with Vasari's *Lives* of both artists, we see that Vasari goes to great lengths to smooth over serious disagreements between Brunelleschi and Ghiberti reported by Manetti. Vasari allows Ghiberti to prevail in bronze sculpture, the baptistery doors competition, thereby eliding the thrust in Manetti's biography where Brunelleschi is deemed the better sculptor.[37] According to Manetti, however, the citizens of Florence remained divided over the worth of Ghiberti and Brunelleschi from the time of the results of the competition for the baptistery doors until Brunelleschi proved himself in the architecture of the cathedral.[38]

In Vasari, Brunelleschi prevails only in the later architectural commis-

sion for the cupola. Thus, Vasari held that the origins of the new style in both bronze sculpture and architecture were uncontroversial, separated neatly from each other according to medium and artist. By maintaining that Ghiberti's preeminence in bronze sculpture occurred at an earlier date than Brunelleschi's in architecture, Vasari was forced to accept the Ghibertian account of the competition for the baptistery doors, found in his much earlier *Commentarii*. It should be remembered that Ghiberti (b. 1378) and Brunelleschi (b. 1377) were virtual contemporaries. By placing the *Life* of Ghiberti first in the sequence of *Lives* (Ghiberti, Masolino, Spinelli, Masaccio, Brunelleschi, Donatello), Vasari betrays a privileging not only of the Ghibertian life and the origins of bronze sculpture but also of the text of the *Commentarii* in the history of art. In setting up Ghiberti as the first modern bronze sculptor and his account as the originary historical account, Vasari affected the interpretation of monuments, artists, and texts for most who followed. Vasari forced, we could say, von Schlosser's interpretation of these.

Contrary to the evidence of the texts themselves but under the influence of Vasari, von Schlosser considered Ghiberti to be the first to establish the genre of the biography of the artist. Indeed, as I argued in the last chapter, judged by the conventions and narrative structure of the genre of biography, and more especially by the form of the artist's biography as it appears consistently from Manetti's *Life* of Brunelleschi to the present, Manetti's text has far greater claim to being called the first biography of an artist than does Ghiberti's. Manetti's text covers the entire life of Brunelleschi from birth to death, it contains extended descriptions of his works in all mediums, it concentrates on early and late works, and it deals in some detail with the artist's patrons and students. Clearly, von Schlosser must have had something to gain by trying to establish Ghiberti as the first art historian and his text as the first biography, contradicting the textual evidence itself. What he gained was a congruence of origin for artist, medium, and history in the story of art that matched that of his models, Vasari and Kallab.

## Early Biography and the Historiography of Renaissance Art History

The book (1956; 2d ed. 1970) by Richard Krautheimer and Trude Krautheimer-Hess on Ghiberti demonstrates what is at stake for the discipline in collapsing text, object, and artist into a point of origin:

precisely the history of Renaissance art as it has been constructed since Vasari.[39] The Krautheimers rightly saw that the crux of the problem concerned the definition of period style itself. This essential element of art history appears in their book in a discussion of the difference of opinion expressed between John Pope-Hennessy and Charles Seymour on whether Ghiberti could be considered a Renaissance or Gothic artist. The Krautheimers wrote:

> As we still see him, Ghiberti stands within a field of artistic and intellectual forces that span ancient Rome, fourteenth-century France, and contemporary Florence. From this broad spectrum he successively derives inspiration; rooted in a sound knowledge of his craft and an innate sense of grace and balance, he integrates such concepts and idioms into a style firmly his own; and within his own language, he creates with perfect freedom. By and large, the same view has been taken by Seymour, modified obviously by his need to place Ghiberti's art into the chronological scheme of a history of fifteenth-century sculpture. . . . The differences of opinion between Pope-Hennessy's view and ours are more fundamental. Where we, and we think Seymour, see a Ghiberti genuinely one of the founding fathers of the Early Renaissance, Pope-Hennessy views him as a basically Gothic artist, suspect even in his mature work of only imitating the thought processes and the idiom of a new style. It is, after all, not by chance that John Pope-Hennessy discusses Ghiberti as the closing figure in the volume on Gothic Sculpture.[40]

I have already established that the interpretation of the significance of Ghiberti's writing—beginning with Vasari and including von Schlosser—led art historians to the view that bronze sculpture and biographical text were interdependent in their respective originary status. With the scholarship on Ghiberti that followed von Schlosser, the search for the beginnings according to genealogical models leads to another origin story central to the history of art: the birth of the Renaissance.[41] In this case the move to establish Ghiberti as primarily Renaissance or Gothic relates to a reliance not only on von Schlosser's points about him but also on preestablished notions, Burckhardt's most notably, of what and when is the Renaissance.

It does not matter here whether Vasari, Kallab, von Schlosser, and the Krautheimers were "wrong" in their assessment of Ghiberti, or whether Pope-Hennessy was "right." Rather, the insistence on the originality of Ghiberti reveals the final consequence of the collapse discussed earlier: the move from origin to originality returns us to the issue of style, what can be called the personal style of the artist. In

the discourse of the tradition outlined here, these are *the marks on the object that distinguish it and him absolutely from other artifacts and artists.* This demonstrates a move to style that is accomplished by isolating the biography of the artist from other historical and literary contexts. For example, Kallab denied Vasari knowledge of the early vernacular *Lives* of the poets, such as Boccaccio's *Life of Dante,* to which, as I have argued in the previous chapters, they are indebted. Von Schlosser argued in the same vein on Ghiberti's part, calling him "our principal witness for the Trecento," but denying him knowledge of both the poetic and historical texts of the previous century.[42]

This concept of the naive original, completely worked out into a historical construct (whose influence has not waned until the present day) appears in the short, albeit comprehensive chapter with which Ghiberti introduced his history of the trecento, as the age of national rebirth. Von Schlosser cannot ascertain that Ghiberti knew the earlier Florentine historian Giovanni Villani's writings, so he considers Ghiberti as original in his history writing as he is in his artwork. Nonetheless, von Schlosser finds evidence for "local tradition" in Ghiberti's contentions.[43]

## Origin, Originality, and Authorship

Von Schlosser's construction of the artist/writer as original and his view of Ghiberti as the originary art historian are mutually supportive positions whose foundations rest on the structure of the biography of the artist. Discussions of origin and originality are normative in the discourse on art, both in terms of the artist and the work of art. As Linda Nochlin has suggested regarding Courbet's *L'origine du monde,* at times origin and originality appear to be the greatest desire of the discourse and the culture, as well as of the artist.[44] I trace the origin of the work of art and the originality of the artist to the beginnings of the history of art in the genre of the biography of the artist. Paul Duro writes:

> The history of the study of imitation in art has been, for the most part, confined to identifying certain works as originals and others as copies of originals. Indeed, one could argue that this somewhat elementary distinction has been the cornerstone of art historical scholarship, in that periodization of style, the designation of schools and, most pertinently, the critical construction of the artist all rely on the ability to separate the authentic work of a given period, school or individual from work which is merely similar to, or in the style of, that period, school or individual.[45]

The maintenance of a hermetic position for the biographies and the anecdotes of artists in the history of art contributes to a lack of discourse at precisely the institutional and ideological level identified by Foucault as prerequisite to historical understanding because it supports a history of art separate from other forms of history. Similarly, the artist remains separate from other historically situated individuals as a result of the same forces. The figure of the artist moves unimpeded through the discourse of art history because he is embedded in the genre of the biography and the assumptions in art-history writing, such as origin and originality, that rely on interpretations of the genre. While it is true that at times the primacy of the artist has been questioned, it is also the case that the related concepts of origin and originality have not been questioned. Giving up these concepts means that an analysis of the language of art history, as Roland Barthes saw, "ceaselessly calls into question all origins."[46]

In recent years art historians have addressed this position of the artist in the literature on art by attempting to understand how the figure of the artist fits into the critique of the author and authorship developed from semiotics and initiated in essays by Barthes and Foucault.[47] The work on the subject of the artist and authorship theory in art history has been most compelling in the writing of the British Marxists Fred Orton, John Christie, Griselda Pollock, and Nicholas Green, not the least because they have been so willing to implicate their own subject position as historians engaged in writing about the individualized subject already constructed by biographical texts.[48] Their efforts have been useful and so have the feminist critiques of the construction of the masculinized "artist" that want to show how the figure or subject "artist" excludes any notion of the female practitioner from interpretation or history.[49] Yet up to now, none of these critiques have provided a satisfactory solution to the problem of the artist, as Pollock, myself, and others have admitted.[50] Arguably, this is because the interdependence of text, artist, and the assumptions of art history that pertain to the discourse of art history, but not to literature, for example, has prevented a means of progressing beyond the arguments made by the classic critiques of the author, even the "author function" as theorized by Foucault.

At this point it will be useful to remember that the critiques of authorship and the author are text-centered approaches, including the earliest and most important one by W. K. Wimsatt and Monroe C.

Beardsley titled "The Intentional Fallacy."[51] With the New Criticism these critics opposed a moral tradition of literary criticism and pointed out the dangers of the appeal to intention. They rejected "the way of biographical or genetic inquiry in criticism," such as von Schlosser's, because, so they argued, the author as well as the critic cannot be "truly or objectively" extrapolated from the aesthetic object—the poem or the text. In its place they called for "poetic analysis and exegesis" that rely solely on the text itself. Such procedures were virtually unthinkable in von Schlosser's time. They remain so today in historical analyses of biographies of artists.

In the "The Death of the Author" Barthes sought to overthrow the "myth" of the author through the birth of the reader but a reader who was not the subject of human construction, in other words, not like a myth but a function of the text. As he said, "a text's unity lies not in its origin but in its destination." Of some significance to art historians is that Barthes also included others besides writers in his critique of the author: "Criticism," he wrote, "still consists for the most part in saying that Baudelaire's work is the failure of Baudelaire the man, van Gogh's his madness, Tchaikovsky's his vice."[52]

Foucault's response to the authorship issue, "What Is an Author?" published in 1969, sought to historicize the figure of the author by delineating an "author function." He wrote: "The function of an author is to characterize the existence, circulation and operation of certain discourses within a society."[53] This function depends on specific cultural practices as much as it does on generic or internal textual considerations.

When viewed collectively and retrospectively, these "theories of authorship" can be seen to have produced a progressively radicalized view of authorship in fields that deal with literary texts. The result, as Stephen Heath put it so neatly when speaking about film criticism that theorizes the *auteur* function, has been "to do away with a criticism whose task has been precisely the construction of the author and [with] an idea of style which is the result of the extraction of marks of individuality, a creation of the author and the area of his value."[54] This result could be termed antihumanistic not only because the individualized maker has been done away with, but also because the ideal of the maker as heroic producer of a universalizing literature or film on which the individual creator depends for his or her construction has also been theorized and eschewed.

In art history, on the other hand, the critical situation remains embedded in humanism: we cling to the idea of brush strokes or chisel marks as referents to and of the individual artist. The individual artist is deemed to be precisely locatable in history and perpetually visible in the work of art, as Ghiberti was for von Schlosser, precisely because the texts through which the artist and the art are interpreted, the history of art, have not been theorized. Semiotics may have shattered the unity of the author, but it did nothing to the unity of the artist, embedded in the work of art.

Kris and Kurz, followers of von Schlosser, argued that the genre of the *Life* of the artist possesses a structure and *topoi* that isolate it from other kinds of biographies thereby imparting a legendary status to the visual artist. Paradoxically, the legend of the artist and mythic points of origin in a discourse are mutually supportive of a history not theorized as fact *and* fiction, or myth, or literature as we understand it today after poststructuralism. Richard Shiff wrote in 1983: "Originality—whether real or illusory—remains a found object. Postmodernist criticism typically reverts to, or simply retains, one of the principles of modernism: Objects of artistic creation (even if copies) are 'original' in the sense that they are found not made."[55]

The artist escapes the clutches of history only when he is textualized differently from other human beings, or when his activities are considered differently from other human activities. Von Schlosser's treatment of Ghiberti allows us to encounter the fissures in the construction of the artist and art in our culture. However, the separation of the figure of the artist textually, here I mean generically and in art-history writing, was also the very procedure that allowed the intrusions of the methods of early psychoanalysis into the construction of the artist in culture. In the next chapter we shall see how, when combined with von Schlosser's philological approach, this led to the theory of the artist in culture found in Kris and Kurz. Finally, these nests of interpretative discourses in art history and psychoanalysis will lead us closer to an understanding of the role of the artist in the formation of the discipline of art history.

# 5 / The Artist in Myth: Early Psychoanalysis and Art History

Biographers are fixated on their heroes in a quite special way. In many cases they have chosen their hero as the subject of their studies because—for reasons of their personal emotional life—they have a special affection for him from the very first. They then devote their energies to a task of idealization, aimed at enrolling the great man among the class of their infantile models—at reviving in him, perhaps, the child's idea of his father.
SIGMUND FREUD, *Leonardo da Vinci and a Memory of His Childhood*

In *Legend, Myth, and Magic in the Image of the Artist* by Ernst Kris and Otto Kurz, the idea of the artist in culture is located in the genre of the biography of the artist. Found there, the artist appears prima facie as a hero, particularly beginning in the Renaissance period. Kris and Kurz wrote:

> It is true that this myth did not evolve into a set form of its own under the probing glare of modern Western culture, but it is woven into the fabric of biography. The heroization of the artist has become the aim of his biographers. Historiography, having once accepted the legacy of myth, is never fully able to break its spell.[1]

Here Kris and Kurz recognize that the content of the form is filled by a theory of what the artist is and does, rather than being based on a depiction of the personality of an individual at a particular historical moment.

Kris and Kurz link their view of the universal representation of the artist to a trend they say is common in Viennese art history, that is, "Art History without artists."[2] They connect this trend with the philosophy of Benedetto Croce, a major influence on their teacher Julius von Schlosser. They maintain that "Croce aptly described this new way of looking at things in the observation that what matters is the aesthetic, and not the empirical, personality of the artist—the creator of works of art, and not the man living in the everyday world."[3]

This view of the artist explicitly rejected an empirically based analysis of the artist in society. It refused a situated historical context for the artist in favor of an idea of an ideal, heroic artist. This view of the artist found in idealist philosophy and Viennese art history can usefully be opposed to the artist as theorized by Sigmund Freud and early psychoanalysis, a key point of departure for Kris and Kurz.

The heroic situation of the artist in biography was lamented by Freud many years before the publication of *Legend, Myth, and Magic* in 1934. He sought to find a way to describe the personality of the individual artist in history while at the same time accepting the conditions of the discourse in which the artist was commonly represented. In the study of Leonardo da Vinci, Freud wrote of biographers in general, and biographers of artists in particular:

> They thus present us with what is in fact a cold, strange, ideal figure, instead of a human being to whom we might feel ourselves distantly related. That they should do this is regrettable, for they thereby sacrifice truth to an illusion, and for the sake of their infantile phantasies abandon the opportunity of penetrating the most fascinating secrets of human nature.[4]

Freud has been criticized for not divorcing his view of the artist in the essay on Leonardo from the Romantic model of the hero, inherited from the nineteenth century.[5] On the other hand, one could argue that Freud's acceptance of the heroic status of the artist was based on his knowledge of the genre in which the artist was primarily represented. Freud's study of the artist was an attempt to find a way to understand the personality of the historical artist using other means, by exploring the psychosexual life of the artist. Significantly, in this form of explanation, called "psychoanalytic biography" by Freud, the author relies on Leonardo's own writing, as well as his paintings and drawings, rather than on biography, as a means of finding the personality of the "heroic artist."[6]

In his study of the artist, Freud rejects traditional biography only as the model for his own historical project, the investigation of the personality of the artist, because it, like all early history writing, relied on legend. He did not, however, reject the premise that the idea of the artist is found in biography. He wrote:

> Historical writing, which had begun to keep a continuous record of the present, now also cast a glance back to the past, gathered traditions and legends, interpreted the traces of antiquity that survived in customs and usages, and in this way created a history of the past.[7]

At the same time Freud embraced the empiricist view that a true picture of the past was recoverable and available to what he called the historian's "objective curiosity." This view was opposed to earlier kinds of history:

> It was inevitable that this early history should have been an expression of present beliefs and wishes rather than a true picture of the past; for many things had been dropped from the nation's memory, while others were distorted, and some remains of the past were given a wrong interpretation in order to fit in with contemporary ideas.[8]

In his own project on Leonardo we could say that Freud, while accepting the conventional portrayal of the artist in biography, *seeks that part of the life of the artist that exceeds the anecdotal.*

Kris and Kurz did not move beyond the anecdotal in their book; indeed, they embraced this aspect of the biography of the artist. They, unlike Freud, did not explore the psychosexual life of the artist.[9] However, in their conclusion they accepted a key aspect of Freud's argument in the essay on Leonardo when they stated that "the anecdotal tradition works over and elaborates a piece of actual life experience."[10] In referring to the "actual life experience" of the artist, they admit, in agreement with Freud, that this level of the artist's life can only be found in the unconscious:

> Biographies record typical events, on the one hand, and thereby shape the typical fate of a particular professional class, on the other. The practitioner of the vocation to some extent submits to this typical fate or destiny. This effect relates by no means exclusively, or indeed primarily, to the conscious thought and behaviour of the individual—in whom it may take the form of a particular "code of professional ethics"—but rather to the unconscious. The area of psychology to which we point may be circumscribed by the label of "enacted biography."[11]

Here Kris and Kurz implicate the form of the biography of the artist in the content of the artist's life theorized by Freud, the unconscious. With nothing more than this implication of Freud's major thesis in the Leonardo essay, Kris seems to have anticipated a resistance, later felt more strongly, in the field of art history to psychoanalytic biography. In 1935, the year following the publication of *Legend, Myth, and Magic*, he published "these more technically psychoanalytic results under his own name and on his own responsibility" in the journal *Imago*.[12] Similarly, his slightly earlier work on psychosis and the artist Franz Messerschmidt had been published in two forums: the art historical *Jahrbuch der Kunsthistorischen Sammlungen im Wien* in 1932 and the psychoanalytic organ *Imago* in 1933. As Gombrich wrote, "In writing it for an audience of art historical experts Kris had felt for the first time that he was inhibited from discussing purely psychoanalytic problems. He had to reserve these for a paper destined for a more specialized readership."[13] Thus, the aspects of the study of the artist that Kris and Kurz got from Freud's essay on Leonardo have received little attention in the art historical literature on the biography of the artist.

## The Dialectic of the Artist as Hero

The assumption about the artist made by Kris and Kurz that allows them to read the biographies as containing stereotypical stories or anecdotes revelatory of culture's understanding of the artist is fundamental: the artist appears in all history writing as heroic. The tension that results when the biographies are read in this way and at the same time as representative of the life and works of individual artists is brought into play when the psychoanalytic intervention of Kris into the project of *Legend, Myth, and Magic* is taken into account. The tension can be seen as expressive of a dialectic between fact and fiction in history writing itself, particularly acute at this time due to the empiricism of the methods and beliefs inherited in the philological operations on texts performed by Kallab, von Schlosser, and Kurz himself. These readings founded on an empirical or scientific approach to the texts result, nonetheless, in the conclusion that a pattern of stereotypical anecdotes and *topoi* can be related to heroic "types" rather than to historical individuals. It is this tension that Kris thought might be resolved or at least understood through the intervention of psychoanalytic methods.

The insertion of psychoanalysis into the problem of the biography of the artist can be understood to have been seen by Kris, and perhaps even by Freud himself, as a way of resolving the tension present in the dialectic of the history of culture between the rational and the instinctive. This was a dialectic that was erected, though not completely or always understood as having been so, through the historical methods of *Kulturwissenschaft*, with its idealist Kantian underpinnings and the later appropriations of Hegelian spiritualism by German historicists.[14]

There can be no doubt that Freud's sympathetic contemporaries understood that his research on the artist and other cultural figures had resolved the tensions between the rational and instinctive seen to be present in culture.[15] Thomas Mann considered that Kris's contribution to the problem of the representation of the artist in biography was his acceptance that the Freudian dialectic of the conscious/unconscious was always at play in the figure of the artist. Mann spoke of Kris's work in a speech delivered in Vienna on May 9, 1936, on the occasion of Freud's eightieth birthday:

> The writer shows how the older and simpler type of biography and in particular the written lives of artists, nourished and conditioned by popular legend and tradition, assimilate, as it were, the life of the subject to the conventionalized stock-in-trade of biography in general, thus imparting a sort of sanction to their own performance and establishing its genuineness; making it authentic in the sense of "as it always was" and "as it has been written." For man sets store by recognition, he likes to find the old in the new, the typical in the individual. From that recognition he draws a sense of the familiar in life, whereas if painted itself as entirely new, singular in time and space, without any possibility of resting upon the known, it could only bewilder and alarm. The question, then, which is raised by the essay, is this: can any line be sharply and unequivocally drawn between the formal stock-in-trade of legendary biography and the characteristics of the single personality—in other words, between the typical and the individual? A question negated by its very statement. For the truth is that life is a mingling of the individual elements and the formal stock-in-trade; a mingling in which the individual, as it were, only lifts his head above the formal and impersonal elements. Much that is extra-personal, much unconscious identification, much that is conventional and schematic, is nonetheless decisive for the experience not only of the artist but of the human being in general. "Many of us," says the writer of the article, "'live' today a biographical type, the destiny of a class or rank or calling. The freedom in the shaping of the human being's life is obviously connected with that bond which we term 'lived *vita.*'"[16]

In Mann's assessment of Kris's contribution to the study of the artist the "extra-personal," the "conventional and schematic" are equated with "unconscious identification." The role of the unconscious in determining the personality of the artist, or of any individual, is comparable to the way that the stereotypical image of the artist, found in the biographies of the artist, determines the individual artist. These are authenticating modes, as Mann puts it. Here the general, the stereotypic—what was termed the mythic by Kris and Kurz—coexists with the particular, the individual. Thus, the dialectic between fact and fiction present in the genre of biography becomes the dialectic between the individual and the mythic when it is applied to the artist using methods associated with the uncovering of the unconscious, that is, psychoanalysis. The attraction that this held for Mann's own view of art and the artist, in particular for his novel *Joseph and His Brothers*, and for other writers has often been remarked on.[17]

A cautionary note to the acceptance of the resolution proposed by Kris and Kurz can be sounded here by way of recent critiques of psychoanalytic procedures made from a narratological approach. According to the argument of Donald Spence in the book *Narrative Truth and Historical Truth: Meaning and Interpretation in Psychoanalysis* (1982), when psychoanalysis inserted its interpretations into this cultural dialectic, it did so with a reliance on the same narrative structures and linguistic constructions that had been used in history writing. The result was that many of the same tensions seen in the historical tradition of biography writing persisted in the psychoanalytic situation—be it case study or the interpretation of a particular clinical session. Spence demonstrates that the narrative of psychoanalysis itself, that is, the case study, presents problems similar to other kinds of narrative regarding its sources and its interpretations that purport to base themselves on historical truth. For, "a case report, by virtue of the assumption that no selection is being exercised by either patient or analyst, is understood to represent a near undistorted record of a clinical event."[18] Following Spence, we could say that biography and the case study are two such kinds of narrative in which "the verbal construction that we create not only shapes (our view of) the past, but, indeed, it, a creation of the present, *becomes* the past."[19]

We have seen that Kris and Kurz accepted historiography's acceptance of myth—they saw it determined by the genre of biography itself. With Spence's assessment of the narrative of psychoanalysis in

mind, we can begin to untangle this assumption of historiography in the discourses of both Viennese art history and early psychoanalysis. Kris and Kurz maintained that the historiography of the artist cannot break the spell of the biography because it accepts the heroization of the artist implicit in biography. In effect, the hands of the interpreter have been tied by the historiographer's own assumptions, resulting in the possibility of the suppression of other methods. Inasmuch as one result of both repression and suppression has been the lack of a critique of the artist in culture, it could be said that the historian colludes with the biographer's overt project and, according to Freud, what must be the artist's unconscious one.

We will see that a suppression of the repressed unconscious of the artist, theorized by Freud in his Leonardo essay and implicit in Kris and Kurz, can be found in the disciplinary history of art history subsequent to the Viennese moment, specifically in the reception of Freud and Kris and Kurz. Here we understand suppression in the second sense as defined by J. Laplanche and J.-B. Pontalis. Their definition, relying on Freud's *Interpretation of Dreams* (1900), is worth quoting in order to be perfectly clear about what has been at stake for the discipline of art history in the discourse on the artist found in psychoanalysis:

> Here suppression stands in opposition to repression, especially from the topographical point of view. In repression, the repressing agency (the ego), the operation itself and its outcome are all unconscious. Suppression, on the other hand, is seen as a conscious mechanism working on the level of that "second censorship" which Freud places between the conscious and the preconscious; suppression involves an exclusion from the field of consciousness, not a translation from one system (the preconsciousness-conscious) to another (the unconscious). From the dynamic standpoint, ethical motives play a leading part in suppression.[20]

Thus, suppression can be understood as social, with ethics being its outcome produced by history. Hayden White has seen this ethical dimension of the social in the "narrativity of the historical discourse": "There is no other way that reality can be endowed with the kind of meaning that both displays itself in its consummation and withholds itself by its displacement to another story, 'waiting to be told' just beyond the confines of 'the end.' "[21] Repression, on the other hand, relates to the internal life of the individual.

Before exploring this collusion any further, which I will undertake

at the end of this chapter, the genealogy of the psychoanalytic story of the artist merits exploration. The complications and the stakes involved in the maintenance of the myth of the artist in this practice will become clear. Rather than resolving the myth of the artist, psychoanalysis, in its early manifestations in Vienna, contributed to the dialectic between fact and fiction in the construction of the artist in culture. Addressing both terms, repression and suppression, we will suggest how this occurred in the appropriation of psychoanalysis's views of the artist by Kris and Kurz and in a disciplinary opprobrium on the part of art history.

## Otto Rank's Artist and Freud's Leonardo

The convergence of the mythic and the individual, the hero and the artist, biography as history and biography as fiction found in Kris and Kurz are all present in Freud's study *Leonardo da Vinci and a Memory of His Childhood*. Freud read his paper on Leonardo at a meeting of the Vienna Psychoanalytic Society at the end of 1909.[22] The first edition of the book appeared in 1910, and major revised editions appeared in 1919 and 1923.[23] In more precise historical and textual terms, however, the convergences in the artist were first expressed by Freud's follower Otto Rank. His book *Der Kunstler* (The Artist) was written in 1905 and published in 1907, partially edited by Freud.[24] In fact it was the manuscript of *Der Kunstler* that caused Rank to be brought to the attention of Freud by Rank's family physician, Alfred Adler.[25] This book and Rank's shorter paper *Der Mythus von der Geburt des Helden* (The Myth of the Birth of the Hero), written between 1907 and 1908 and published in 1909, form the basis of much of Freud's thinking regarding Leonardo. The importance of Rank's thinking for Freud's *Leonardo da Vinci* has not been explored in the large literature on the subject of Freud and Leonardo.[26]

When used in early psychoanalytic literature, the term *artist* (*der Kunstler*) means "the creative personality," as Rank noted in the fourth (1925) edition of his book: "Another peculiarity has been the largely comprehensive treatment of the concept 'artist' as the ideally creative type, whether he be the founder of a religion, a philosopher or scientist, whose counterpart the author established later (in other essays) in the hero, the pragmatically creative type."[27] According to Rank, the original artist type predates the hero and the author-hero.

Thus, he investigates the "birth" of the hero type in his later study of the hero, where Shakespeare, Michelangelo, and other artists figure prominently. Leonardo must be considered another one of the hero-artists, as he is found in Freud's essay.

In *Der Kunstler* Rank theorized the creative personality, arguing that it precedes history and therefore represents a "primitive" kind of personality. In this way the artist is directly connected to the world of myth, before history. According to Rank, the artist exists in the world of preconsciousness, just as the first epic tale did for Freud:

> The first epic tale, according to Freud, was a mythical ideal formation . . . soon, however, the critical voices of the ego ideal begin functioning, supporting the tendencies towards punishment, increasing thereby the guilt feelings and, at an ending period of our occidental, literary development, culminating in the conscious insight.[28]

The use of the term "primitive" in this context also recalls the way that Kris and Kurz theorized the artist anecdotes as the "primitive cell" of the genre of the biography of the artist. By this, Kris and Kurz clearly meant that the discourse on the artist predates history, having its origins, perhaps, in workshop gossip and the like. But they also would have thought of the origin of the artistic personality as understood by Rank, that is, as manifesting a preconscious state.

Rank wrote *Der Kunstler* after having read Freud's *Interpretation of Dreams* (1900).[29] The second part of his book, called "Artistic Sublimation," is an attempt to reconcile the idea of myth with that of dreams, the representation of the unconscious according to Freud. Freud and others credited Rank with reconciling the theories of individual personality held by psychoanalysis with a theory of culture.[30] Rank writes: "The myth is thus comparable to a mass dream."[31] The artist has access to that dream and, like the physician-analyst in Freudian theory, is the interpreter of dreams. Rank locates the artist in a position analogous in Freud's work to the analyst: "Psychologically the artist stands between the dreamer and the neurotic."[32] Thus, the artist's dream interpretations are his creations, the work(s) of art.

According to Rank, the artist possesses a different relationship to neurosis; he is able to express his sexual energy in wholly creative ways. This aspect is taken up by Freud in his essay on Leonardo: "In virtue of a special disposition, the third type, which is the rarest and most perfect, escapes both inhibition of thought and neurotic com-

pulsive thinking. It is true that here too sexual repression comes about, but it does not succeed in relegating a component instinct of sexual desire to the unconscious."[33] Rank writes: "He executes his real achievement through the artistic technique of *giving form* to unconscious fantasies which had become unpleasurable through the suppression process and which in art find and provide a sublimated kind of gratification and pleasure."[34] Near the end of his essay on the artist, Rank establishes the sexual and cultural terms of repression outside of the artist and art: "For the progressive sexual repression in the development process of the human race ever more urgently demands control, becoming conscious of the unconscious and art cannot reach this goal."[35]

Finally, for Rank, the most "psychologically interesting" artist is the actor, whose dream interpretations, his "works," are given in closest proximity to his audience. Here Rank explicitly equates the artist-actor with the physician-analyst: "The actor may be compared to the physician who offers the neurotic the handle for cure; the actor is in effect physician translated into the artistic, as priest is physician translated into religion."[36] The equation of actor, physician-analyst, and priest, albeit in different cultural spheres, that is, theatrical, medical, and religious, allows Rank to reach the conclusion to his essay on the artist. This is a conclusion where the authority of the writer and the artist converge at an originary moment, just as they did in von Schlosser's and Kallab's histories of art.

In the conclusion to the book on the artist, Rank compares the artist to Moses "founder of religion": "But as the 'founder of religion' was overcome, so the artist must be overcome also, he must become the physician; the creative ones become healing-artists, and the recipients become neurotics; for in that way only can people arrive at 'consciousness': the neurosis is the basis of general widening of consciousness."[37] Rank's conflation of artist, physician, and analyst makes the physician-analyst a healer of culture and humanity. No doubt this formulation had great appeal for Freud, the physician analyst and, like Moses, a Jew.[38]

This summary of Rank's view of the artist in culture clearly sets the stage for that found in Freud and Kris and Kurz.[39] In the final paragraph of his later study of the hero, based, as he says, on "chiefly biographic hero myths," Rank puts into play the last elements essential to the psychoanalytic investigations into the lives of particular artists,

such as Freud's Leonardo. Rank suggests where one might begin to establish the terrain between fact and fiction or myth and the individual:

> For the present let us stop at the narrow boundary line where the contents of innocent infantile imaginings, suppressed and unconscious neurotic fantasies, poetical myth structures, and certain forms of mental disease and crime lie close together, although far apart as to their causes and dynamic forces. We resist the temptation to follow one of these divergent paths that lead to altogether different realms, but which are as yet unblazed trails in the wilderness.[40]

Rank uses biographies, narrative accounts of different men, to establish a typology of the hero. In other words, in his study of the hero in culture he uses the biographies in much the same way that philologists like Kallab and von Schlosser did to understand the various legends that emerge and are repeated concerning the artist. For example, in *La letteratura artistica*, the first time that von Schlosser praises Kallab's work is in the context of Manetti's *Life of Brunelleschi*, when he shows how Vasari's *Life* of the same artist was totally dominated by legends because it relied on Manetti's precedent, itself dominated by legends. In these cases, the biography is used as source for establishing at one and the same time the historical veracity and mythical dimension of the subject, the hero-artist. Rank's legacy in Kris and Kurz acknowledges biography to be the generic and structural "narrow boundary line" in history writing.

Freud's view of Vasari's early biographies of artists in *Leonardo da Vinci* also relies explicitly on Rank:

> In the last hour of his life, according to the words that Vasari gives him, he reproached himself with having offended God and man by his failure to do his duty in his art. And even if this story of Vasari's has neither external nor much internal probability but belongs to the legend which began to be woven around the mysterious Master even before his death, it is still of incontestable value as evidence of what men believed at the time.[41]

On the other hand, psychoanalytic biography, a form of "psychiatric research" according to Freud, was "subject to the laws which govern both normal and pathological activity with equal cogency."[42]

This view of biography governs Freud's *Leonardo da Vinci*. Present in Freud's essay are all of the "boundary line" areas that Rank delineates in his essay on the hero: "innocent infantile imaginings, suppressed and unconscious neurotic fantasies, poetical myth structures,

and certain forms of mental disease and crime."[43] These themselves are all very different aspects of a psychoanalytic study of an artist. They pertain to Freud's understanding of both the genre of biography and the methods of his new, psychoanalytic biography. He explicitly addresses all of these boundaries in his essay.

The later critiques of Freud's essay are about one or more of the four very different aspects of the biography of an artist that Freud mentions: (1) the convergence of artist and myth in this study of the artist; (2) Freud's uses of Leonardo's adult account of "an innocent infantile imagining" to attempt an explanation of homosexuality and narcissism, the tail of the vulture/kite in the mouth of the child; (3) the problem of countertransference in which the biographer/interpreter reads his own neuroses into the historical personality; and (4) the use of sources in the construction of the interpretation of the artist subject.[44]

Freud begins the second part of his essay with Leonardo's vulture/kite fantasy, and at one point in the narrative he offers the possibility of "explaining it on the basis of his inclination, of which he makes no secret, to regard his preoccupation with the flight of birds as preordained by destiny."[45] He quickly turns this explanation around from one that closes interpretation to one that opens it up, and he does so by making an analogy with legends from the historical past:

> Yet in underrating this story one would be committing just as great an injustice as if one were carelessly to reject the body of legends, traditions and interpretations found in a nation's early history. In spite of all the distortions and misunderstandings, they still represent the reality of the past: they are what a people forms out of the experience of its early days and under the dominance of motives that were once powerful and still operate to-day; and if it were only possible, by a knowledge of all the forces at work, to undo these distortions, there would be no difficulty in disclosing the historical truth lying behind the legendary material. The same holds good for the childhood memories or phantasies of an individual.[46]

Freud relates the individual memory or fantasy to the legends and stories that make up the collective memories or history of a nation. The latter are valuable because they contain valuable truths. In like manner, childhood memories contain as much truth as legends do. The biography of the individual is related to the legends that form the history of a nation. The mythic level of history is approached through the stereotypical and the traditional. We have already seen how important the creation of a national, what I called an autochthonous,

origin myth for the artist and art was in the Renaissance period. This is how we find origin expressed in Freud and in Kris and Kurz.

This brings us to the next aspect of Freud's understanding of the biography of the historical Leonardo, the investigation of the sexuality of the historical personality. Elizabeth Wright wrote: "Freud wishes to trace the continuing effects of sexuality as experience in childhood on the adult life of a great man."[47] Freud stated this aspect of his contribution to historical biography in this way: "If a biographical study is really intended to arrive at an understanding of its hero's mental life it must not—as often happens in the majority of biographies as a result of discretion or prudishness—silently pass over its subject's sexual activity or sexual individuality."[48]

Furthermore, in many of the later scholarly assessments of Freud's essay on Leonardo, the term *psychobiography* is invoked to *characterize* something more than just an investigation of the subject's sexuality. In these cases, the use of the term *psychobiography* refers to a psychoanalytic sort of history writing in which the historical figure (the figure from the past) becomes the subject of analysis by the analyst, Freud. Instead of a clinical case study, an account of the analysis in a clinical situation, we have a psychobiography, an account of an analysis in a historical situation. The evidence for the analysis takes the form of writings and drawings gleaned from Leonardo's notebooks, account books, drawings, and paintings—those artifacts touched by the artist's own hand. In fact, Freud goes to great lengths to appear not to have used the contemporary biography by Vasari, calling it conventional. He wishes to maintain the fiction of a clinical situation of unmediated intercourse between analyst and analysand. As Spence suggests, this is the fiction nested within the illusory fact of a clinical event that serves as the narrative of psychoanalysis that Spence addressed.

According to Spence, the way that psychoanalysis understands the analyst's role as interpreter affects the kind of narrative that is being written about the analysand. The aspects of the unconscious, from dreams, for instance, in the clinical situation affect the analyst in ways of which he is not always or only partially aware but on which he may focus in his understanding of the analytic situation. This is countertransference, defined by Laplanche and Pontalis as: "the whole of the analyst's unconscious reactions to the individual analysand—especially to the analysand's own transference."[49] The psychoanalyst who writes a historical analysis will also be subject to countertransference, ren-

dering him essentially uncritical because unconscious. Thus, in common with the biographer, he too accepts the historiography of this position. Freud acknowledges this in the Leonardo essay.

The implications of countertransference in Freud's project of psychoanalytic biography have been discussed by Richard Wollheim and Ellen Spitz.[50] Spitz begins her discussion by quoting Freud's own view of countertransference stated in the sixth part of the essay on Leonardo. Here Freud defends not only psychoanalysis itself but also his views of the analysis of a historical figure. The long paragraph begins as an apologia for the appearance of cracks in the facade of the legendary Leonardo.[51] It becomes a defense of psychoanalytic methods on the basis of their truth value:

> The real motives for the opposition are different. We can discover them if we bear in mind that biographers are fixated on their heroes in a quite special way. In many cases they have chosen their hero as the subject of their studies because—for reasons of their personal emotional life—they have felt a special affection for him from the very first. They then devote their energies to a task of idealization, aimed at enrolling the great man among the class of their infantile models—at reviving in him, perhaps, the child's idea of his father. To gratify this wish they obliterate the individual features of their subject's physiognomy; they smooth over the traces of his life's struggles with internal and external resistances, and they tolerate in him no vestige of human weakness or imperfection. They thus present us with what is in fact a cold, strange, ideal figure, instead of a human being to whom we might feel ourselves distantly related. That they should do this is regrettable, for they thereby sacrifice truth to illusion, and for the sake of their infantile phantasies abandon the opportunity of penetrating the most fascinating secrets of human nature.[52]

Spitz concludes from this passage that Freud "based his work quite heavily on a methodology founded on unanalyzed countertransference plus the ad hoc application (and creation) of new theory." She judges that the value of Freud's essay is "not to make a contribution to our understanding of this particular artist and his works but rather to use both artist and works to illustrate aspects of psychoanalytic theory with which Freud was struggling at that time: the theories of narcissism and of a type of male homosexuality derived from an early identification with the mother that subsequently develops into narcissistic object choices."[53] For Spitz, Freud on Leonardo is valuable for the light he sheds on narcissism rather than on the historical artist. She dismisses his approach to the historical figure of the artist through

biography at a variety of levels, but most importantly she insists on the fictionality of Freud's approach.

## Art History's "Leonardo"

In her assessment of Freud's use value for the historian, Spitz concurs with the major art historical critique of the essay, Meyer Schapiro's influential article of 1956 in which he criticized Freud's use of his sources. Schapiro does not address countertransference or other psychoanalytical uses of the essay. Wollheim has related the dismissal of the use value of Freud on the basis of truth claims, such as we find in Schapiro, to be prevalent in philosophy as well as in history: "the more specific reasons that I want to go on to adduce for the philosophical neglect of Freud are more local in application. They relate to academic philosophy as this developed in British and North American universities under the broad title of logical empiricism."[54] We shall see that in art history, as in philosophy, the reception of early psychoanalytic theory depended on the course of the discipline of art history in the early years of this century, as well as on more particular considerations of method.

Schapiro's critique was especially damning as he went to great lengths to refute the veracity of the interpretation of the material of Leonardo's notebooks upon which Freud relied so profoundly. He wrote: "I believe this study of Freud's book points to weaknesses which will be found in other works by psychoanalysts in the cultural fields: the habit of building explanations of complex phenomena on a single datum and the too little attention given to history and the social situation in dealing with individuals and even with the origin of customs, beliefs, and institutions."[55]

Schapiro's criticism of Freud is a criticism of the use of analysis to establish a case study when the materials available for investigation are only artifacts by the artist's own hand, whether drawings, notebook entries, or works of art. He puts the sources that Freud used to build his interpretation of the unconscious of Leonardo, the historical artist, into question. In addition, the possibility of the analysis of the manifestations of the artist's personality in the artist's work is also questioned. According to Schapiro, the methods used to deal with the artifacts and the person of the artist are not set against "history and the social situation," that is, whatever there was from the time besides

the works and writings by the artist to tell us about the artist. If this is Schapiro's complaint, it is true of any psychoanalytic interpretation, even a case study. The "story" in psychoanalysis can be told from only one point of view, that of the analysand.

By quoting Jacob Burckhardt in a passage prior to giving his own view of Vasari, Freud acknowledged that the prevailing art historical assessment of Leonardo relied on the writings of Leonardo's contemporaries.[56] Ironically, as Freud recognized, the major source to be found for such information concerning the artist, at least until the nineteenth century, was the biography of the artist. Freud tried to avoid these sources by going directly to the texts and images produced by the artist himself. By criticizing Freud and the use of psychoanalytic biography in understanding the artist, Schapiro and the *"doxa"* of the profession in effect forced the discipline into the position of relying on the biographies as empirically evidentiary, as the only social and historical documentation of the artist. The determining force of the unconscious can never be recognized in such an empirically constituted system.[57] In devaluing psychoanalytic methods, Schapiro and others consequently bolstered the primacy of the evidentiary value of the biographies.

Schapiro accomplished two things with his critique of Freud.[58] He demonstrated that the methods of psychoanalytic biography were historically unreliable, and he encouraged a reliance on early biographies as historically or empirically more reliable. Although he states in his essay that his purpose is "not in order to criticize psychoanalytic theory," he does want to question its validity for the history of art.[59] Schapiro calls for a "fuller knowledge of Leonardo's life and art" in the last sentence of his essay. Schapiro demonstrates throughout his paper that this could only be found in the early biographies, especially those by Vasari.[60] It could be said that the fullness of knowledge required the maintenance of the legend of the artist, argued by Kris and Kurz to be located in the biographies.

The critical reception of the book by Kris and Kurz, with its emphasis on the unreliability of the historical evidence of the biographies, helps to explain the success of Schapiro's critique of Freud within the field of art history. When Kris's reformulation of *Legend, Myth, and Magic* appeared as the chapter "The Image of the Artist: A Psychological Study of the Role of Tradition in Ancient Biographies" in his 1952 book *Psychoanalytic Explorations in Art*, it had little impact on art

historians. This can be attributed to the ambivalence Kris himself expressed in the book about the usefulness of psychoanalysis in understanding the cultural construction of the artist. Kris's rethinking of the artist substantially abbreviated the work he had done earlier with Kurz. His remarks on biography in the introduction to *Psychoanalytic Explorations in Art* reveal how little Kris had come to think of the genre of psychoanalytic biography and its ability to address the image of the artist.

Kris says in the preface to this book that the only part of the book substantially changed since the war is the introductory essay, "Approaches to Art."[61] This essay is Kris's postwar view of the efficacy of the project of art history in light of psychoanalysis. He is particularly condemning of the former. When he confronts the subjects of the art historian or critic *and* the biography of the artist, he negates art history:

> And there are works of art of various degrees of depth. In the instances of "great art," the superficial gratification which a first approach affords to the public may only be a bait; the artist, as it were, draws his public closer into his net. One stands on the fringe and gradually moves to the center. On a third reading, the plot is but of little interest, and the fascination turns to active response. The formal qualities then become important and the question arises of how the artist has done it. If this question is consciously posed, we are faced with the response of the connoisseur or critic, the silent or vocal competitor or prophet of artists. Most statements on reaction to art stem from him, and their study remains incomplete if his peculiar position is not taken into account. He will at times be concerned with the actual personality of the artist, will arouse interest in the artist's biography, which is then presented to the educated, first as a general model of greatness and then in order to deepen the understanding for the artist's work. Benedetto Croce's distinction between the empirical and the aesthetic persona of the artist proves in this connection to be relevant. Even those who consciously identify themselves with the artist, and whom—we here comprehend with an extension of the traditional meaning—as connoisseurs, are as a rule concerned with the aesthetic person, with the artist as creator of art, not with the artist as common man. It speaks for the usefulness of this distinction that the impact of the greatest poet of Western civilization was not impeded by his relative anonymity, and little has as yet been gained by attempts to link his work to his life history.[62]

With this last sentence Kris rejects a study of the artist, in fact negating the views expressed in the conclusion of *Legend, Myth, and Magic*. In rejecting the aspects of Freud's work on the unconscious of

the artist, Kris also rejects the possibility of psychoanalytic biography. He can no longer see it as an alternative to earlier biographies of artists.

Perhaps by 1952 Kris had become cognizant of the tensions in Freud's approach to the issue of the hero in biography and the individual artist whom he sought in other kinds of earlier texts, such as Leonardo's notebooks and drawings. Certainly the reference to Croce in Kris's text would indicate such an ambivalence. However, Kris's attitude after the war must also be related to his own history during the years following the publication of *Legend, Myth, and Magic* in Vienna in 1934.

How did Kris fare during these years in Vienna, the very years in which his work in art history became more and more inflected by his research in psychoanalysis? From 1934 to 1938, when he finally moved to London from Vienna, Kris drew away from art history, seeing "in aesthetics a field of research in which certain general propositions of psychoanalysis could best be developed and illustrated."[63] According to the account by Gombrich, Kris remained in Vienna during the 1930s because he refused to leave until Freud did. At the same time, Kris was moved to focus on the psychoanalytic studies of the comic as a result of "telling an anti-government joke at the office and being met with frozen stares."[64] The apparent self-consciousness about his own plight engendered in the Jewish Kris by the response to his joke changed the direction of his work forever.

We can trace some of those changes in the 1930s. From his earlier study of Messerschmidt and the investigations of physiognomies in art he moved into the study of the unconscious and the comic, which had been explored by Freud in his work on jokes. Kris's work on the visual joke or caricature, related both to physiognomic and drawing practices, was the result of the earlier studies and Freud's thinking. Significantly, the research on caricature was done in collaboration with Gombrich and published just before the outbreak of the war.[65] It appeared again, like the work on the artist, in Kris's book *Psychoanalytic Explorations in Art*, where it was essentially disavowed.

In 1937 Kris wrote on "Ego Development and the Comic." By the time of his move to England in 1938, he was interested in issues of psychological warfare and Nazi propaganda. By the time he left for Canada in 1940 and soon afterwards emigrated to the United States, Kris had pretty much rejected the history of art as a discipline worth

his attention, even, according to Gombrich, teasing Gombrich for his "continued interest" in the field.[66] In the preface for the 1952 book, Kris explains how the main goal of his work could no longer be historical: "The study of art and of creative processes in the broadest meaning of the word seemed to facilitate contributions to psychoanalytic psychology itself and to crystallize certain impressions gained in clinical work."[67]

Gombrich has called Kris's years in art history in Vienna his "former life." This was a life that began to change in Vienna with his introduction to psychoanalysis and the work on Messerschmidt and the biography of the artist. The changes became more radical because of the circumstances of Jewish intellectual life in Vienna in the 1930s, his attachment to Freud, and his forced emigration, which resulted in a total change of career from art history to psychoanalysis. Is it possible that in an effort to forget those times he also refused art history as a legitimate field of inquiry?

According to Rank and Freud, repression has a key role in determining the artistic personality. Kris and Kurz indicated its importance in their concept of the "enacted biography." Kris's change in direction, a self-critique that could be termed a suppression, was largely successful in burying the importance of psychoanalysis for the study of art. Schapiro's critique of only a few years later further devalued it.

The radical self-rejections of his "former life" and work point to the significance of Kris's Jewish ethnicity and identity in the intellectual history of art history, particularly its discourse on the artist. Recent historical and autobiographical studies have stressed the prevalence of a negation of the past in Jewish refugees and survivors of the Nazi genocide. These studies can be invoked usefully here as means of understanding Kris's self-dismissal. As Saul Friedlander said: "The rejection of the past that was forced upon me was neither a pro forma affair . . . nor, of course, the result of a spiritual journey. The first ten years of my life, the memories of my childhood, were to disappear, for there was no possible synthesis between the persona I had been and the one I had become."[68]

This last observation returns us to the negative reception of Freud's psychoanalytic approach to the historical artist by both art history and psychoanalysis. The failure by art history to produce a concept of the artist useful for historical discourse can be located here. Schapiro's article and later critiques of Freud that accept Schapiro's belief that

there is no use to be had in Freud's approach create the same result as Kris's disavowal. The historical dimension of Freud's essay has been lost to the discourse of art history.[69] How do psychoanalytic methods operate with the historical figure, Leonardo, or the historical text, the biography of the artist? In answer to this question, Kris and Kurz gestured toward "enacted biography."

This term is never used in either psychoanalysis or history. We must look elsewhere, outside the texts themselves for the site of cultural enactments if we are to understand the profound ramifications for art that Freud's assessment of the artist had. We must look to a disciplinary history if we are to understand the lack of influence of Rank, Freud, and Kris and Kurz on discourse. The importance of a disciplinary history for a disciplinary discourse can be particularly acute, as others have noted before.[70] When the linkage between the two reveals a dominant ethnic or racial component, such as the Jewish identity in Viennese art history, it suggests that the political and moral implications for both the discipline and the discourse are particularly high.[71]

## Jewish Identity in Art History

A comprehensive history of the diaspora of Jewish intellectuals from German-occupied countries and its impact on the configuration of the academy in Europe and America remains to be written. Viennese art history and psychoanalysis in Vienna were particularly dominated by Jews who were forced to flee. A critique of the work of the non-Jewish art historians who stayed on appeared in the *Art Bulletin* as early as 1936, written by Meyer Schapiro.[72] But the issue of Jewish identity in Viennese art history remains relatively unexplored.[73] The rather extensive literature on the Jewish ethnicity and psychoanalysis, particularly concerned with Freud's identity, often examines the consequences for the professional formation of psychoanalysis in the years following 1938.[74] How do we explain the relative silence in the field of art history?

Kris, Kurz, and Gombrich were Jews in Vienna whose collaborative efforts took place in the interdisciplinary space between art history and psychoanalysis where they found the cultural construction of the artist. The work on the artist was inextricably bound up with the Jewish identity of these historians and its burdens, just as Freud's work on the artist had been influenced by his identity, a major aspect in the the-

ory of countertransference. We should not be surprised to find a reticence on their parts to talk about those times and that work. Reticence about a prewar history was the norm rather than the exception, for survivors of the death camps as well as for those fortunate enough to get out. We have already seen this reticence in Kris.

Claude Lanzmann's film *Shoah* documents the eradication of the memory of the Polish Jews by the Poles, but because Lanzmann chose to have the story told by Jews whose voices had until that moment been silent, the film demonstrates the pervasiveness of the aforementioned silence on the part of the Jews. A similar gloss on *Shoah* has been made by David Carroll:

> "And let's not talk about that."
> In Claude Lanzmann's film *Shoah*, and in almost all of the narratives of survivors of the Nazi concentration camps, especially of those who survived the death camps, one finds statements of this kind, which both command and plead at the same time. They are the pleas of a reluctant narrator not to be made to talk, at least not yet, not here, not with these listeners and in this situation (whatever the public and circumstances), pleas to be left alone, to be allowed to go on with his or her life, a reluctance or refusal to be forced to take on the terrible responsibility of "keeping alive" the memory of the Shoah. They are equally commands that such things not be talked about at all, for talking about "that" accomplishes nothing, changes nothing, and even makes of "that" something that can be talked about.[75]

The agonies of this reticence have been understood by Saul Friedlander, among others, to be an important factor for the history of all Jews, not the least because it results from the habits of assimilation formed in pre-World War II Europe.[76] Robert Wistrich calls the paradoxes of forgetting in memory inherent in Jewish integration in any diasporic situation the "dilemma of assimilation."[77] These dilemmas were present in Vienna before the war, as has been well documented.[78] We should not be surprised to find them and or their effects in the Jewish refugees after the war.[79] The argument here is that the reticence, and in some cases, repression of Jewish identity pertained in Vienna before the war among art historians and psychoanalysts and, in the case of many of them, continued in their respective professional communities after the war. For a discipline such as art history, many of whose practitioners in both museums and universities were trained by these Jewish émigrés or their first generation of students, these dilemmas must be seen as particularly significant.

The emigration of Jewish art historians in the 1930s and 1940s coincided with art history's relatively recent constitution as a discipline in the English-speaking academy, where its intellectual background in the German-speaking context could not be forgotten.[80] These German-speaking Jewish intellectuals fueled the simultaneous growth of art history as a museum profession and in the academy in the second half of the twentieth century. Therefore, for art history, reticence to speak about the past in Europe has been particularly significant, especially in the study of European art history, because it has contributed to a lack of self-criticism about the art historical enterprise including the approaches to all visual culture. These problems, where a lack of theorization in art history is evident, include the construction of the artist and the problems inherent in the uses of visual and written sources, especially biography.

Kurz's life in the 1930s presents a useful case study of the conflicted responses to Jewish identity as manifested in professional art-historical activities. His reticence about all things personal relating to these years makes the exact documentation of his life during them difficult. The difficulty of documentation arises in no small part because Gombrich, the biographer and longest living survivor of the Viennese School of art history, has himself found it difficult to document the terrors of these years in any detail. Even in recent interviews when questioned directly about the impact of Jewish persecutions in Vienna, Gombrich denied anti-Semitism, at least in the circles in which he grew up.[81] Gombrich did reveal, however, that in the case of Kurz there were particularly compelling reasons why he would want to forget the time when *Legend, Myth, and Magic* was written.

Sometime around 1932 Kurz was the victim of a severe beating by "Nazi thugs": "Inside the institute we led a very happy life. I say 'inside' because during these years gangs of Nazi students began to go round looking for Jews and beating them up. But that epidemic was still confined to the outside world."[82] As a result of the beating, Kurz was advised "to improve his prospects by enlisting in the course of the Österreichisches Institut für Geschichtsforschung," where he was very unhappy. He was therefore grateful when in 1932–33 he was contacted by Kris (via his relationship with their common advisor and teacher, Julius von Schlosser) about his possible interest in a project on "the typical legends told about artists."[83] This project resulted in their collaboration.

Despite his experience with the Nazis, Kurz, through the interven-
tion of Kris at exactly this time, chose to transfer to the Warburg Li-
brary in Hamburg. Gombrich says, "Kurz was to remark later that he
must have been the only Jew to immigrate into Germany at the time of
the Nazis."[84] In December of 1933 Kurz was again in Vienna to com-
plete his exams and his collaboration with Kris, which they dedicated
to the Warburg Institute. By April of 1934 Kurz was able to go to
London to join the Warburg Institute in its new home there. His move
to London was supported by a grant for another collaborative re-
search project with Kris, also sponsored by the Warburg Institute.
This "research into 'the magic of effigies and the prohibition of im-
ages,'" also combining art history and psychoanalytic approaches,
was never completed.[85] The theme of the prohibition of images clearly
also had significant resonances with Kurz's Jewish identity, although
Gombrich does not remark on this. The collaborations of Kris and
Kurz ended here, as did Kris's work in art history and Kurz's in psycho-
analysis. Their joint efforts in those fields remained *the* book on the
study of the artist in culture.

In recent interviews with Didier Eribon, Gombrich perfectly articu-
lates the paradox of the Jewish intellectual's identity in European cul-
ture. The exchange situates the problem in disciplinary and method-
ological terms for art history:

> In your biography of Aby Warburg, you wrote: "He never saw himself as
> a detached observer." Can we apply this sentence to you? I have the feel-
> ings that you consider the art historian to be what we call in France "un
> intellectual engagé."
> *Yes. You are right.*
> You are fighting for values?
> *Yes, that is how I see the art historian, or the historian.*
> And what are the values you are fighting for?
> *I think I can say this very simply: the traditional civilization of Western*
> *Europe. I know there are also very horrible things in that civilization. I*
> *know it very well. But I think art historians are the spokesmen of our*
> *civilization: we want to know more about our Olympus.*
> In order to preserve the memory of the past?
> *Not only the memory, but also what we owe. I have criticized those who*
> *talk of "escapism." Life would be unbearable if we could never escape*
> *to the consolations of great art. One must pity those who lack contact*
> *with this heritage of the past. One must be so grateful that one can lis-*
> *ten to Mozart and look at Velazquez and must be sorry for those who*
> *cannot.*[86]

In *Heidegger and "the jews,"* Lyotard theorized the desperation of this position where the interpreter of European culture also becomes its profound defender in spite of having been its victim:

> But on the side of "the jews," absence of representability, absence of experience, absence of accumulation of experience (however multimillennial), interior innocence, smiling and hard, even arrogant, which neglects the world except with regard to its pain—these are the traits of a tradition where the forgotten remembers that it is forgotten, "knows" itself to be unforgettable, has no need of inscription, of looking after itself, a tradition where the soul's only concern is with the terror without origin, where it tries desperately, humourously to originate itself by narrating itself.[87]

Outside the Viennese context, we find the same reticence in the famous essay by Erwin Panofsky, first published in 1953, "Three Decades of Art History in the U.S.: Impressions of a Transplanted European." The denial of his Jewish identity resonates in the title of the essay itself. Panofsky's essay served as the statement for the field of art history in a book on the emigration of European scholars to the United States. Yet, the author's Jewishness and the reasons for the dislocation, that is, its specifically ethnic, Jewish effects, are scarcely given any weight in this scholarly autobiography. Panofsky refuses the personal voice in its opening paragraph on the grounds, again, of empiricism:

> Even when dealing with the remote past, the historian cannot be entirely objective. And in an account of his own experiences and reactions the personal factor becomes so important that it has to be extrapolated by a deliberate effort on the part of the reader. I must, therefore, begin with a few autobiographical data, difficult though it is to speak about oneself without conveying the impression of either false modesty or genuine conceit.[88]

Indeed, in the case of Panofsky, only recently have several of his most important essays, written in the early years in Hamburg before his emigration, become available in English.[89] Like so much of the work done in the discipline by Jews in Germany and Austria, much of it remained available only in German and only in relatively inaccessible German language periodicals that ceased publication during the war and often never resumed again.[90]

The agonies of the Jewish intellectuals involved in art history at this time are apparent in their willingness, even their extreme desire in some cases, to suppress the work and the professional affiliations of their own pasts when they left Germany and Austria. Another para-

dox, not yet mentioned, comes into play here, for the complicity that this forgetfulness shares with the intentions of the genocide of the Jews by the Third Reich is most apparent.[91] The ultimate persecutions, the absolute horror, occurred through the systematic extermination of those who were not able to escape, and no other trauma can be said to be equal to this. However, for those who survived, suffering occurred through the dissolution of the family and loss of family members, loss of jobs, and treatment as an alien racial presence.

The reticence of this group of Jewish émigrés, or survivors, has been "normalized" or assimilated in the discipline to the extent that the historiography of an account of the discipline has never been able to incorporate these important ethnic, that is, Jewish, aspects of its own history. This lack of the major ethnographic aspect of the historiography of art history is remarkable on the grounds of Jewish prominence, but at the same time totally explicable on the same grounds.

In his essay on "the jews," Lyotard posits three prerequisites for the kind of forgetting that we have seen operating in the discourse and discipline of art history. All of these have profound political and ideological implications for the present model of the historiography of the artist in art history. According to Lyotard, the necessary conditions for a "politics of forgetting" are (1) aesthetics, as in the aestheticization of the artist in culture posited by von Schlosser through biography; (2) the avant-garde, as in the use of new psychoanalytic approaches for interpreting the artist in history; and (3) "the jews," as the practitioners of the Viennese School of art history and psychoanalysis who undertook an examination of the artist and the texts in which he is represented.[92] The brilliance of Lyotard's argument resides in his understanding of the importance of a theory of representation that can allow aesthetics, the avant-garde, and "the jews" to be interdependent in the construction of the theory itself and supportive of (each on its own terms) a "politics of forgetting."

Given these conditions, it follows that for art history, the artist could not be theorized. In Lyotard's terms, there was no place for him to be represented other than the place in which he was represented, the biographies. This has remained the situation until now. This partial historiography of the culture of forgetting, what could be termed a special kind of culture of representation, has allowed this impasse to be uncovered and only partially disengaged from itself. Today, given the impact of other disciplines on the field of art history, precisely in

thinking theoretically about visual culture in many of the areas about which art history has not itself been able to speak, a self-consciousness by art history of its own genealogy, in essence its own politics, seems all the more necessary. The historiography of the attitude of the Viennese School of art history and psychoanalysis toward the artist reveals that major ruptures in disciplinary formation and discourse history adhere, particularly around the issues of origin and the artist.

# 6 / The Artist in the Text:
# Rhetorics in the Myth of the Artist

At one moment I grasp the presence of the glass and the distance of
the landscape; at another, on the contrary, the transparance of the
glass and the depth of the landscape; but the result of this alterna-
tion is constant: the glass is at once present and empty to me, and
the landscape unreal and full. The same thing occurs in the mythical
signifier: its form is empty but present, its meaning absent but full.
To wonder at this contradiction I must voluntarily interrupt this
turnstile of form and meaning, I must focus on each separately, and
apply to myth a static method of deciphering, in short, I must go
against its own dynamics: to sum up, I must pass from the state of
reader to that of mythologist.   ROLAND BARTHES, *Mythologies*

It is impossible to understand a myth as a continuous sequence. This
is why we should be aware that if we try to read a myth as we read a
novel or a newspaper article, that is line after line, reading from left
to right, we don't understand the myth, because we have to appre-
hend it as a totality and discover that the basic meaning of the myth
is not conveyed by the sequence of events but—if I may say so—by
bundles of events even though these events appear at different mo-
ments in the story.   CLAUDE LÉVI-STRAUSS, *Myth and Meaning*

The biography of the artist, I argue, has been the dominant cultural,
and, therefore, art historical source for the construction of the image
of the artist since the beginning of the Early Modern period. I pro-
posed that the biography of the artist constitutes a genre in which cer-

138

tain features pertaining to the artist alone prevail and are consistently repeated. These are evident in the biographies of artists from the time of the invention of the genre in fifteenth-century Florence to the present. Regarding the nature of genre in its Italian context, Rosalie Colie has argued convincingly that all literary invention was determined by "generic instruments and helps."[1] Therefore, it is not surprising that the prevalent and repeating features of the biography of the artist, the anecdote, for example, which are found throughout its history, are most evident in the earliest manifestations of the genre. Indeed, the potency of these early texts, especially in terms of their rhetorical features, is due to the strength of what Colie describes as generic models in the genesis and configuration of the early models.

The strength, or what could be called the generic coherency, of the early examples meant not only that they could and did serve as models, as we might expect, for later biographies of the same genre, but also that particular aspects of the genre, again, the anecdote preeminent among them, could be used by later historians in the interpretation of the artist in culture as chunks or "cells"—units beyond which further examination was unnecessary or in which a certain kind of historical truth was understood to be immanent.

A useful example of this operation of the anecdote can be found in the biographical history of Bolognese painting by Caro Cesare Malvasia, called *Felsina Pittrice* (1678). Giovanni Perini has examined an anecdote that appears in the *Life* of Guido Reni in which the painter Annibale Carracci criticizes a painting by the rival to his and Reni's style, the Lombard painter Caravaggio.[2] Perini correctly observes that the veracity of the anecdote—of whether or not the painting said to be by Caravaggio was actually by him and available to Carracci and Reni in Bologna at the time that Malvasia reports it—matters less than that the anecdote represents several major themes concerning differences in Carracci's, Reni's, and Caravaggio's styles, which are found in two texts that predate Malvasia's. The series of *Lives* by the art critic Giovanni Pietro Bellori appeared in 1672; a discussion of the contrast in styles between Reni and Caravaggio appears in the biography of the latter.[3] In another location, Perini finds an exact correspondence between the text by Malvasia and a letter written by Vicenzo Giustiniani, a major patron of Caravaggio's, and published in 1675.[4] Furthermore, the "spirit, though not in detail" of the anecdote is appropriated by the later Bolognese chronicler Antonio Francesco Ghiselli,

who changes the exact content of the anecdote by dropping the refer-
ence to Carracci and highlighting the contribution of Reni, again in
order to emphasize the exact nature of the style of Reni the Bolognese
versus Caravaggio the Lombard.[5] Here, as elsewhere, early *Lives* re-
veal a consistent typology. They are consistently appropriated (in their
structural totality or in their rhetorical features) in the assessments of
the artist that follow, including other kinds of art-history writing.

We have seen that the strength of the typology of the genre of
artists' biographies led Kris and Kurz to posit that the image of the
artist in culture rested exactly on the structure of these texts: "Our
primary source is how the artist was judged by contemporaries and
posterity—the biography of the artist in the true sense of the word. At
the very core of this stands the legend about the artist."[6] Furthermore,
with their investigation of the artist in generic terms, Kris and Kurz
inserted the visual artist into the conceptual framework of myth and
mythology, that which constitutes the "myth of the artist." In recent
years, British Marxist and feminist critics in art history have said that
this view of the artist prevents understanding the artist as a product of
historical and critical practices in society.[7] In this chapter I take ac-
count of their critiques and of the position of the artist at which they
are aimed, that is as it was identified and accepted by Kris and Kurz,
in order to address the problem of the construction of the artist in cul-
ture. I do this by applying historiographical methods directly to the
realm of myth in which the artist resides. This is where the discussion
of the artist in culture must begin.

Unlike Kris and Kurz and the recent critics, I admit that to enter the
discussion of the idea of the artist with the term "myth," as they have
done, is already an admission that the concept of the artist in culture
presents an enigma whose identity and boundaries are beyond inter-
pretation. This is essentially the interpretative situation of all myth, as
Roland Barthes argued in 1957 in the book *Mythologies*.[8] To be sure,
the myth of the artist may compensate for a lack of historical speci-
ficity desired for the object from the past that we experience in the
present. For this reason, we may adduce the necessity of the biography
or life of the individuated artist as a response to the lack of historical
specificity felt for the object. Nonetheless, the profound interpretative
problems and epistemological dilemmas that pertain when the artist is
a priori a myth or mythologized cannot be ignored, and the epigraphs
quoted from the work on myth by Barthes and Claude Lévi-Strauss

testify to difficulties in apprehending, discovering, and interpreting the meaning of any myth. The many discussions that have taken place in the twentieth century regarding the function of myth in culture by anthropologists, such as Malinowski and Lévi-Strauss, by early psychoanalysts, such as C. G. Jung, and by their later commentators and critics reveal the complexities and interests of a variety of discipline-based approaches to the subject of myth.[9] These approaches often represent themselves as self-conscious, and perhaps for this reason they have achieved a canonical status. But in all of these discussions, the specific content and place of the myth of the visual artist has remained virtually unexplored.

From the point of view of the representation of the artist in culture, the study of myth today is best expressed by Marcel Detienne in his book *The Creation of Mythology*, which deals with the study of the myths of the ancient Greeks:

> Whoever goes hunting without the excuse that the wild animal is shy should remember that in spring before the perfume of flowers disturbs the dog's sense of smell, the tracks of the hare are clear but intermingled. Not as a result of the ruse which induces the hare when fearing pursuit to retreat through the same places by leaping together and placing "tracks within its tracks," but because, particularly at that season, the hare's mate and "roaming together . . . make similar tracks." However confused he may be in choosing between trickery and vagabond pleasure, the "myth" hunter will not be surprised to find that in the land of beginnings, at this season in History, the "pure" tracks as they are called in *L'art de la chasse* [by Xenophon] are mingled with others, mixed up and so faint that the scent, the technical term used by hunters, seems to have vanished. He will be even less surprised to find that his hare makes its form in the sites of illusion.[10]

Whether the artist has been represented by history or literature, we are still "in the land of beginnings, at this season in History." Even if the hunter today were a Diana (understood to be the feminist huntress) rather than a Xenophon or Detienne, the scent might well remain as elusive or situated in the sites of illusion as ever. Myth prevails here precisely because the site of myth is the site of illusion. The myth remains intact because the work on myth, even that of Barthes, on whom Detienne relies, does not disturb the site, a point that Barthes himself admits at the end of the essay "Myth Today."[11]

Following Detienne's view of the Greek tradition, it can be argued that all literary and historical approaches to or representations of the

artist that return to the site of the early modern *Lives* of artists will persist in supporting the mythic status of the artist in society and the mythologies about the artist in culture. For example, art history has barely been provoked by the alternatives to traditional views of authorship provided by the idea of the death of the author/subject and the birth of the reader in the work of Barthes and Foucault and their commentators.[12] In literature these have been taken to be approaches that demythologize the author; that is, they move toward response criticism, the construction of a text from other texts, the notion of a common *langue*, and so on. On the other hand, the visual artist, with the important exception of the *auteur*-director, was not specified and, therefore, was undertheorized in those debates.[13] More significantly, the site of the illusion of the myth of the artist, the generic form of biography, remains intact because it was not identified in debates about the representation of the author in texts. It fell outside the post-structural efforts to understand textual construction and narrative form. This omission perpetuated the mythologized status of artist, even as the corresponding notion of the *auteur* or author fragmented, or came to have a historical and formally constructed specificity.

## Exemplarity, Narrativity, and Myth

We may well be forced to draw the conclusion that society requires this unexamined position for the visual artist. If so, this assumption bears some consideration here. Concerning the use of mythological constructions in film, Bill Nichols has written:

> Mythic icons or exemplary figures give concrete representation to cultural ideals and psychic desires. They are imaginary projections, or fetishes, answering to the needs that arise within the body politic or the unconscious . . . the mythic domain arrests a singular moment, a transfixing glimpse at an otherwise obscure object of desire, and renders it indelible. It tries to seize the moment and make it perpetual. If it is of sufficient force, mythic identification places a blockage in the way of narrative development or historical referentiality.[14]

Furthermore, when the mythological artist appears in biography, we think that we are provided with an exemplar, and a "proof," of the "reality"—literally, the bodily presence—of the historical and the imaginary.

Hayden White has theorized the function of narrative in history similarly, that is, as a moral imperative that represents the imaginary

as "real" in order to tame or understand it.[15] Elsewhere, White has explained that at this moral level of meaning, history, as opposed to fiction writing, can function "in a given dominant modality of language use: metaphor, metonymy, synecdoche, or irony."[16] These dominant linguistic modes of history, however, do not fit easily with the texts that serve as the models for the cultural representation of the artist, the biographies. This is another case, like Barthes's, where art history sources, that is, biographies, fall outside the domain of significant revisionary work in other disciplines. I have shown elsewhere that the early biographies of artists are themselves based on vernacular biographies of poets, particularly Dante, Petrarch, and Boccaccio.[17] Intrinsic to all of these early biographies of poets is the importance of poetry and poetic language itself, represented contemporaneously in more theoretical discussions by the debates known as the *questione della lingua*. Thus, by recognizing not only that these biographies of poets provide the first models for the image of the artist, but also that in the kind of linguistic structures used in them and their successors are embedded poetic modalities that pertain as much to poetry as to history writing, we can understand the importance of the representation of the imaginary in the "reality" of the artist in culture. We can begin to see the shape of a myth tailored distinctly for the body of the artist.

A result of such an understanding concerns White's determination regarding the recognition of the site, using Detienne's term, of the mythic mode itself, that is, the fact that "these mythic modes are more easily identifiable in historiographical than they are in literary texts." This determination does not pertain because "the remission of the *poetic moment*," which White theorizes for most history writing, and which enables the identification of the mythic modes of linguistic representation in poetry, is not readily evident in the biography of the artist.[18] The poetic moment is never completely in remission, as it would be in other genres or in representations of other kinds of historical figures. What White calls the poetic mode is generally thought of as a property of literature rather than history writing. As Tzvetan Todorov observed, "We may suppose that this property of literature is what Aristotle had in mind when he noted, first, that poetic representation parallels representation 'by color and form,' and, second, that '[the statements of poetry] are of the nature rather of universals, whereas those of history are singulars.'"[19]

In addition, the dominance of the (mythic) reality of the artist in

narrative contexts, such as biographies, plays into the needs of the marketplace to authenticate works of art and establish attributions to named artists, thereby increasing the value of "art objects" or commodities. In fact, the Early Modern biographies are the first place where the history of a life and a commentary on the works are combined. At the time when biographies of artists first appeared, and until the eighteenth century, there was no separate genre for the criticism of the works of art. This conflation in terms of the visual artist differs significantly from the situation of the biography of the poet and the separate genre of the commentary, already present in the Early Modern period, which deals with the poetry proper.[20] This linkage of the artist and the work of art, what could be called the commodification (and/or fetishization) of the artist in the form of the object, accounts, in part, for the resistance, as far as the artist is concerned, to the recent theories of authorship, as noted earlier. The artist is less easily separated from the work of art or the commodity per se. The linkage of the two also makes the remission of the mythic in the social sphere even less likely.

The body is ever present in culture's construction of the work of art and in the texts that represent it and the artist because biography is the dominant genre or place where that construction has occurred. In this sense, the discourse in artists' biographies resembles the *pli*, or fold, understood as a continual unfolding and refolding of the discourse upon itself, introduced into cultural theory by Gilles Deleuze.[21] In the first chapter, I discussed the term *biography*, and its root in the Greek term *bíos*, meaning a distinctly human, as opposed to animal or other creature, existence. Life, a human life lived in a human body, cannot be separated from the representation of the artist in this culture. Thus, a new approach to the artist must incorporate thinking about not only narrative and its moral implications, and representation and its ethical implications, but also the embodiment of the artist in the mythology of the visual itself.

Narrative is purely textual and oral. In our culture the artist's body comes into existence as a text, usually in biography, or, as suggested earlier, through the work of art itself, the commodity. In art historical discourse, as in the early biographies, the body of the artist and the work of art are often conflated narratively. Historically speaking, this happened first in the genre of biography. Then, when art history developed as a discipline, genres—such as the monograph and catalogue

raisonné—specific to the discipline maintained many rhetorical structures of the biography, particularly the anecdote, in which body and work of art are joined. I have argued just this point with the case of Burckhardt's *Civilization of the Renaissance in Italy*. In such contemporary "professional" genres as the catalogue raisonné or the exhibition catalogue that pertain to art history alone, discussions of the body and the works are joined textually. Both of these professional genres present what is often referred to as the *corpus* of the artist's works.[22] If we push these textual analogies between the originary genre, the biography of the artist, and professional genres that replicate many of the biographical tropes and rhetorical structures, we could state that the monograph of the artist is art history's simulacrum of the biography of the artist. As a simulacrum it is even farther removed from the originary site of illusion, and thus more deeply embedded in the illusion of which Detienne speaks.

Although I rely on White's ideas regarding narrative modes and the moral level of history writing, I would say that the situation, moral or otherwise, is invariably more complex in the case of the dimensions of the myth of the artist than it is in the case of the function of narrative in fiction or history. That this is so has to do not only with the potency of the genre and the use of its rhetorical structures in subsequent and other kinds of writing about the artist but also with the expectations, engendered precisely by this genre and these structures, that we hold regarding the figure of the artist. My observations here and in the previous chapters will suggest that this complexity results in fetishization, in the deferral of the critical gaze of the interpretative community, and in cultural repression. Repeating Detienne's metaphor, "The hare makes its form in the sites of illusion."

## Artist Anecdotes

In the last chapter I demonstrated that Kris and Kurz, supported by von Schlosser's philological methods and the work that psychoanalysts, particularly Rank and Freud, had done on the artist, were the first to understand that the artist in culture was an image constructed through texts, particularly biographies. The rest of this chapter will address the following question, which arises when considering Kris and Kurz today: What happens if we accept, as Kris and Kurz did, the representation of the artist as found in biography and the the-

orizations of that representation found in art historical and psycho-analytic circles in Vienna in the early years of the twentieth century?

Here I want to enter the text of the biography of the artist at the specific level of the rhetorical element that Kris and Kurz termed "the primitive cell" of the genre: "artist anecdotes."[23] The biological refer-ent in their brief characterization recalls the root of the word *biogra-phy* in the Greek *bíos*. Throughout their investigation of artist anec-dotes, Kris and Kurz maintain that the particular anecdotes in the particular texts that they examine do not refer to an individual artist's existence but to "the artist's" existence: in other words and following the root meaning of *biography*, to an ideal type of human whose ac-tions and character conform to universally held conventions and stan-dards. Since Greek times this ideal human has been known as "the hero." I have established the importance of Rank's concept of the hero for the theorization of the artist found in Kris and Kurz: the heroic fig-ure of the artist lies at the foundation of the moral exemplum required by culture and represented in texts.

In their investigation of artist anecdotes, Kris and Kurz made two arguments that concern me here. The first is their assertion that the anecdote functions as the carrier of meaning of the "fixed" or "typi-cal" themes in the consideration of the artist, that the anecdote is the basis of the typology of the genre of the biography of the artist, in-cluding origin, naming, early talent, elevated patronage, and spiritual old age. A full theory of anecdote would recognize that the typology is not carried, in the main, generically, but rather narratively, in the in-ternal form of the anecdote itself. In this way we can understand that the anecdote is a generic convention with a narrative function. The narrativity of the artist anecdote is so coherent or self-contained that it can break out of its originary generic location and be found intact, as a self-contained and recognizable narrative unit, in other narratives.

The second argument, the one most important for the historio-graphical analysis here, is that the anecdote contains "*the image of the artist* that the historian had in mind."[24] The logic of Kris and Kurz is not entirely clear here, for if the historian had this image in mind, it was an image that was "primitive," using their terminology for anec-dote, or instinctive, using a psychoanalytic terminology. Either way, it would preexist history itself. Given their psychoanalytic background, Kris and Kurz may have seen the artist as preexistent in the uncon-scious of the historian. This is the way that mythic figures are theo-

rized by C. G. Jung. Certainly, for them, the anecdote contains and carries (like a solid container) the culture's ideas about the artist.

If we theorize the anecdote narratively, we may begin to allow the artist into the circle of critical interpretation from which he is always excluded because he has been represented as prehistorical or mythic by historians and mythologists alike.[25] Understanding the operation of the narrative form, the artist anecdote, becomes essential if we are to understand the artist in culture and the requirements attendant on this form, or the shape of culture's myth.

Joel Fineman investigated the form of the anecdote in an important and difficult article, "The History of the Anecdote: Fiction and Fiction."[26] Fineman was not interested specifically in artist anecdotes. He never mentions the work on anecdotes by Kris and Kurz. Yet, he identifies the anecdote and its structure as key in the understanding of the construction of culture in the discourses of philosophy, history, and literature. Fineman, borrowing from poststructuralist rhetorics and narratology, prefers the term *historeme* to characterize "the smallest minimal unit of the historiographic fact." For him, as for Kris and Kurz, "the anecdote, let us provisionally remark, as the narration of a singular event, is the literary form or genre that uniquely refers to the real." Or, in the words of Barthes, it is one of the "effects of the real."[27] Fineman recognizes that as a literary form it is nonetheless "directly pointed towards or rooted in the real . . . and the question that the anecdote thus poses is how, compact of both literature and reference, the anecdote possesses its peculiar and eventful narrative force." Fineman makes an important addition to Kris and Kurz, not only because he is able to be precise about the way that the anecdote references the real and historicity itself, but also because of his distinct approach to the anecdote as *form*. Anecdote engenders an impression of the real through its form. The discrete rhetorical operations and function, as well as contextual placement, affect our understanding of the content or subject contained by the form as much as or more than the content or subject matter itself.

Thus, a critique of the rhetorical form and generic conventions of biography, as exemplified by the anecdote, yields ways of entering the texts of the biographies of artists that could provide us with an understanding of the artist in culture on both the historical and mythological levels. This is a more formal approach than "the New Art History," which attempts to place the artist socially. The approach here yields a

more textually sensitive but historically and culturally rooted way to interpret *how* the myth of the artist gets produced and takes effect. It enables us to know that we can move back and forth between two levels in the text: the typicality that Kris and Kurz insisted on in their assessment of the form *and* the specificity of a particular anecdote in a particular text or a particular representation of the artist. This approach renders and conjoins a physical body, a body of work, and a myth transcendent to both. The second level of analysis is possible only when we allow the anecdote to be contextualized rhetorically, as Fineman has argued.

## The Function of the Artist Anecdote

I begin the investigation of the artist anecdote with a look at its originary operation and character. Anecdotes are a central aspect of the historical narrative of the artist, serving to yoke storytelling (that is, biography, the written story of a life) to experience (that is, "real" events). Thus, for example, in the case of narratives about the artist, the anecdote as a form invariably preexists the biography of the artist, which, as I argued earlier, appeared first in the fifteenth century with Manetti's *Life* of Brunelleschi. Artist anecdotes can be found much earlier. In even their earliest manifestations, the artist anecdote always ties a name (the artist) to an action. Artist anecdotes seem to have a Greek origin, like Detienne's mythology.[28] Pliny the Elder's (ca. A.D. 23–79) *Natural History*, which contains the first surviving accounts of any length about the history of Greek art and artists, reveals that accounts about art and artists were woven into a larger historical project and that they appear most coherent and obvious in the form of the artist anecdote. These anecdotes cluster in Pliny in Books 33–35, and significantly, as Kris and Kurz recognized, they are repeated endlessly (often with names and places changed) throughout the subsequent history of art, most particularly beginning in the Early Modern period.

One of the most repeated and glossed of these anecdotes concerns the Croton painter Zeuxis and his rival Parrhasius:

> This last, it is recorded, entered into a competition with Zeuxis, who produced a picture of grapes so successfully represented that birds flew up to the stage-buildings; whereupon Parrhasius himself produced such a realistic picture of a curtain that Zeuxis, proud of the verdict of the birds, requested that the curtain should now be drawn and the picture displayed; and when he realized his mistake, with a modesty that did him

honour he yielded up the prize, saying that whereas he had deceived birds Parrhasius had deceived him, an artist.[29]

This anecdote returns us to the topic of rivalry between artists, which I discussed in chapter 2. Here the rivalry plays out in the rendering of nature (mimesis) and the statement that what constitutes good, even miraculous, art is acknowledged by good, even miracle-making artists.[30] Good art by good artists gives clear indication of the linkage of artist with the work of art at a moral level, even in the earliest examples of the form.

Kris and Kurz suggested that this anecdote, as well as the tropes about the artist that it contains, can be found repeated frequently, either exactly or paraphrastically, in other anecdotes from the Renaissance to the present. These small narratives float, and being able to do so, they exhibit a meaning dependent on their originary text. The meaning is, in part, preformed, no matter where the anecdote may adhere in a new text. When newly situated, the content of the artist anecdote also gains additional meaning subject to the contingencies of its placement, that is, by what precedes and follows it in the larger narrative. These anecdotes are so integral to the criticism of art and the disciplinary discourse of art history itself precisely because they can travel so readily and inflect so easily the new text in which they are found. The anecdotes and tropes are found in the criticism on art and in the discourse of art history removed from their original biographical location and inserted in another kind of narrative, now known as art history. As a result of the narrative properties specific to artist anecdotes, the image of the artist constructed around the anecdote persists. The result is the perpetuation of the myth of the artist in art history itself, carried by the form of the anecdote.

This point is of enough significance to my argument that it deserves some elaboration and refinement. These can be obtained by recourse to examples of the use of the Zeuxis-Parrhasius anecdote just cited drawn from three books that deal with very different aspects of visual culture, each written by a different author in one of the last three decades. This selection, or historiographical sample, of the use of the Zeuxis-Parrhasius anecdote will allow us to draw conclusions regarding the operation of the anecdote in recent art historical discourse and criticism. It will also allow us to see that the use of the anecdote is a universalizing gesture, whatever the date or historical specificities of

its appearance in a particular text by a particular author, or in reference to a particular artist or work(s) of art. I have suggested earlier that this universalizing tendency inherent in the use of the artist anecdote is due to the unrepressed poetic modalities of the language. In terms of the analysis of art history discourse, this characteristic of the artist anecdote in a historical context could be understood as *historicized exemplarity.*

In the book *Annibale Carracci and the Beginnings of Baroque Style* (1977), Charles Dempsey paraphrases the anecdote as found in Pliny and then cites its paraphrased appearance in the seventeenth-century *Life* of the Bolognese painter Agostino Carracci by Carlo Cesare Malvasia:

> "He painted a grey horse (that is, the picture depended upon *chiaroscuro* for illusion) with such semblance of life that a stallion whinnied at it, tried to approach it, and finally in frustration destroyed it with a blow from its hooves. He deceived a painter with a picture (this time with color added to the light effects) showing a flayed and gutted sheep hanging from a hook, which the painter drew near, praising the quality of the meat, and touched with his hand, which destroyed the illusion."[31]

Dempsey's point is that Carracci's use of chiaroscuro was "used as the foundation of perfect illusion." This is one of Pliny's points in the original anecdote. Mine is that the repetition of the anecdote allows Dempsey in his interpretation to make the stylistic point about Carracci, just as Malvasia was able to do the same in the biography by repeating the same anecdote (using Carracci's name). Moreover, as Malvasia records, the story was told to him by yet another artist, Faberio. The numerous repetitions of the anecdote give the interpretation the air of "reality." The number (4) of earlier authors cited as having used the anecdote enhances this authority: Dempsey (1) cites Pliny's (2) Zeuxis-Parrhasius anecdote; Dempsey (1) cites Malvasia (3), who cites Faberio's (4) use of the anecdote as an actual account of the artist Carracci's painting procedures. It should be noted that in this case the anecdote appears in the context of a critique of a style of painting.

My next example of the use of the Zeuxis-Parrhasius anecdote is taken from Norman Bryson's book *Vision and Painting: The Logic of the Gaze* (1983). Bryson (1) quotes the anecdote as found in Pliny (2) and uses it as evidence of "the essence of working assumptions still largely unquestioned" in the discipline of art history, specifically the importance of the mimetic standard.[32] Like Dempsey, Bryson cites the

anecdote in order to gloss the work of an earlier historian, in this case, Ernst Gombrich (3), whose book on painting and perception, *Art and Illusion*, Bryson reveals as *"fundamentally* wrong" and of which the Zeuxis-Parrhasius anecdote is taken to be emblematic. In this case, the anecdote appears in the context of a disciplinary critique about the choice of style.

My final example is the most complex and is taken from Fredric Jameson's book on film, *Signatures of the Visible* (1990). Jameson (1) takes his citation of Pliny's (2) anecdote from Lacan (3), who uses it, so Jameson tells us, in "his meditation on the 'scopic' drive in the Eleventh Seminar" or "to define the Freudian (4) conception of an 'instinctual' drive."[33] Jameson employs Lacan's use of the anecdote as a

> point of departure for grasping the postmodern image as a phenomenon in which the scopic consumption of the veil has itself become the object of desire: some ultimate surface which has triumphantly succeeded in drawing that "other thing," that "something else," the objects behind it, out onto a unified plane such that they shed their former solidity and depth and become the very images of themselves, to be consumed now in their own right, as images rather than as representations of something else.[34]

Here the anecdote is used to understand the essence of images in the postmodern era, or as an adjustment to the view of mimesis as it first appeared in Pliny's anecdote.

Whether the anecdote is being used to describe or elucidate a painting in grey and white tonality (Dempsey's chiaroscuro), a regime of representation known as mimesis, which has pertained since the Early Modern era (Bryson on Gombrich), or the idea of moving images in the contemporary culture (Jameson), the usage of the form is similar in all three authors. It is used repetitively through citation of the text in its originary and in subsequent sites. For this reason, and with each additional repetition, it carries with it the authority of all of the authors who are cited by the author of the current text as having used it. In this way its authority is established not only in terms of its content and the consumers of its content, the many named authors, but also in terms of the history of art itself, which instantly (by virtue of repetition) recognizes the form as its own. In this disciplinary discourse, the anecdote calls attention to itself and by doing so refers the reader to the anecdotality of the discourse, that is, to those parts of the discourse that are represented by anecdote, the artist and the works of

art. This keeps the contents of the text, at least partially, prisoner of the form—of anecdotality and all that it represents, such as its illusory or impressionistic reference to the "real" or its intrinsic dimensions of the mythic.

We have seen that in Dempsey, Bryson, and Jameson this anecdote signifies a way of understanding the goals of the artist and his procedures—or the ends of these procedures, the image itself. The form anecdote is mimetic of the procedure of art itself, its repetitions, and its similarities regardless of the medium (painting in Dempsey, representation in Bryson, film in Jameson). But when we understand the usage of the form rhetorically, we can see that it consistently thwarts the purported aim of a synchronic art history or art criticism, the dominant one in this century. The specificities of every maker and of every object are elided or made invisible when history uses anecdote. Kris and Kurz understood that no history was more replete with anecdotality than art history. This situation, most acute in art history but present also in other disciplines where the interpretation of cultural representations or images is seen as central, has certain profound political implications for the discipline.

An illustration of this last point about disciplinary discourse and the anecdote can be found in the notice that James Clifford has made of the anecdote and its function as authorizing narrative in the field of anthropology. Clifford saw that in a famous essay by Clifford Geertz, "Deep Play: Notes on the Balinese Cockfight," the intrusion of the police into the illegal cockfight, related as anecdote by the ethnographer-author, "establishes a presumption of connectedness" between Geertz's earlier "childlike status within the culture" and an "adult, confident" state. As Clifford states, the insertion of the anecdote allows the accepted and knowing anthropologist to emerge and be maintained for the rest of the story.[35] Following my earlier argument, at the same time, just as the police intrude into the cockfight, so too the anecdote breaks into Geertz's narrative. Rhetorically, its intrusive function here is mimetic of the "real" event, the police action. With the use of the form we should understand that authority and mimesis are somehow always sustained.

The use of Geertz's anecdote by Clifford illustrates the mnemonic function of all anecdotes. In this function, it is not difficult to see how the anecdote contributes significantly to a cultural memory, especially to ways of remembering. Repetition and familiarity are two essential

aspects of remembering. In addition, the familiar narrative structure of the form, with its clearly demarcated beginning and ending are characteristics that contribute to its mnemonic function. When the narrative unit appears inserted into a larger or longer narrative, it causes a break or division in the "carrier" narrative—literally in media res. The anecdote's beginning and end mark the boundaries between itself and its surrounding narrative. Thus, recalling or repeating the anecdote can remind us not only of its content but also of the content of the text that once surrounded it. This recollection is naturally easier in terms of the anecdotal narrative because it is shorter than the narrative that it interrupts. As an abbreviated but "whole" form within the larger narrative, it is more easily grasped than the big story to which it can always refer and of which it is, in all senses, exemplary.

When Clifford recalls the anecdote of the police raid in the Balinese cockfight, it serves as a reminder of the whole essay, including its canonical, or authoritative, situation in the field of cultural anthropology and later interpretations—on the side of "the natives" and in opposition to the suppression of their culture.[36] Recalling the anecdote serves as a sort of shorthand for Clifford, a way of remembering the whole of the famous essay by Geertz and the authority of that text without having to refer to it beyond the recollection of the anecdote. This is important for Clifford's own text, *The Predicament of Culture*, whose purpose is to provide a historiographical critique of ethnography, including aspects of Geertz's uncritical use of narrative structure. The same remarks about the placement and function of the Geertz anecdote hold true for the Zeuxis-Parrhasius anecdote, especially in its paraphrastic citation, as it appears in Dempsey, Bryson, and Jameson. Ironically, according to the point of view expressed here, the account of the Geertz essay in Clifford occurs not only at the end of a section but also almost exactly at the midpoint in the chapter. Its position bifurcates two central parts of Clifford's essay and suggests further ways of thinking about the textual function of this anecdote, but this takes me beyond the scope of the artist anecdote.

## Secrets in the Form

The etymology of the term *anecdote* is often invoked on those rare occasions when it is used self-consciously in historical interpretation. Kris and Kurz do this in the introduction to their book when they re-

mind the reader of the oldest meaning of the word as "something new, unknown and therefore secret."[37] But this usage of the word misses an important aspect of its earliest definition, which Kris and Kurz bypass in order to associate it with the genre of the novella or short story, to which, I would argue, it is only superficially related. To give Kris and Kurz their due here, the anecdote does appear more related to the novella or short story the more it is removed from its originary narrative context: biography and history writing.

The most famous use of the term *anecdote* occurs in its use as the title of the sixth-century Greek historian Procopius's book *Anekdota*. As the author himself tells it, the book was the inside scoop or alternative story to the one he told in his earlier book *History in Eight Books*, or *Wars*, as it is also known. The earlier book attempted a strictly factual account of Justinian's famous general Belisarius. Procopius's *Anekdota*, on the other hand, has been characterized as a bitter and scathing attack on all of the principals found in *Wars*. The reasons posited for the untoward viciousness of *Anekdota* have to do with Procopius's frustration at being unable to openly criticize the regime in power and his own political affiliations with the powerful and conservative landholding aristocracy that Justinian was trying to curb.[38] The secretive, the political, and the unpublished are all embedded in the title of Procopius's book and in the meaning of the term. As Arthur Boak said in his introduction to Procopius's work, "The term was regularly applied to secret, posthumously published, political writings which smeared political enemies, particularly those in authority whom it would have been dangerous to attack openly."[39]

In a repressive society, such as Italy in the Early Modern period, and at a time just following the invention of the printing press, when the genre of the biography first appeared, "secrets" could be published and more widely diffused. The public exposition of political secrets could be called subversive or revelatory, depending on the point of view of the author and the audience.[40] In terms of the artist, if the anecdote in the early biographies of artists is viewed in these ways, it can be related to the particular social aspects of the artist in Early Modern society, where the artist and his public had clear, and at times, competing political claims. In the discussion on Manetti's *Life* of Brunelleschi in chapter 2, we saw that these included the changing status of the artist in society from craftsman to "artist," the demise of the guild system and its regulations, and the founding of the first modern

academies of art with their new systems of regulation for the practice of art and the behavior, as in rivalries, of the artist.[41] Clearly, the commodity value of the mythic artist, mentioned earlier, is implicated again in these more obviously political and economically strategic areas, with the "real" body of the artist represented in the anecdote as the one "standing behind" a given body of work.

The following famous passage from Giorgio Vasari's *Lives of the Most Eminent Painters, Sculptors, and Architects* supports the view that the contents of his biographies, preeminent among them the artist anecdote, could be read as revelatory or subversive, that is, as the political secrets of the artist revealed (or withheld) by the historian. Indeed, the following passage from Vasari is foundational to culture's investment in the artist, which eventually saw him as custodian of the imaginary with an attendant moral weight or responsibility unlike that held by any other member of society. Vasari says:

> I have striven not only to say what these craftsmen have done, but also, in treating of them, to distinguish the better from the good and the best from the better, and to note with no small diligence the methods, the feelings, the manners, the characteristics, and the fantasies of the painters and sculptors; seeking with the greatest diligence in my power to make known, to those who do not know this for themselves, the causes and origins of the various manners and of that amelioration and that deterioration of the arts which have come to pass at diverse times and through diverse persons.[42]

As I indicated earlier in my discussion of myth, this moral tone is required in the representation of the imaginary as "real," although now we can begin to understand exactly how Detienne's "site of illusion" resides in the mythology itself. We can also begin to see how it relates to the interpretive struggle with issues of power, intrinsic to the form.

In this sense we could understand every anecdote at the metalevel to mean the secret political narrative within the larger historical narrative. Secretiveness lies in the form itself, for even as the content of the anecdote appears to give the reader access to a heightened level of realism or actuality—to a firsthand account—the form itself resists revelation. We have seen with the example of the Zeuxis-Parrhasius anecdote that anecdote moves intact from narrative to narrative and maintains the integrity of its internal coherence, although its later meanings may be changed slightly from the original, as its deployment in the discourse of art history has shown. The appearance of revela-

tion and the "reality" of perpetual secrecy are maintained in a tight dialectic.

As an aid to this resistance, to the revelation promised but never completely revealed by the anecdote, we must also admit that the form "anecdote" trivializes itself. When it does so self-consciously, or when it tries to escape its own political essence, it becomes gossip: "The secret lay not long in the Embers, being gossiped out by a woman," wrote the playwright Stapylton in 1650.[43] In terms of the artist, this contradiction in the form between immense seriousness and triviality has often been recognized by art historians as a contradiction in the representation of the artist. Great effort goes to circumventing it, instead of accepting and understanding it as part of the representation itself.[44]

John Guare reveals the triviality of the anecdote in *Six Degrees of Separation*, a recent play and film. The protagonists Ouisa and Flan argue over the meaning and appearance of the elusive Paul, who claimed, falsely, it turns out, to be the son of Sidney Poitier and able to get them into the movie version of *Cats*. Ouisa complains:

> And we turn him into an anecdote to dine out on. Or dine in on. But it was an experience. I will not turn him into an anecdote. How do we fit what happened to us into life without turning it into an anecdote with no teeth and a punch line you'll mouth over and over for years to come. "Tell the story about the impostor who came into our lives—That reminds me of the time this boy—." And we become these human joke boxes spilling out these anecdotes. But it was an experience. How do we *keep* the experience?[45]

Here anecdote in its trivialized form, gossip, is understood to be subversive of experience, or one could say, reality. By reducing, containing, and enclosing experience, it functions better to redeem the large (illusory) truth of the biography, which, by contrast, is not so trivial and with which the author is fully invested, in contrast to the anecdotes cited as "mere" examples. The "real" in the genre is also only maintained by a clear contrast between the larger narrative and the inserted anecdotes.

The seeming contradictions between content and form in the anecdote, as secret, subversive, and political narrative on the one hand, or as revelatory and trivializing gossip on the other, are essential to understanding how anecdotes, particularly artist anecdotes, have been received by historians and used in history writing. By recognizing still

unexamined contradiction as central to the operation of the anecdote and central to its existence in the genre of the artist's biography, I think we can go a long way toward understanding why it has been so little theorized.

## Myth, History, and the Historian

More profoundly, the contradiction between a content that holds out the hope of the revelation of truth or actuality—"reality"—and the form itself, which insists on secrecy, creates a resistance to interpretation on many levels and may be partially responsible for the regress to myth, or a form of the unknowable, which Kris and Kurz use as the ultimate explanation of the form. Their use of the term "primitive cell" in reference to the artist anecdote meant that the artist remained "intimately linked with the legendary past" from which he cannot be separated and without which no heroes, or artists, would exist. They wrote:

> For historians have learned to recognize that the anecdote in its wider sense taps the realms of myth and saga, for which it carries a wealth of imaginative material into recorded history. Thus, even in the histories of comparatively modern artists we find biographical themes [e.g., anecdotes] that can be traced back, point by point, to the god- and hero-filled world before the dawn of history.[46]

Here, the anecdote travels backwards through historical time, understood as linear, to tap into another narrative time of myth and prehistory. This view of a cultural preconscious came to Kris and Kurz via the work of Freud, especially the book *Totem and Taboo*, and it is present in different ways in Jung as well. However, anthropologists beginning with Lévi-Strauss have shown the flaws in such a concept of culture, and recent critiques of Freud have underlined the problems with such an approach.[47] A view of the artist that holds, even implicitly, that culture's idea of the artist can be traced back to such a preconscious state refuses historical specificity or individual human agency for the artist. For Kris and Kurz, the prehistoric or "primitive" anecdote preexists history itself. This view of the form ignores its essentially literary and linguistic character and its rhetorical structure, those elements presupposed in Fineman's approach, and indeed in White's. It maintains the secret that the "reality" disclosed and secured by the anecdote is itself mythic and generic. The "reality," then,

is a type of experience at the essence of which lies the threat of revelation, disguised rhetorically as seduction. The resultant image of the artist marks and produces the illusions about art required by a culture invested in aestheticizing the commodity and endowing the maker with a higher moral stature than other humans.

In contrast, a rhetorical and discursive interpretation of the form would not only criticize the reversion to myth taken by Kris and Kurz and many others but also insist that the secrecy inherent in the form is a result of the political weight of the narrative, rather than of a mystified or prehistoric origin. In art history, at least, the power of history resides in the anecdote. I have shown that Kris and Kurz recognized this and that Burckhardt's use of artists' biographies, weighty with artist anecdotes, was foundational to the writing of art history as we know it today. A politically informed rhetorical interpretation of the artist anecdote would recognize the choice called forth by the very use of the form itself. It would question the naturalized mythologies of the artist in culture. If, as Detienne would have it, the hare always "makes its form in the sites of illusion," it is at least time to name the sites and to describe the illusion. It is time in art history to lift the veil of illusion secreted by the work of the anecdote as a generic form.

At the same time we should recognize that the interpreter, especially one who appears to divulge the secrets of the form to reveal the meaning of the form and the content of the individual anecdote, will always appear to some degree or another suspect, because she, like Diana the huntress, is a subversive in the dominant political reality. This suspicion will be most acute when it is directed not at the addition of an element of historical (as in the social history of art) or feminist contextualizing to a still intact mythic form, but instead at challenges to the very form of the narrative of biography and nonfictional representation itself. We can then understand how institutions, such as disciplinary formations in the contemporary academy, or professions, such as art history, will react to thinkers seeking to find meanings "in the land of beginnings, at this season in History."

# Notes

## Introduction

1. Friedrich Nietzsche, "On the Uses and Disadvantages of History for Life" (1874), in *Untimely Meditations*, trans. R. J. Hollingdale (Cambridge: Cambridge University Press, 1983), 59.

2. Paul Bové, "Discourse," in *Critical Terms for Literary Study*, ed. Frank Lentricchia and Thomas McLaughlin, 2d ed. (Chicago: University of Chicago Press, 1995), 54–55. I am grateful to Paul Bové for his support at a very early stage of my work on artists' biographies.

3. The best discussion of the entailment referred to here remains the entry on "Arts, Practice and Profession of the," in *Encyclopedia Britannica, Macropedia*, 15th ed., vol. 14: 88–121. See also John Barrell, *The Political Theory of Painting from Reynolds to Hazlitt: "The Body of the Public"* (New Haven: Yale University Press, 1986); Jürgen Habermas, *The Structural Transformation of the Public Sphere: An Inquiry into a Category of Bourgeois Society*, trans. Thomas Burger (Cambridge: Harvard University Press, 1989); David H. Solkin, *Painting for Money: The Visual Arts and the Public Sphere in Eighteenth-Century England* (New Haven: Yale University Press, 1993); Martha Woodmansee, *The Author, Art, and the Market: Rereading the History of Aesthetics* (New York: Columbia University Press, 1994).

4. On the centrality of visual culture today, see my review article, "The Turn to Visual Culture," *Visual Anthropology Review* 12 (spring-summer 1996): 1–7.

5. Milton C. Nahm, *The Artist as Creator: An Essay on Human Freedom* (Baltimore: Johns Hopkins University Press, 1956), 19.

6. Maurice Merleau-Ponty, "Cézanne's Doubt," in *Sense and Non-Sense*, trans. Hubert L. Dreyfus and Patricia Allen Dreyfus (Evanston: Northwestern University Press, 1964), 22. Compare this quotation with the recent statement by the biographer Richard Holmes, in James Atlas, "Holmes on the Case," *The New Yorker*, September 19, 1994, 58: "By reconstructing a life through narrative, it emphasizes cause and consequence,

159

the linked pattern of growth and change, the vivid story-line of individual responsibility and meaningful action. . . . The life informs the work—in some way *is* the work."

7. G. W. F. Hegel, *The Introduction to Hegel's Philosophy of Fine Art*, trans. Bernard Bosanquet (London: Kegan Paul, 1886), 18.

8. I paraphrase here from the excellent study by Jack Kaminsky, *Hegel on Art: An Interpretation of Hegel's Aesthetics* (New York: New York State University Press, 1962), 27.

9. Richard Wollheim, *Art and Its Objects*, 2d ed. (Cambridge: Cambridge University Press, 1980), particularly 151–53. David Summers has argued similarly for "conceptual" images or art, by stating that "social reality is actually constituted as real places and activities," that is, art, rather than the reverse, in "Real Metaphor: Towards a Redefinition of the 'Conceptual' Image," in *Visual Theory: Painting and Interpretation*, ed. Norman Bryson, Michael Ann Holly, and Keith Moxey (New York: Polity Press, 1991), 233. I think Wollheim's argument, particularly in its last parts, allows for both positions. In this book I try to show how to move between both positions when examining "the artist."

10. Wollheim, *Art and Its Objects*, 152.

11. Hegel, *Philosophy of Fine Art*, 21.

12. See my article on this phenomenon, "*Lives* of Poets and Artists in the Renaissance," *Word and Image* 6 (April–June 1990): 154–62.

13. I therefore must reject the statements often made about nineteenth-century biographies of artists or about the Romantic view of the artist in the nineteenth century that the view of the artist found then is indigenous and unique to that time and place; for example, see Nicholas Green, "Dealing in Temperaments: Economic Transformation of the Artistic Field in France during the Second Half of the Nineteenth Century," *Art History* 10 (March 1987): 69. The concept and the form in which the concept is expressed emerged together in the Early Modern period, as I argue at length in chapters 1 and 2. In this sense, although I agree with Ira Nadel's desire to locate both fiction and fact in the form of biography, I cannot accept a delineation of this problem as due to the rise of the latter in the Enlightenment and the preeminence of the former beginning with John Gibson Lockhart's *Scott* (1837–38); see Ira Bruce Nadel, *Biography: Fiction, Fact and Form* (New York: St. Martin's Press, 1984), 1–12. For further support of my point here concerning the artist in the discourse of biography, see the interesting remarks by Martin Kemp on the role of biography in art history, "Lust for Life: Some Thoughts on the Reconstruction of Artists' Lives in Fact and Fiction," in *L'Art et les Révolutions*, XXVIIe Congrès International d'Histoire de l'Art (Strasbourg: Société Alsacienne pour le Développement de l'Histoire de l'Art, 1992), 183.

14. Nahm, *Artist as Creator*, 327.

15. Charles Dempsey, *Annibale Carracci and the Beginnings of Baroque Style* (Glückstadt: J. J. Augustin Verlag, 1977), 70.

16. In light of this tradition, it is illustrative to consider that when the contemporary artist Barbara Kruger writes her art, or uses political slogans, produced with the aid of stencil or mass-printing techniques, in exhibition spaces formerly designated for purely visual objects or works, she breaks down this object-artist binary in significant ways. She not only changes the terms for which we have to judge the individual artist by using mass-production printing techniques and words instead of "handmade" images, she also removes the artist from the realm of expressivity. She is therefore removed from the realm of judgment, or at least from the terms of judgment formerly used to judge the work of art. Consequently, other terms of judgment must prevail. One of these will be whether or not the viewer agrees with the politics of the messages that the words convey.

17. Immanuel Kant, *Critique of Judgment*, trans. J. H. Bernard (New York: Macmillan, 1951), 150–51.

18. Dempsey, *Annibale Carracci*, 71.

19. In a valuable book, *The Critical Historians of Art* (New Haven: Yale University Press, 1982), Michael Podro makes the argument through an investigation of the major art historians of the nineteenth and early twentieth centuries that the foundations of art history are historicist. See also my essay "Historicism in Art History," in *The Encyclopedia of Aesthetics*, ed. Michael Kelly (New York: Oxford University Press, forthcoming).

20. E. T. A. Hoffmann, "Beethovens Instrumentalmusik," *Musikalische Novellen und Aufsätze*, i, ed. E. Istel (Regensburg, 1919), 69, quoted in Lydia Goehr, *The Imaginary Museum of Musical Works: An Essay in the Philosophy of Music* (Oxford: Clarendon Press, 1992), 1.

21. On this bust and the work of the great anatomist His, see Hugo Kurz, *Wilhelm His (Basel und Leipzig): Seine Beiträge zur Weltgeltung der Anatomie im 19. Jahrhundert* (Basel: Anatomisches Institut der Universität Basel, 1992). I am grateful to the museum for their generosity in providing me with a photograph of the bust and the pamphlet on His. It is not unusual to find that the allusions in the passage on Beethoven are to painting, or that the *Bust of Bach* relies on theories of visual representation for its recovery of Bach's genius. Early nineteenth-century music criticism relied on the most prominent and preexistent representations of the artist to construct ideas about musicians, particularly composers. These were textual and visual representations of the visual artist that had circulated in European culture since the fifteenth century.

22. Filippo Baldinucci, *Life of Gianlorenzo Bernini*, trans. Catherine Enggass (University Park: Pennsylvania State University Press, 1966), 28.

23. Michael Ann Holly calls this place where the artist is located an "in-between realm," although she locates in that realm only "our words and those images from the past" and not the artist; see her "Writing Leonardo Backwards," *New Literary History* 23 (1992): 173–211.

24. On *doxa*, see Roland Barthes, *Roland Barthes by Roland Barthes*, trans. Richard Howard (New York: Farrar, Straus and Giroux, 1977), 47. The definition appears there under the heading, "*L'arrogance* – Arrogance: The *Doxa* (a word which will often recur) is Public Opinion, the mind of the majority, petit bourgeois Consensus, the Voice of Nature, the Violence of Prejudice. We can call (using Leibnitz's word) a *doxology* any way of speaking adapted to appearance, to opinion, or to practice."

25. Hayden White, "The Fictions of Factual Representation," in *Tropics of Discourse: Essays in Cultural Criticism* (Baltimore: Johns Hopkins University Press, 1978), 126.

26. I take the inaugural text of "the New Art History" to be key in establishing the beginning of a necessarily polemical self-critique, at least in the English-speaking context; see Timothy J. Clark, "The Conditions of Artistic Creation," *Times Literary Supplement*, May 24, 1974, 561–62. To give a complete list of these self-critiques here is impossible, but it is worth noting that most of them come out of a British Marxist position or from American scholars who are sympathetic to that position. This is not to say that they are entirely homogeneous or that they embody a dominant method or system of thought regarding the visual. In fact, this position has changed since 1980, so that now it could be said to be virtually in alignment with the approaches to culture found in contemporary cultural studies as it is practiced in the United States, particularly those approaches that are inflected by culture critiques from within the disciplines of sociology and anthropology and from the British Marxist perspective. A good history and synthesis of many of these more recent developments in art history can be found in Keith Moxey, *The Practice of Theory: Poststructuralism, Cultural Politics and Art History* (Ithaca: Cornell University Press, 1994). Some of the key texts in this self-critique have

been Norman Bryson, *Vision and Painting: The Logic of the Gaze* (New Haven: Yale University Press, 1983); Victor Burgin, *The End of Art Theory: Criticism and Postmodernity* (Atlantic Highlands, N.J.: Humanities Press International, 1986); Griselda Pollock, *Vision and Difference: Femininity, Feminism and the Histories of Art* (London: Routledge, 1988); John Tagg, *Grounds of Dispute: Art History, Cultural Politics and the Discursive Field* (London: Macmillan, 1992); Janet Wolff, *The Social Production of Art*, 2d ed. (Ann Arbor: University of Michigan Press, 1993). I see my project in this book as contributing to a critique, but I see my methods, in that they are historiographical, as essentially different from theirs. I do not reject art history.

27. "Guidelines for the 1996 Annual Conference," *Newsletter of the College Art Association* 19 (May/June 1994): 8.

28. Martin Jay, *Downcast Eyes: The Denigration of Vision in Twentieth-Century French Thought* (Berkeley, Los Angeles, London: University of California Press, 1993), 57.

29. Ibid., 57.

30. Arnaldo Momigliano, *The Development of Greek Biography* (Cambridge: Harvard University Press, 1971); Jerome Pollitt, *The Ancient View of Greek Art: Criticism, History, and Terminology* (New Haven: Yale University Press, 1974). A useful and comprehensive discussion of Pliny's writing on art and artists can now be found in Jacob Isager, *Pliny on Art and Society: The Elder Pliny's Chapters on the History of Art* (London: Routledge, 1991). See the important review by Alice Donohue, *Bryn Mawr Classical Review* 3 (1992): 192–97.

31. Friedrich Nietzsche, *On the Genealogy of Morals and Ecce Homo*, ed. Walter Kaufmann, trans. Walter Kaufmann and R. J. Hollingdale (New York: Random House, 1969), 77. This passage appears in section 12 of *On the Genealogy of Morals*, titled " 'Guilt,' 'Bad Conscience' and the Like."

32. Thomas J. Heffernan, *Sacred Biography: Saints and Their Biographers in the Middle Ages* (New York: Oxford University Press, 1988), 18.

33. Michel Foucault, *The Archaeology of Knowledge*, trans. A. M. Sheridan Smith (London: Tavistock Publications, 1972), 25.

34. Ibid., 25.

35. For the most coherent articulation of this "lack" that the image of the artist fills and that is infinitely replaceable by another artist in the same image, see Mikkel Borch-Jacobsen, *The Freudian Subject* (Stanford: Stanford University Press, 1988).

36. The definition of historicism is very complex but to begin, see Raymond Williams, *Keywords: A Vocabulary of Culture and Society*, rev. ed. (New York: Oxford University Press, 1983), 147: "Historicism, as it has been used in mC20, has three senses: (i) a relatively neutral definition of a method of study which relies on the facts of the past and traces precedents of current events; (ii) a deliberate emphasis on variable historical conditions and contexts, through which all specific events must be interpreted; (iii) a hostile sense, to attack all forms of interpretation or prediction by 'historical necessity' or the discovery of general 'laws of historical development' (cf. Popper)." See also what follows immediately here on Gombrich and Popper.

37. E. H. Gombrich, *Art and Illusion: A Study of the Psychology of Pictorial Representation* (Princeton: Princeton University Press, 1960), x.

38. E. H. Gombrich with Didier Eribon, *Looking for Answers: Conversations on Art and Science* (New York: Abrams, 1993), 121–27.

39. Karl R. Popper, *The Poverty of Historicism* (1957; New York: Harper and Row, 1964).

40. This argument is for the most part implicit in *Art and Illusion*. It is made overtly and strongly in Gombrich's contemporaneous essay, "Psycho-Analysis and the History

of Art" (1953) in *Meditations on a Hobby Horse and Other Essays on the Theory of Art* (Chicago: University of Chicago Press, 1963), 30–44.

41. A persuasive analysis of Gombrich's argument and its centrality for art history has been made by Norman Bryson in *Vision and Painting*. My view of Bryson's critique can be found in the last chapter of this book.

42. Carlo Ginzburg, "From Aby Warburg to E. H. Gombrich: A Problem of Method," in *Clues, Myths, and the Historical Method*, trans. John and Anne C. Tedeschi (Baltimore: Johns Hopkins University Press, 1989), 17–59.

43. William K. Wimsatt Jr. and Monroe C. Beardsley, "The Intentional Fallacy," in *The Verbal Icon: Studies in the Meaning of Poetry* (Lexington: University of Kentucky Press, 1954).

44. Thomas Kuhn, *The Structure of Scientific Revolutions*, 2d ed. (Chicago: University of Chicago Press, 1970), 1.

45. I take the work of Edgar Wind and the history of its reception to be symptomatic of the approaching paradigm shift; see Edgar Wind, *Art and Anarchy*, 3d ed. (Chicago: Northwestern University Press, 1985); and Edgar Wind, *The Eloquence of Symbols: Studies in Humanist Art*, ed. Jaynie Anderson (Oxford: Clarendon Press, 1983).

# 1 / On the Threshold of Historiography

1. On Cellini's *Autobiography* and its place in the interpretation of the artist and in art history, see the introduction by Charles Hope in Benvenuto Cellini, *The Autobiography of Benvenuto Cellini*, ed. and abr. Charles Hope and Alessandro Nova, trans. John Addington Symonds (Oxford: Phaidon, 1983), 7–13. I am grateful to Charles Hope for his encouragement early in this project. On early interviews with Picasso and their importance in the understanding of him and his work, see Lydia Gassman, "Mystery, Magic and Love in Picasso 1925–1938: Picasso and the Surrealist Poets" (Ph.D. diss., University of Virginia, 1981). On autobiography in general, the major study remains Georg Misch, *Geschichte der Autobiographie*, 8 vols. (Bern and Frankfurt: G. Schulte-Bulmke, 1949–69). See also the fundamental studies by K. Weintraub, *The Value of the Individual: Self and Circumstance in Autobiography* (Chicago: University of Chicago Press, 1978); *Autobiography: Essays Theoretical and Critical*, ed. James Olney (Princeton: Princeton University Press, 1980); Philippe Lejeune, *On Autobiography*, trans. Katherine Leary, ed. Paul John Eakin (Minneapolis: University of Minnesota Press, 1989).

2. Giorgio Vasari, *Lives of the Most Eminent Painters, Sculptors and Architects*, trans. Gaston du C. De Vere (London: Macmillan and Medici Society, 1912–15; reprint, New York: AMS Press, 1976), 1: xxiii–xxiv. I use this translation throughout as it is the best and is available in most good libraries.

3. Michael Baxandall, *Patterns of Intention: On the Historical Explanation of Pictures* (New Haven: Yale University Press, 1985). An excellent recent assessment of the problems associated specifically with autobiography, the concept of the self's consciousness, and the position of these in texts and documentary film can be found in Jim Lane, "Notes on Theory and Autobiographical Documentary Film in America," *Wide Angle* 15 (July 1993): 21–35.

4. Joseph Koerner's fine book on Dürer is an excellent example of the use of the self-portrait used to illuminate the artist and his work; see Joseph Leo Koerner, *The Moment of Self-Portraiture in German Renaissance Art* (Chicago: University of Chicago Press, 1993). See also Michael Levy, *The Painter Depicted: Painters as a Subject in Painting* (London: Thames and Hudson, 1981), for an excellent if too brief examination of the subject of the artist represented visually.

5. Bernard Williams, *Problems of the Self: Philosophical Papers 1956–1972* (Cambridge: Cambridge University Press, 1973), 1–10.

6. Stephen Greenblatt, *Renaissance Self-Fashioning from More to Shakespeare* (Chicago: University of Chicago Press, 1980). For a recent and illuminating discussion of the formation of the self in the Early Modern period, especially in discursive contexts, see Timothy Hampton, *Writing from History: The Rhetoric of Exemplarity in Renaissance Literature* (Ithaca, N.Y.: Cornell University Press, 1990), 8–30.

7. Harry Berger has argued along these lines; "Fictions of the Pose: Facing the Gaze in Early Modern Portraiture," *Representations* 46 (summer 1994), 87–120.

8. Ernst Kris and Otto Kurz, *Legend, Myth, and Magic in the Image of the Artist: A Historical Experiment* (New Haven: Yale University Press, 1979), 132: "Biographical formula and life appear to be linked in two ways. Biographies record typical events, on the one hand, and thereby shape the typical fate of a particular professional calling, on the other hand. The practitioner of the vocation to some extent submits to this typical fate or destiny. This effect relates by no means exclusively, or indeed primarily, to the conscious thought and behavior of the individual—in whom it may take the form of a particular 'code of professional ethics'—but rather to the unconscious. The area of psychology to which we point may be circumscribed by the label of 'enacted biography.'" A complete discussion of this concept follows here in chapter 5.

9. Janet Malcolm, "Forty-One False Starts," *The New Yorker*, July 11, 1994, 68.

10. See especially the essays in *The Rhetorics of Life-Writing in Early Modern Europe: Forms of Biography from Cassandra Fedele to Louis XIV*, ed. Thomas F. Mayer and D. R. Woolf (Ann Arbor: University of Michigan Press, 1995). This book appeared after I had written this book, but I have tried to account for its importance here.

11. On Komar and Melamid and other artists concerned with the fabrications of artistic identity, see the catalogue for the exhibition curated and edited by Karen Moss, *Altered Egos*, Santa Monica Museum of Art, 1994.

12. Pierre Bourdieu's understanding of the proper name of the artist as the "constant" in the social identity of the biographical subject, particularly in all institutional and official contexts, provides a useful elaboration of my point here; see Pierre Bourdieu, "L'Illusion Biographique," *Actes de la Recherche en Sciences Sociales* 63 (June 1986): 70–71.

13. Vasari, *Lives*, 9: 4. See my article on the imitation of the name and artistic persona of Michelangelo by the seventeenth-century artist Gianlorenzo Bernini, "Imitatio Buonarroti," *Sixteenth Century Journal* 20 (winter 1989): 582–602. Paul Barolsky, *Why Mona Lisa Smiles and Other Tales by Vasari* (University Park: Pennsylvania State University Press, 1991), elaborates on the many instances in Vasari where the naming and names of artists play a central part in the typology of the book. See also later in this chapter.

14. Hayden White, *Tropics of Discourse: Essays in Cultural Criticism* (Baltimore: Johns Hopkins University Press, 1978), 4: "Considered as a genre, then, discourse must be analyzed on three levels: that of the description (mimesis) of the 'data' found in the field of inquiry being invested or marked out for analysis; that of the argument or narrative (diegesis), running alongside of or interspersed with the descriptive materials; and that on which the combination of these previous two levels is effected (diataxis)."

15. Domenico Bernini, *Vita del Cavalier Gio. Lorenzo Bernino* (Rome, 1713). This book is exceedingly rare. It has never been translated or issued in another edition. A partial translation and discussion of it can be found in *Bernini in Perspective*, ed. George C. Bauer (Englewood Cliffs, N.J.: Prentice Hall, 1976), 1–41.

16. On this issue see Cesare d'Onofrio, "Priorità della biografia del Dom. Bernini su quello del Baldinucci," *Palatino* 10 (1966): 201–8.

17. On the literature on Gianlorenzo Bernini, see my "Critical Topoi in the Sources on the Life of Gianlorenzo Bernini" (Ph.D. diss., Bryn Mawr College, 1982).

18. Eric Cochrane, *Historians and Historiography in the Italian Renaissance* (Chicago: University of Chicago Press, 1981).

19. Julius von Schlosser, *Die Kunstliteratur: Ein Handbuch zur quellenkunde der neuerren Kunstgeschichte* (Vienna: Anton Schroll, 1924); Julius von Schlosser, *La letteratura artistica: Manuale delle fonti della storia dell'arte moderna*, trans. Filippo Rossi (Florence: La Nuova Italia, 1964).

20. Tzvetan Todorov, *Genres in Discourse*, trans. Catherine Porter (Cambridge: Cambridge University Press, 1990), 1–12. This book appeared in French in 1978. See the discussion of Todorov and other issues raised here about genre by Adena Rosmarin, *The Power of Genre* (Minneapolis: University of Minnesota Press, 1985). Terry Eagleton made the same point about "Literature" in his essay "What Is Literature?" in Terry Eagleton, *Literary Theory: An Introduction* (Minneapolis: University of Minnesota Press, 1983), 1–16.

21. Todorov, *Genres in Discourse*, 13.

22. Walter Benjamin, *The Origin of German Drama*, trans. John Osborne (London: Verso, 1977), 44. I am grateful to James Clifford for this reference.

23. Victor Shklovsky, "Art as Technique," in *Russian Formalist Criticism: Four Essays*, trans. Lee T. Lemon and Marion J. Reis (Lincoln: University of Nebraska Press, 1965), 24.

24. Immanuel Kant, *Critique of Judgment*, trans. J. H. Bernard (New York: Macmillan, 1951), 150–51.

25. Jacques Derrida, "La loi du genre/The Law of Genre," *Glyph* 7 (1980), 221.

26. Lejeune, *On Autobiography*, 154.

27. The best discussion of this tension in the genre of biography is James Clifford, " 'Hanging Up Looking Glasses at Odd Corners': Ethnobiograpical Prospects," in *Studies in Biography* (Harvard English Studies 8), ed. Daniel Aaron (Cambridge: Harvard University Press, 1978), 41–56.

28. Francis Cairns, *Generic Composition in Greek and Roman Poetry* (Edinburgh: Edinburgh University Press, 1972), 70.

29. This is not the conclusion reached by Dudley Andrew, who otherwise provides an interesting survey of the genre-*auteur* nexus in film theory; see Dudley Andrew, *Concepts in Film Theory* (Oxford: Oxford University Press, 1984), 107-32. See also the important review of this book by Bill Nichols in *Film Quarterly* 39 (winter 1985): 56–61.

30. Bill Nichols, *Movies and Methods: An Anthology* (Berkeley, Los Angeles, London: University of California Press, 1976), 108.

31. Andrew Sarris, *The American Cinema: Directors and Directions 1929–1968* (New York: E. P. Dutton, 1968), 30.

32. See, however, Carl Goldstein, "Rhetoric and Art History in the Italian Renaissance and Baroque," *Art Bulletin* 73 (December 1991): 646–47; Goldstein attempts to outline the aspects of early artists' *Lives*.

33. Thomas Luckmann, "The Constitution of Human Life in Time," in *Chronotypes: The Construction of Time*, ed. John Bender and David E. Wellbery (Stanford: Stanford University Press, 1991), 161.

34. Svetlana Alpers, "Ekphrasis and Aesthetic Attitudes in Vasari's *Lives*," *Journal of the Warburg and Courtauld Institutes* 23 (1960): 190–215; Mark Jarzombek, *On Leon Battista Alberti: His Literary and Aesthetic Theories* (Cambridge: MIT Press, 1989).

35. Richard A. Lanham, *A Handlist of Rhetorical Terms*, 2d ed. (Berkeley, Los Angeles, Oxford: University of California Press, 1991).

36. Giovanni Pietro Bellori, *Le vite de' pittori, scultori et architetti moderni* (fasc. ed., Rome: 1672; New York: Broude International Editions, 1980), 33–65.

37. Catherine M. Soussloff, "Old Age and Old-Age Style in the *Lives* of Gianlorenzo Bernini," *Art Journal* 46 (summer 1987): 115–21.

38. Catherine M. Soussloff, "*Lives* of Poets and Painters in the Renaissance," *Word and Image* 6 (April-June 1990): 154–62.

39. Victoria Kirkham, "The Parallel Lives of Dante and Virgil," *Dante Studies* 10 (1992): 233–53. See also Goldstein, "Rhetoric and Art History in the Italian Renaissance and Baroque."

40. Saul A. Kripke, *Naming and Necessity* (Cambridge: Harvard University Press, 1980). On naming in Vasari's *Lives*, see Barolsky, *Why Mona Lisa Smiles and Other Tales by Vasari*, 39–56. Barolsky covers many important topics in this book, but his approach is simply to survey Vasari for common and interesting tropes. I am grateful to him for encouragement in my project.

41. I am grateful to Martin Scorsese for permission to use the unpublished screenplay of *Life Lessons* by Richard Price. I am grateful to Annette Insdorf for her help in obtaining this permission.

42. Vasari, *Lives*, 9: 4.

43. The early biographies of saints were also important models for the Renaissance *Lives* of the artist, at least tropologically. For the *Lives* of saints and their generic structure, see the important study by Thomas J. Heffernan, *Sacred Biography: Saints and Their Biographers in the Middle Ages* (New York: Oxford University Press, 1988).

44. Richard Price, *Life Lessons*, unpublished screenplay, 40.

45. The reference to a self-portrait of Michelangelo in the *Florentine Pietà* is first made by Vasari after Michelangelo's death, and therefore long after he stopped working on the sculpture, in a letter to Lionardo Buonarroti; see Soussloff, "Old Age and Old-Age Style," 121 nn. 39, 41.

46. Ernst Steinmann, *Die Portraitdarstellungen des Michelangelo* (Leipzig: Klinkhardt & Bierman, 1913); see also Ernst Steinmann, *Michelangelo in Spiegel seiner Zeit* (Leipzig: Poeschel & Treptel, 1930).

47. Vasari, *Lives*, 9: 124.

48. Ibid., 9: 125. For a thorough discussion of all of the literature on Michelangelo's death and funeral, see Rudolf and Margot Wittkower, *The Divine Michelangelo: The Florentine Academy's Homage on His Death in 1564 A Facsimile Edition of "Esequie del Divino Michelangnolo Buonarroti," Florence, 1564* (London: Phaidon, 1964). Note should also be made here of the book by these same authors on the artist, which deals with some of the issues raised here: Rudolf and Margot Wittkower, *Born under Saturn: The Character and Conduct of Artists: A Documented History from Antiquity to the French Revolution* (New York: Norton, 1969).

49. Price, *Life Lessons*, 39–40. This is another example of the cultural "given" that the artist is always gendered male.

50. Henry George Liddel and Robert Scott, *A Greek-English Lexicon* (Oxford: Oxford University Press, 1968), 316. Another, and for the most part complementary, account of early biography has appeared recently; see the excellent introduction by Mayer and Woolf in *The Rhetorics of Life-Writing*, 1–37.

51. The best study of the eighteenth-century English context of biography is William Dowling, *Language and Logos in Boswell's Life of Johnson* (Princeton: Princeton University Press, 1981).

52. On this point I concur with a major argument of Raymond Williams, *Culture and Society: 1780–1950* (Harmondsworth: Penguin, 1963).

53. Sarah Franklin, "Life," unpublished essay, 3. I appreciate the generosity of Sarah Franklin for sharing her unpublished work with me.

54. I use the term *purposive* deliberately as this is the term used by Kant when he speaks of the teleological judgment in his *Critique of Judgment*. Kant's book appeared at the end of a century's worth of scientific theory regarding the definition of what it means to be "human."

55. Franklin, "Life," 3. Franklin writes: "The sacred act of divine creation which brought life into being was, in this schema, paralleled by the secular production by natural philosophers, such as Linnaeus, of a classification system through which life forms were named, defined and ordered according to their perceived nature, which was seen to be immutable."

56. Kant, *Critique of Judgment*, 151.

57. Most useful of these remain Donald Stauffer, *English Biography before 1700* (Cambridge: Harvard University Press, 1930); J. A. Garraty, *The Nature of Biography* (New York: Knopf, 1957); and more recently Heffernan, *Sacred Biography*; and Mayer and Woolf, *The Rhetorics of Life-Writing*.

58. Timothy Hampton, *Writing from History: The Rhetoric of Exemplarity in Renaissance Literature* (Ithaca, N.Y.: Cornell University Press, 1990). Exemplarity, particularly as understood by Hampton, has also been seen as central to early biography by Mayer and Woolf; see *The Rhetorics of Life-Writing*, 1–37.

59. Hampton, *Writing from History*, 30.

60. Michael Holquist, "From Body-Talk to Biography: The Chronobiological Bases of Narrative," *Yale Journal of Criticism* 3 (1989): 20. I am grateful to Michael Holquist for discussing aspects of biography with me at an early stage of my research.

61. Ibid., 20.

62. Arnaldo Momigliano, *The Development of Greek Biography* (Cambridge: Harvard University Press, 1971), 12.

63. Bruno Gentili and Giovanni Cerri, *History and Biography in Ancient Thought* (Amsterdam: J. C. Gieben, 1988).

64. Ibid., 61–85.

65. Ibid., 63,

66. Vasari, *Lives*, 2: 78.

67. Hampton, *Writing from History*, 298.

68. Holquist, "From Body-Talk to Biography," 20–21.

69. Soussloff, "Poets and Painters," 158.

70. Luigi Lanzi, *The History of Painting in Italy: From the Period of the Revival of the Fine Arts to the End of the Eighteenth Century*, trans. Thomas Roscoe (London: Henry G. Bohn, 1847), 1: 11. These are the opening lines of Lanzi's preface.

# 2 / The Artist in Nature

1. On the dating of the Boccaccio *Life* of Dante, see Giovanni Boccaccio, "Trattatello in Laude di Dante," ed. Pier Giorgio Ricci, in vol. 3 of *Tutte le opere di Giovanni Boccaccio*, ed. Vittore Branca (Milan: Mondadori, 1974), 425–35.

2. Wilhelm Dilthey, *Gesammelte Schriften* (Stuttgart: B. G. Teubner, 1960), 11: 70–76; translation mine. Dilthey's review of Jacob Burckhardt's book on the Renaissance, from which this phrase is taken, will be discussed at length in the following chapter.

3. Nicole Loraux, *The Children of Athena: Athenian Ideas about Citizenship and the Division between the Sexes*, trans. Caroline Levine (Princeton: Princeton University

Press, 1993). I am grateful to my colleague Karen Bassi for her discussion of the topic of autochthony.

4. Hubert Damisch, *The Origin of Perspective*, trans. John Goodman (Cambridge: MIT Press, 1994).

5. In my thinking here, I am indebted to the work of Carlos J. Alonso, *The Spanish American Regional Novel: Modernity and Autochthony* (Cambridge: Cambridge University Press, 1990). See also Roberto Gonzalez Echevarria, *Myth and Archive: A Theory of Latin American Narrative* (Cambridge: Cambridge University Press, 1990).

6. Jorge Luis Borges, "El escritor Argentino y la tradición," in *Discusión* (Buenos Aires: Emecé, 1974), 151–62. See Alonso's discussion of Borges in the introduction to *The Spanish American Regional Novel*. See also Jorge Luis Borges, "Tlon, Ggbar, Orbius Tertius," in *Labyrinths* (New York: New Directions, 1962).

7. For a good recent discussion of the terms *hybrid* and *hybridity* and the problems associated with them in cultural criticism, see Ella Shohat and Robert Stam, *Unthinking Eurocentrism* (London: Routledge, 1994), 40–43.

8. Carlo Dionisotti, "Dante nel Quattrocento," in *Atti del Congresso Internazionale dei Studi Danteschi* (Florence: Sansoni, 1965), 373–75.

9. Boccaccio, "Trattatello in Laude di Dante," 442, paragraph 19.

10. J. R. Smith, *The Earliest Lives of Dante* (1901; reprint, New York: Harper & Row, 1972), 15. I prefer this translation, but see for comparison Giovanni Boccaccio, *The Life of Dante (Trattatello in Laude di Dante*, trans. Vincenzo Zin Bollettino (New York: Garland, 1990), 8: "This was that Dante who gave purpose to this commentary. This was that Dante who was granted special grace by God in our times. This was that Dante who was the first person to prepare the way for the return of the Muses, who had been exiled from Italy. It is his great works that lend nobility to the Florentine language, and it is because of him that the beauty of our vernacular poetry received its proper rhyme and meter. Because of him it can also justly be said that poetry was brought back to life from death. All these things, when duly considered, will show that he could not have carried any other name but that of Dante [The Giver], a most deserved reputation."

11. *Le Opere di Giorgio Vasari*, ed. Gaetano Milanesi (Florence: Sansoni, 1981), 1: 369. It is interesting to note that the first edition of Vasari, dated 1550, does not include imitation in the assessment of Giotto's contribution: "Quello obligo istesso, che hanno gli artefici pittori alla Natura, la quale continuamente per essempio serve a quegli, che cavando il buono da le parti di lei piu mirabili & belle, di contrafar la sempre s'ingegnano; il medesimo si deve avere a Giotto"; Giorgio Vasari, *Le Vite de Piu Eccellenti Architetti, Pittori, et Scultori Italiani* (fasc. ed., Florence, 1550; New York: Broude, 1980), 1: 138.

12. Giorgio Vasari, *Lives of the Most Eminent Painters, Sculptors and Architects*, trans. Gaston du C. De Vere (London: Macmillan and Medici Society, 1912–15; reprint, New York: AMS Press, 1976), 1: 71.

13. See, for example, Milanesi, ed., *Le Opere di Giorgio Vasari*, 1: 372: "Il quale, fra gli altri, ritrasse, come ancor oggi si vede, nella cappella del palagio del Podestà di Firenze, Dante Alighieri, coetaneo ed amico suo grandissimo, e non meno famoso poeta che si fusse nei medesimi tempi Giotto pittore; tanto lodato da messer Giovanni Boccaccio nel proemio della novella di messer Forese da Rabatta e di esso Giotto dipintore."

14. The literature on Dante in the Renaissance is now enormous. For an excellent recent assessment of the criticism and bibliography, see Deborah Parker, *Commentary and Ideology: Dante in the Renaissance* (Durham, N.C.: Duke University Press, 1993). See also notes following here.

15. On Dante, Virgil, and Boccaccio, see the important article by Victoria Kirkham, "The Parallel Lives of Dante and Virgil," *Dante Studies* 110 (1992): 233–53.

16. Boccaccio's *Life of Dante* may have preceded his famous lectures on the *Divine Comedy*, which were commissioned by the Florentine Commune; see my article, "*Lives* of Poets and Painters in the Renaissance," *Word and Image* 6 (April–June 1990): 157. Vasari's book was dedicated to Cosimo de' Medici.

17. For the texts of the *Lives* of the Three Crowns of Florence, see A. Solerti, *Le Vite di Dante, del Petrarca e del Boccaccio scritte fino al secolo decimosettimo* (Milan: Vallardi, 1904–05). For translations of some of these early *Lives* and an excellent introduction to the genre, see *The Three Crowns of Florence: Humanist Assessments of Dante, Petrarch, and Boccaccio*, trans. and ed. D. Thompson and A. F. Nagel (New York: Harper and Row, 1972).

18. Martin Kemp, "The Mean and Measure of All Things," in *Circa 1492*, ed. Jay A. Levenson (Washington, D.C.: National Gallery of Art; New Haven: Yale University Press, 1991), 97.

19. Parker, *Commentary and Ideology*, 92–93.

20. T. S. R. Boase, *Giorgio Vasari: The Man and the Book* (Princeton: Princeton University Press, 1979), 43–72.

21. Milanesi, ed., *Le Opere di Giorgio Vasari*, 1: 372.

22. See Laura Corti, *Vasari: Catalogo completo dei dipinti* (Florence: Cantini, 1989), 49.

23. On the relationship of Vasari to these poets and the Tuscan language, see the excellent article by Edgar Peters Bowron, "Giorgio Vasari's 'Portrait of Six Tuscan Poets,'" *Minneapolis Institute of Arts Bulletin* 60 (1978): 43–51.

24. I base this assertion on Lorenzo Ghiberti's *Life* of Giotto in the *Commentarii*, written around 1440: Lorenzo Ghiberti, *I Commentarii*, ed. Ottavio Morisani (Naples: Riccardo Ricciardi, 1947), 33–34.

25. Milanesi, ed., *Le Opere di Giorgio Vasari*, 1: 399: "Doveva questo campanile, secondo il modello di Giotto, avere per finimento sopra quello che si vede, una punta ovvero piramide quadra alta braccia cinquanta; ma, per essere cosa tedesca e di maniera vecchia, gli architettori moderni non hanno mai se non consigliato che non si faccia, parendo che stia meglio così. Per le quali tutte cose fu Giotto non pure fatto cittadino fiorentino, ma provvisionato di cento fiorini d'oro l'anno dal Commune di Firenze, ch'era in que'tempi gran cosa; e fatto provveditore sopra questa opera, che fu seguitata dopo lui da Taddeo Gaddi, non essendo egli tanto vivuto che la postesse vedere finita."

26. See the part-title page of the facsimile edition of Robert Herrick, *Hesperides or the Works Both Divine and Human 1648* (Menston, Yorkshire and London: Scolar Press Ltd., 1969; reprint, 1973), 399. I am grateful to Michael Warren for this reference.

27. I owe this observation to Clark Hulse, *The Rule of Art: Literature and Painting in the Renaissance* (Chicago: University of Chicago Press, 1990), 38. Hulse explores the implications of *ut pictura poesis* in many more aspects than I do here, and his book provides an excellent background to the more specific glosses of the Renaissance literature undertaken here.

28. Horace, *His Art of Poetrie*, trans. Ben Jonson (1640), vol. 8 of *Ben Jonson*, ed. C. H. Herford and Percy and E. Simpson (Oxford: Clarendon, 1925–52), 309. Compare the Loeb translation: "Many terms that have fallen out of use shall be born again, and those shall fall that are now in repute, if Usage so will it, in whose hands lie the judgement, the right and the rule of speech. In what measure the exploits of kings and captains and the sorrows of war may be written, Homer has shown. Verses yoked unequally first embraced lamentation, later also the sentiment of granted prayer: yet who first put forth humble elegiacs, scholars dispute, and the case is still before the courts" (1: 71–81) (Horace, *Satires, Epistles and Ars Poetica*, trans. H. Rushton Fairclough [London: William Heinemann; New York: G. P. Putnam, 1926], 457).

29. Boccaccio's understanding of Dante's contribution to poetry in the vernacular was sanctioned by and mediated through Horace's claims for poetry. Three of the claims made for Dante by Boccaccio are present in the Horatian texts. These are (1) that Dante revived dead poesy (the correlative here is that dead poesy is revivable, an important belief in any conception of a renaissance), (2) that the distinguishing character of Dante's revival and poetry was that he set the vernacular to a true and just measurement, and (3) that this kind of measurement is based on a theory of imitation.

30. Rensselaer W. Lee, *Ut Pictura Poesis: The Humanistic Theory of Painting* (New York: W. W. Norton, 1967), 3–9. Boccaccio could not have known the Aristotle.

31. Ibid., 5–6.

32. Dilthey, *Gesammelte Schriften*, 11: 76; translation mine.

33. The best English translation of Bruni's biography of Dante remains James Robinson Smith, *The Earliest Lives of Dante* (1901; reprint, New York: Russell & Russell, 1968), 81–95; for the Latin, see Solerti, *Le vite di Dante, del Petrarca e del Boccaccio*, 97–107; and most recently, Leonardo Bruni, *Le vite di Dante e del Petrarca*, ed. Antonio Lanzo (Roma: Guido Izzi, 1987), 31–52.

34. Edward Moore, *Dante and His Biographers* (1889; reprint, New York: Haskell House, 1970), 77.

35. Smith, *The Earliest Lives of Dante*, 91.

36. Ibid., 93. On Bruni on Dante's use of the volgare, see Moore, *Dante and His Biographers*, 78–80.

37. Hans Baron, *The Crisis of the Early Italian Renaissance: Civic Humanism and Republican Liberty in an Age of Classicism and Tyranny* (Princeton: Princeton University Press, 1966).

38. David Thompson's brief but excellent study of Landino's *Life* of Dante has been particularly useful in understanding his significance for the issues raised here; see David Thompson, "Landino's Life of Dante," *Dante Studies* 88 (1970), ed. Anthony Pellegrini, 119–27. I am grateful to my colleague Robert Durling for suggesting to me the significance of Landino in the history of the *Lives* of Dante.

39. See Parker, *Commentary and Ideology*, 142–44, on Manetti and Landino. For a bibliography on the Manetti illustrations, see 213–14 n. 50.

40. Vasari, *Lives*, 2: 199.

41. Boase, *Giorgio Vasari*, 43–44. David Cast is completing a book that will examine the significance of this dinner in greater detail.

42. On this, see Norman Bryson, *Vision and Painting: The Logic of the Gaze* (New Haven: Yale University Press, 1983).

43. Julius von Schlosser, "On the History of Art Historiography—'The Gothic,'" in *German Essays on Art History*, ed. Gert Schiff (New York: Continuum, 1988), 206–33.

44. Lee, *Ut Pictura Poesis*, 9–10.

45. Understood in this way, we can overcome the perplexity Michael Baxandall expressed in the conclusion to his immensely valuable book *Giotto and the Orators* that the theoretical claims made for painting in this period appear so clearly to contradict the visual evidence of the paintings themselves. Baxandall's conclusions regarding the disjunction between theory and practice in the trecento rely on his sources, all of them in Latin. Mine rely on vernacular sources. See Michael Baxandall, *Giotto and the Orators: Humanist Observers of Painting in Italy and the Discovery of Pictorial Composition 1350–1450* (Oxford: Clarendon Press, 1988).

46. The date of Manetti's manuscript is problematic, although the authorship no longer seems to be in dispute. For a discussion of both, see the introduction by Howard Saalman to Antonio di Tuccio Manetti, *The Life of Brunelleschi*, trans. Catherine Enggass (University Park: Pennsylvania State University Press, 1970), 10–20; Saalman has

good reasons for dating it after 1482 and before 1489. More recently, Damisch (*The Origin of Perspective*, 66) accepts Tanturli's date of just after 1475; see Antonio Manetti, *Vita di Filippo Brunelleschi*, ed. Domenico Robertis and Giovanni Tanturli (Milan: Mondadori, 1976). Robert Klein dated it to 1480 (Klein, *Form and Meaning: Essays on the Renaissance and Modern Art*, trans. Madeline Jay and Leon Wieseltier [New York: Viking, 1979], 245 n. 3). Martin Kemp appears to accept Saalman's view of the date (Kemp, *The Science of Art: Optical Themes in Western Art from Brunelleschi to Seurat* [New Haven: Yale University Press, 1990], 9–15, 344–45). The date is not central to my argument, although its relationship to Landino's edition of Dante in my view would make an interesting reason for a close comparative reading of the two.

47. Manetti, *The Life of Brunelleschi*, ed. Howard Saalman, trans. Catherine Enggass, 42. The Italian is on the facing page 43.

48. Ibid., 42–43. In Italian: "ella è una parte di quella scienza che è in effetto porre bene e con ragione le diminuizionj e acrescimenti, che appaiono agli occhi degli huomini delle cose di lungi e d'apresso, casamenti, piani e montagnie e paesi d' ognj ragione e innognj luogo le figure e l' altre cose di quella misura che s' apartiene a quella distanza che le si mostrano di lungi."

49. Vasari, *Lives*, 1: 71.

50. On these panels, see Damisch, *The Origin of Perspective*, 169–447; and especially Kemp, "The Mean and Measure of All Things."

51. Damisch, in *The Origin of Perspective*, recognizes these panels and Brunelleschi to be foundational to the understanding of painting since the Renaissance.

52. Damisch states that Manetti's treatise was "unavailable to Vasari" (*The Origin of Perspective*, 66); Saalman in his introduction to Manetti, *The Life of Brunelleschi*, makes no statement about whether Vasari knew the Manetti biography, but he does state that Filippo Baldinucci relied on it heavily in his biography of the artist (8–9). Robert Klein appears to accept that Vasari knew the Manetti text (*Form and Meaning*, 130). Julius von Schlosser believes that Vasari knew the text without citing from it directly (*La letteratura artistica*, trans. Filippo Rossi, ed. Otto Kurz [Florence: La Nuova Italia Editrice, 1977], 115). Kemp, in *The Science of Art*, makes no statement about Vasari's knowledge of Manetti. Based not only on the *Life* of Brunelleschi by Vasari but also on his *Lives* of Giotto, Ghiberti, and Uccello, I have no doubt that he knew Manetti.

53. Marvin Trachtenberg, "What Brunelleschi Saw: Monument and Site at the Palazzo Vecchio in Florence," *Journal of the Society of Architectural Historians* 47 (March 1988): 42 n. 92. This is a fundamental article in my understanding of the significance of Brunelleschi's panels. See Damisch, *The Origin of Perspective*, 72 n. 36.

54. Kemp, *The Science of Art*, 14. Kemp makes the same point again regarding the close "links between perspective and the new conceptions of civic space" in one of his contributions to the exhibition catalogue *Circa 1492*, 100.

55. Trachtenberg, "What Brunelleschi Saw," 14–44.

56. Manetti, *Life of Brunelleschi*, 42–46.

57. Leonardo Bruni, "Panegyric to the City of Florence," trans. Benjamin G. Kohl, in *The Earthly Republic: Italian Humanists on Government and Society*, ed. Benjamin G. Kohl and Ronald G. Witt with Elizabeth Welles (Philadelphia: University of Pennsylvania Press, 1978), 175. To my knowledge, Kemp was the first to bring Bruni's text into discussions of Brunelleschi's panels and other city views; see Kemp, "The Mean and Measure of All Things," 98. The fundamental text for the Cathedral of S. Maria del Fiore and the history of the surrounding precinct is Howard Saalman, *Filippo Brunelleschi: The Cupola of Santa Maria del Fiore* (London: A. Zwemmer, 1980). Most recently, Mary Bergstein's conclusions in "Marian Politics in Quattrocento Florence:

The Renewed Dedication of Santa Maria del Fiore in 1412," *Renaissance Quarterly* 44 (winter 1991): 673–719, supports my view of the significance of Bruni's text and Brunelleschi's panels for determining Florentine views of self-representation in the context of the cathedral and baptistery at the beginning of the quattrocento.

58. Saalman, *Filippo Brunelleschi*, 205–12.

59. Leopold Ettlinger, "The Emergence of the Italian Architect during the Fifteenth Century," in *The Architect: Chapters in the History of the Profession*, ed. Spiro Kostof (New York: Oxford University Press, 1977), 96–123.

60. Vasari, *Lives*, 1: 220–21.

61. Ibid., 1: 197.

62. Bruni, *Panegyric to the City of Florence*, 174–75.

63. Trachtenberg, "What Brunelleschi Saw," 42.

64. Nicolai Rubenstein, "The Piazza della Signoria in Florence," in *Festschrift Herbert Siebenhuner*, ed. Erich Hubala and Guner Schweikhart (Würzburg: Ferdinand Schoningh, 1978), 26. Similarly, the demonstration panels give Damisch occasion to examine the genre of ideal cityscapes, to which he argues Brunelleschi's panels are precursors in terms that include considerations of rule, chauvinism, and the artist but using the categories of architecture, theater, and decoration. He considers these to be "distancing maneuvers." He appears to critique the causal connection implied by studies such as Rubenstein's or Trachtenberg's, while at the same time appreciating their usefulness to other approaches, including his own (*The Origin of Perspective*, 169–234). My reading of the demonstration panels is motivated by my reading of the texts; in this way it may be seen to be in concert with Damisch, particularly when he quotes Walter Benjamin: "For it is not a question of presenting works in correlation with their time, but rather, in the time in which they are born, of presenting the time that knows them" (as quoted in Damisch, *The Origin of Perspective*, 185).

65. Trachtenberg, "What Brunelleschi Saw," 42–43.

66. Samuel Y. Edgerton Jr., *The Renaissance Rediscovery of Linear Perspective* (New York: Basic Books, 1975). For a discussion of Edgerton's views, see Trachtenberg, "What Brunelleschi Saw," 43 n. 95.

67. Manetti, *Life of Brunelleschi*, 42–43.

68. Kemp, *The Science of Art*, 21–35.

69. Here I am indebted to Paul Bové's study of Erich Auerbach, *Intellectuals in Power: A Genealogy of Critical Humanism* (New York: Columbia University Press, 1986), 79–208. Auerbach's concept of Renaissance culture depends on Burckhardt in *The Civilization of the Renaissance in Italy*. From this understanding, I was led to consider Auerbach's assessment of Dante's use of mimesis in light of the arguments made here concerning the vernacular and the use of sources in Auerbach's method. This is a point that deserves further elaboration than I can provide here.

70. On the vernacular in the revival of a "literary" history, see M. L. McLaughlin, "Humanist Concepts of Renaissance in the Tre- and Quattrocento," *Renaissance Studies* 2 (October 1988): 131–42.

# 3 / The Artist in Culture

1. Aby Warburg on August 18, 1927, to his friend the Belgian art historian Jacques Mesnil; quoted and translated in E. H. Gombrich, *Aby Warburg: An Intellectual Biography* (Chicago: University of Chicago Press, 1986), 322.

2. Giorgio Vasari, *Lives of the Most Eminent Painters, Sculptors and Architects*,

trans. Gaston Du C. de Vere (London: Macmillan and Medici Society, 1912–15; reprint, New York: AMS Press, 1976), 1: xiii.

3. For a discussion of Winckelmann, see Alex Potts, *Flesh and the Ideal: Winckelmann and the Origins of Art History* (New Haven: Yale University Press, 1994). This chapter on Burckhardt was written before the publication of Potts's book. Although I agree with much of what Potts has written on Winckelmann, I argue throughout that "the origin of art history," if understood discursively and to be inclusive of art and artists, must be located in the Renaissance texts. Potts locates it in Winckelmann's work. A good review of the neoclassical and Romantic views of the artist, particularly in France, is found in Georges Matoré, "Les Notions d'art et d'artiste à l'epoque romantique," *Revue des Sciences Humaines* (1951): 120–37. See also the discussion of genius in chapter 1.

4. The following studies, particularly those of Courbet, attempt to define the role of the artist in the establishment of a new, "modern" social order, although they do so using different approaches. There are others that could be cited, but they essentially follow the outlines of inquiry and approaches established by these writers. Linda Nochlin, *Realism and Tradition in Art 1848–1900* (Englewood Cliffs, N.J.: Prentice-Hall, 1966); Linda Nochlin, *Realism* (Harmondsworth: Penguin, 1971); Timothy J. Clark, *Image of the People: Gustave Courbet and the 1848 Revolution* (London: Princeton University Press, 1973); Timothy J. Clark, *The Absolute Bourgeois: Artists and Politics in France 1848–51* (London: Princeton University Press, 1973); Timothy J. Clark, *The Painting of Modern Life: Paris in the Art of Manet and His Followers* (New York: Knopf, 1985); Michael Fried, "The Beholder in Courbet: His Early Self-Portraits and Their Place in His Art," *Glyph* 8 (1978): 85–129; Michael Fried, *Courbet's Realism* (Chicago: University of Chicago Press, 1990). See also the important essays in the exhibition catalogue by Sarah Faunce and Linda Nochlin, *Courbet Reconsidered* (Brooklyn: Brooklyn Museum, 1988).

5. Thus, in recent art history there has developed a large body of literature on the critical reception of these artists in their times, of which I cite only two important examples: George Heard Hamilton, *Manet and His Critics* (New Haven: Yale University Press, 1954); and Steven Z. Levine, *Monet and His Critics* (New York: Garland, 1976).

6. I am indebted to a lecture by Molly Nesbit, given at the DIA Foundation in November 1990 for this insight. See Molly Nesbit, "The Rat's Ass," *October* 56 (spring 1991): 7–20.

7. Martin Kemp, " 'Equal Excellences': Lomazzo and the Explanation of Individual Style in the Visual Arts," *Renaissance Studies* 1 (1987): 1.

8. Hayden White, *Metahistory: The Historical Imagination in Nineteenth-Century Europe* (Baltimore: Johns Hopkins University Press, 1973), 164, 167.

9. Ibid., 166. White is quoting here from Theodore M. von Laue, *Leopold Ranke: The Formative Years* (Princeton: Princeton University Press, 1950), 138.

10. Ernst Cassirer, "Force and Freedom: Remarks on the English Edition of Jacob Burckhardt's 'Reflections on History,' " *American Scholar* 13 (autumn 1944): 408.

11. White, *Metahistory*, 167. White's perceptions here about the contradiction in Ranke between narrative description and objectivity pertain to the writing about the function of narrative in literature and myth that was done in the 1960s by Emile Benveniste in the field of historical linguistics and by Claude Lévi-Strauss in the field of cultural anthropology; see Hayden White, "The Question of Narrative in Contemporary Historical Theory," in *The Content of the Form: Narrative Discourse and Historical Representation* (Baltimore: Johns Hopkins University Press, 1987), 216–17 n. 1.

12. Edward Burnett Tylor, *Primitive Culture: Researches into the Development of*

*Mythology, Philosophy, Religion, Language, Art and Custom* (1871; Boston: Estes-Lauriat, 1874).

13. For a succinct statement of the project of cultural studies today, see James Clifford, "The Transit Lounge of Culture," *Times Literary Supplement*, May 3, 1991, 7–8. Part of the appeal of and a warning against cultural studies as a field is that it has not yet been defined or delineated either disciplinarily or intellectually.

14. Raymond Williams, *Keywords: A Vocabulary of Culture and Society*, rev. ed. (New York: Oxford University Press, 1983), 87–93. For recent statements about the meaning of culture from a cultural studies perspective, see *Cultural Studies*, ed. Lawrence Grossberg, Cary Nelson, and Paula A. Treichler (New York: Routledge, 1992).

15. Thomas Mann, *Reflections of a Nonpolitical Man*, trans. Walter D. Morris (New York: Frederick Ungar, 1983). This book was first published in Berlin in 1918 with the title *Betrachtungen eines Unpolitischen*. I am indebted to Susan Sontag for reminding me of the importance of this essay for the understanding of *Kultur* and the artist.

16. On the critical practices of early art history, particularly in the German context, see Michael Podro, *The Critical Historians of Art* (New Haven: Yale University Press, 1982). See also Udo Kultermann, *The History of Art History* (n.p.: Abaris, 1993). For a discussion of the importance of German historicism to art history, see my "Historicism in Art History," in *The Encyclopedia of Aesthetics*, ed. Michael Kelly (New York: Oxford University Press, forthcoming).

17. In Fritz Saxl's history of the Warburg Library found in Gombrich, *Aby Warburg*, 325–38, it is difficult to determine if there was actually a particular day on which the library officially became part of Hamburg University and an Institute.

18. Edgar Wind, "Warburg's Concept of *Kulturwissenschaft* and Its Meaning for Aesthetics," in *The Eloquence of Symbols*, ed. Jaynie Anderson (Oxford: Clarendon, 1983), 25.

19. Ibid., 24–25; and E. H. Gombrich, *Aby Warburg*, 15–16. Gombrich introduces Burckhardt's book *The Civilization of the Renaissance in Italy* when he attempts to define the Warburgian project and *Kulturwissenschaft*. My work in this chapter attempts to dissolve Gombrich's compressed statement of the problem: "somehow the English language refuses to absorb either of the constituents of the compound *Kulturwissenschaft*."

20. Peter Murray, "Jacob Burckhardt's *Geschichte der Renaissance in Italien*," in *Scritti di storia dell'arte in onore di Roberto Salvini* (Florence: Sansoni, 1984), 574. Murray concludes by calling for a reconsideration of the role of biography, typology, and aesthetics in architectural history. My work in this chapter responds to such a call for the field of art history.

21. Wallace K. Ferguson, *The Renaissance in Historical Thought: Five Centuries of Interpretation* (Cambridge, Mass.: Riverside Press, 1948). For an excellent recent summary of views of the Renaissance, see Anthony Hughes, "Interpreting the Renaissance," *Oxford Art Journal* 11, 2 (1988): 76–87. A careful review of the use of the words *rinascità* and *rinascere* in the Renaissance can be found in M. L. McLaughlin, "Humanist Concepts of Renaissance and Middle Ages in the Tre- and Quattrocento," *Renaissance Studies* 2 (October 1988): 131–42.

22. Cassirer, "Force and Freedom," 409. Cassirer wrote his review of Burckhardt's historiography in 1944. He considered Burckhardt's acceptance of the individual over the group or collective to have been prescient not only of the Franco-Prussian conflict in his own time but also of the situation of Germany in World War II.

23. Ibid., 412.

24. This is a quotation from Gertrude Bing's valuable introduction to the Italian edi-

tion of Warburg's writing; see Aby Warburg, *La Rinascità del Paganesimo Antico* (Florence: La Nuova Italia, 1966), xviii.

25. Jacob Burckhardt, *The Civilization of the Renaissance in Italy* (New York: Harper & Row, 1958), 1: 21.

26. Cassirer, "Force and Freedom," 412.

27. Benjamin Nelson and Charles Trinkaus, introduction to Burckhardt, *Civilization*, 1: 7.

28. Ferguson, *The Renaissance in Historical Thought*, 174–77.

29. Werner Kaegi, *Jacob Burckhardt: Eine Biographie* (Basel: B. Schwabe, 1947–77), 3: 682–87.

30. Lucien Febvre, *Michelet et la Renaissance* (Paris: Flammarion, 1992), 14. Febvre makes interesting reading on the relationship of Burckhardt's idea of the Renaissance with Michelet's earlier ideas. Febvre's view of Michelet's contribution to the concept of the Renaissance is controversial. In any case, Burckhardt and the Germanic tradition are dominant in art history's understanding of the art and culture of the period, and my arguments here proceed from this understanding.

31. White makes this observation in *Metahistory*, 246. It is significant that the chronological boundaries of the Renaissance vary according to discipline, but that even from the beginning they appear to have been fluid.

32. Gombrich, *Aby Warburg*, 16.

33. Wind, "Warburg's Concept of *Kulturwissenschaft*," 26.

34. White characterizes Burckhardt's tone as "elegiac." This is apt whether or not we accept White's assertion that it indicates the political dimension of Burckhardt's view of his own moment in history; see, for example, White, *Metahistory*, 247: "The tone is elegiac, but the subjects of the picture are both savage and sublime. The 'realism' of the subject-matter stems from the refusal to hide anything crude or violent, yet all the while the reader is reminded of the flowers that grew on this compost heap of human imperfection. But the purpose is Ironic. Throughout the work, the unspoken antithesis of this age of achievement and brilliance is the gray world of the historian himself, European society in the second half of the nineteenth century. By comparison not even the Middle Ages suffered in the same way that the Modern Age does. The Renaissance was everything that the modern world is *not*. Or, rather, the Modern Age represents the one-sided development of all those traits of human nature which were sublimated into a great cultural achievement during the Age of the Renaissance. The Modern Age is a product of human *losses*. Something was misplaced during the period between 1600 and 1815, and this 'something' is 'culture.'"

35. Karl Löwith, *Samtliche Schriften 7: Jacob Burckhardt* (Stuttgart: J. B. Metzlersche, 1984), 374. This quotation comes from Löwith's review of Burckhardt's late historiographical essay *Force and Freedom*, also called *Reflections on History*. It should be compared with Cassirer's review of the same essay cited earlier.

36. Kaegi, *Jacob Burckhardt*, 3: 654–750.

37. Burckhardt, *Civilization*, 2: 324.

38. E. H. Gombrich, "In Search of Cultural History," in *Ideals and Idols: Essays on Values in History and Art* (Oxford: Phaidon, 1979), 37.

39. Burckhardt, *Civilization*, 2: 406.

40. Ibid., 2: 406.

41. Martin Kemp, *The Science of Art: Optical Themes in Western Art from Brunelleschi to Seurat* (New Haven: Yale University Press, 1990); Hubert Damisch, *The Origin of Perspective*, trans. John Goodman (Cambridge: MIT Press, 1994). Neither author deals with the arguments of the other, but both see perspective as profoundly important for understanding Brunelleschi, the culture of the Renaissance, and the project

of art making in general. Erwin Panofsky's classic essay on perspective has also appeared recently in translation; see Erwin Panofsky, *Perspective as Symbolic Form*, trans. Christopher S. Wood (New York: Zone Books, 1991). I have not been able to take into account the recent book on perspective by James Elkins, *The Poetics of Perspective* (Ithaca, N.Y.: Cornell University Press, 1994).

42. Damisch, *The Origin of Perspective*, 59.

43. On individual genius and German historicism, see most recently the excellent study by Carl Pletsch, *Young Nietzsche: Becoming a Genius* (New York: Free Press, 1991).

44. Gombrich, *Aby Warburg*, 141–44. Gombrich is quoting here and in the quotations that follow in this paragraph from a draft of a letter by Warburg to Adolph Goldschmidt dated August 1903.

45. Gombrich, *Aby Warburg*, 145.

46. E. H. Gombrich, "The Ambivalence of the Classical Tradition: The Cultural Psychology of Aby Warburg (1866–1929)," in *Tributes: Interpreters of Our Cultural Tradition* (Ithaca, N.Y.: Cornell University Press, 1984), 117–37.

47. The "centrality" implicit in *Kulturwissenschaft*'s conception of history has been seen by Gombrich to have been due to the influence of Hegel's image of a universal and unchanging Spirit as the guiding force of the dialectic of history; see E. H. Gombrich, "In Search of Cultural History," 24–57. I do not agree with many of the points made by Gombrich in this article, although I find the metaphor of the "spoked wheel" of cultural history interesting. Gombrich's views in this article should be compared with Cassirer's views expressed in the review of Burckhardt cited earlier. A recent assessment of Warburg's contribution to the history of art argues that he can be recuperated for other, more radical methods of understanding culture, such as feminism and Lacanian analysis; see Margaret Iversen, "Retrieving Warburg's Tradition," *Art History* 16 (December 1993): 541–53.

48. Wilhelm Dilthey, *Gesammelte Schriften* (Stuttgart: B. G. Teubner, 1960), 11: 70–76. I am grateful to Magdalena Zscholke for her help in refining my English translation of this review, which I will use here. White's critique of Burckhardt in *Metahistory* appears to owe much to Dilthey's assessment.

49. Michael Ann Holly, *Panofsky and the Foundations of Art History* (Ithaca, N.Y.: Cornell University Press, 1984), 34–42.

50. Hajo Holborn, "Wilhelm Dilthey and the Critique of Historical Reason," *Journal of the History of Ideas* 11 (1950): 93–118. This is the best discussion in English of Dilthey's philosophy of history. I am also indebted to the assessment of Dilthey found in David Couzens Hoy, *The Critical Circle: Literature, History and Philosophical Hermeneutics* (Berkeley and Los Angeles: University of California Press, 1978).

51. Holborn's excellent discussion in "Wilhelm Dilthey and the Critique of Historical Reason" of the interchangeability of the two terms in Dilthey's writing is important not only for semantic reasons but also because as a discussion it illustrates the complexities of the problems inherent in the term *Kultur* that I have been examining here. Therefore, I quote at length from it here (98–99 n. 25):

It is difficult to translate the German term "*Geisteswissenschaften*" into English. The German translator of J. S. Mill's *Logic*, I. Schick, in 1849 rendered the title of the sixth book, "On the logic of the moral sciences," as *Von der Logik der Geisteswissenschaften oder moralischen Wissenschaften*. The term *Geisteswissenschaften* spread amazingly quickly in Germany. For its general acceptance it was most important that Germany's leading scientist, H. Helmholtz, propagated the concept in his famous Heidelberg speech of 1862, "On the relation between the natural sciences and the totality of the sciences." As the English term "moral

sciences" superseded the older concept of "moral philosophy," so *Geisteswissenschaften* was used in Germany to describe more aptly what Hegel's philosophy of *Geist* or the romantic theory of *Volkgeist* had aimed at.

Dilthey had not yet used the new term *Geisteswissenschaften* in his article of 1875, "On the study of the history of sciences of man, society, and the state" (V, 31). Though he mentioned Mill's *"Logik der Geisteswissenschaften,"* he still preferred the term "moral-political sciences." In 1883 his *Einleitung in die Geisteswissenschaften* conceives of the *Geisteswissenschaften* as "the totality of the sciences which have historico-societal reality as their subject-matter." The book made the term classic in Germany. (Cf. for a full history of the term E. Rothacker, *Logik und Systematik der Geisteswissenschaften* [Munich, 1926] 3–16, in *Handbuch der Philosophie,* ed. A. Baumler and M. Schroter.) But even in the last years of his life Dilthey was still saying: "When beginning with the eighteenth century the need developed to find a common name for this group of sciences, they were called *sciences morales* or *Geisteswissenschaften* or ultimately *Kulturwissenschaften.* This change of names itself shows that none of them is quite adequate to what is to be defined." (VII, 86)

52. Dilthey, *Gesammelte Schriften,* 11: 70.

53. Ibid., 11: 71. On Burckhardt's antipathy to the Counter Reformation in *Civilization,* see Eckhard Heftrich, *Hegel und Jacob Burckhardt* (Frankfurt am Main: Vittorio Klostermann, 1971).

54. Cassirer, "Force and Freedom," 414. In the same review Cassirer regards Burckhardt's rejection of the role of the state in the explanation of culture to be anti-Hegelian: "To say that man possesses his whole spiritual reality only through the State was to him blasphemy. He regarded this Hegelian deification of the state as sheer idolatry, which he resisted with all his intellectual and moral power" (413).

55. Dilthey, *Gesammelte Schriften,* 11: 70.

56. Ibid., 11: 70. In *Metahistory* White argues that Burckhardt's liberal political agenda was already disappearing by the time *Civilization* was published, to be replaced by an ironic (and cynical) view of history. This latter view is clearly expressed in Burckhardt's historiographical writing; see Jacob Burckhardt, *Reflections on History* (Indianapolis: Liberty Classics, 1979).

57. Dilthey, *Gesammelte Schriften,* 11: 71.

58. Ibid., 11: 70.

59. On this point, see especially Hans Baron, *In Search of Florentine Civic Humanism: Essays on the Transition from Medieval to Modern Thought,* 2 vols. (Princeton, Princeton University Press, 1988); and Hans Baron, *The Crisis of the Early Italian Renaissance: Civic Humanism and Republican Liberty in an Age of Classicism and Tyranny* (Princeton: Princeton University Press, 1966).

60. On this statement, see the arguments and example following and my article, "*Lives* of Poets and Painters in the Renaissance," *Word and Image* 6 (April-June 1990): 154–62. For this debate in the contemporary commentaries on Dante, which provide supporting evidence for the arguments in this chapter, see Deborah Parker, *Commentary and Ideology: Dante in the Renaissance* (Durham, N.C.: Duke University Press, 1993).

61. Burckhardt's sources are concerned with literary (poets in the main) and artistic figures, or with the poetry by political leaders, like Lorenzo de' Medici; for example, Burckhardt concludes his book with the following: "Echoes of medieval mysticism here flow into one current with Platonic doctrines, and with a characteristically modern spirit. One of the most precious fruits of the knowledge of the world and of man here comes to maturity, on whose account alone the Italian Renaissance must be called the

leader of modern ages" (*Civilization*, 2: 516). This summation of the age and culture depends upon the vernacular poetry of Lorenzo. In the passage immediately preceding this one, Burckhardt justifies his reliance on the biographies and poetry as sources: "The theoretical works and even the letters of these men show us only half their nature" (*Civilization*, 2: 515).

62. Dilthey, *Gesammelte Schriften*, 11: 71.

63. These ideas of von Schlosser's on the periodization and character of the Renaissance as expressed in the early texts on art are found in his early writings on Ghiberti and later in his book *Die Kunstliteratur* (1924), which I will discuss in the next chapter. His essay on the Gothic is the one I use here: "On the History of Art Historiography— 'The Gothic,'" in *German Essays on Art History*, ed. Gert Schiff (New York: Continuum, 1988), 206–33.

64. Dilthey, *Gesammelte Schriften*, 11: 76–77.

# 4 / The Artist in History

1. Ernst Kris and Otto Kurz, *Legend, Myth, and Magic in the Image of the Artist: A Historical Experiment* (New Haven: Yale University Press, 1979). The German title of the book is *Die Legende vom Künstler: Ein historischer Versuch* (Vienna: Krystall Verlag, 1934).

The epigraph for this chapter is Otto Kurz (quoting Julius von Schlosser), "Julius von Schlosser: Personalità, Metodo, Lavori," *Critica d'Arte* 2 (1955): 406; my translation.

2. Julius von Schlosser, "Die Wiener Schule der Kunstgeschichte: Rückblicke auf ein Sakulum deutscher Gelehrtenarbeit in Österreich," *Mitteilungen des österreichischen Instituts für Geschichtsforschung* 13 (1934): 145–210; my translation. I am grateful to James Sievert for his help in translating this important but little noted article.

3. Ibid., 162. Von Schlosser credited the development of the use of a philological method in approaching the literature of art history to Moritz Thausing (1835–84), who had been the student of Rudolf Eitelberger (1819–85), the founder of the Österreichisches Museum, where von Schlosser held a position, and the first "modern" art historian in Vienna (159).

4. Kurz, "Julius von Schlosser," 408.

5. Kris and Kurz, *Legend, Myth, and Magic*, xi. According to Gombrich, Kurz had been working simultaneously on issues of Renaissance biography in his study of Fra Filippo Lippi; see Otto Kurz, "Zu Vasaris Vita des Fra Filippo Lippi," *Mitteilungen des österreichischen Instituts für Geschichtsforschung* 47 (1933).

6. Kris's work on the psychotic artist Franz Messerschmidt is invariably cited as evidence of his psychoanalytic interests before the war, although there is much else; see Ernst Kris, "A Psychotic Sculptor of the Eighteenth Century," in *Psychoanalytic Explorations in Art* (New York: Schocken Books, 1964), 128–50.

7. Kris and Kurz, *Legend, Myth, and Magic*, xiii.

8. Ibid., 2. In a note to the translation of this passage, Gombrich remarks that "these legends define 'the image of the artist.'"

9. Ibid., 3.

10. Ibid., 11.

11. Ibid.

12. Vladimir Propp, *Morphology of the Folktale*, 2d ed., rev. and ed. Louis A. Wagner (Austin: University of Texas Press, 1968). The usefulness of Propp in terms of narrative in film has been discussed by Teresa de Lauretis, *Alice Doesn't: Feminism, Semiotics, Cinema* (Bloomington: Indiana University Press, 1984), 118–22. Peter Wollen uses the

analysis of Propp's functions and spheres of action in his discussion of film narrative, which seems further from the symbolic and ideological level of narrative found by de Lauretis to be the most valuable part of Propp's work; see Peter Wollen, "North by Northwest: A Morphological Analysis," in *Readings and Writings* (London: Verso, 1982), 18-33.

13. Propp, *Morphology of the Folktale*, xxi.

14. Ibid., xi.

15. Ibid.

16. Michel Foucault, *The Archaeology of Knowledge*, trans. A. M. Sheridan Smith (London: Tavistock, 1972); Michel Foucault, *Power/Knowledge: Selected Interviews and Other Writings 1972–1977*, ed. Colin Gordon, trans. Colin Gordon et al. (New York: Pantheon Books, 1980); Michel de Certeau, *The Writing of History*, trans. Tom Conley (New York: Columbia University Press, 1988); Hayden White, *Tropics of Discourse: Essays in Cultural Criticism* (Baltimore: Johns Hopkins University Press, 1978).

17. The best account of the relationship of Kris and Kurz to von Schlosser can be found in the introduction to the English edition of their book, written by Ernst Gombrich; see Kris and Kurz, *Legend, Myth, and Magic*, xi. On the Viennese School of art history as a whole, see Udo Kultermann, *The History of Art History* (n.p.: Abaris Books, 1993), 157–70.

18. For von Schlosser's bibliography and recent articles on him, see the special issue of *kritische berichte* 16 (1988): esp. 49–60.

19. Kurz, "Julius von Schlosser," 414–17; Ernst Gombrich, "Obituary—Julius von Schlosser," *Burlington Magazine* 74 (1939): 98–99; Gian Lorenzo Mellini, "Storiografica Artistica di Julius von Schlosser," *Critica d'Arte* (1958): 288–98.

20. David Roberts, *Benedetto Croce and the Uses of Historicism* (Berkeley and Los Angeles: University of California Press, 1987).

21. See my article, "Historicism in Art History," in *The Encyclopedia of Aesthetics*, ed. Michael Kelly (New York: Oxford University Press, forthcoming).

22. Von Schlosser in the *Enciclopedia Treccani* (1929), quoted in Mellini, "Storiografica Artistica di Julius von Schlosser," 288; my translation.

23. Von Schlosser, "Die Wiener Schule," 181-89. On Riegl and von Schlosser, see Otto Pächt, *Methodisches zur Kunsthistorischen Praxis* (Munich: Prestel-Verlag, 1977), 141–52. I hope that the recent interpretations of Riegl's contributions to the history of art together with the work on von Schlosser here will finally provide the opportunity to historicize more completely the development of art history in Vienna; see Margaret Iversen, *Alois Riegl: Art History and Theory* (Cambridge, Mass.: MIT Press, 1993); Margaret Olin, *Forms of Representation in Alois Riegl's Theory of Art* (University Park: Pennsylvania State University Press, 1992). Central to such a project should be Meyer Schapiro, "The New Viennese School," *Art Bulletin* 18 (June 1936): 258–66.

24. Julius von Schlosser, *Die Kunstliteratur: Ein Handbuch zur quellenkunde der neueren Kunstgeschichte* (Wien: Anton Schroll, 1924), 265–68. These complaints occur in von Schlosser's book in his discussion of Vasari's *Lives*. Thus, they can be understood as his insistence on the essential dependence that art history has on the early Italian biographies.

25. See the chronological bibliography of von Schlosser's writing provided by Karl T. Johns in *kritische berichte* 16 (1988): 49–59. Von Schlosser's last book on Ghiberti appeared posthumously in 1941, *Leben und Meinungen des florentinischen Bildners Lorenzo Ghiberti* (Basel: Holbein-Verlag, 1941).

26. See especially von Schlosser's edition of Ghiberti's *Commentarii*, discussed at length here: Julius von Schlosser, *Lorenzo Ghibertis Denkwürdigkeiten (I Commentarii)* (Berlin: J. Bard, 1912).

27. Wolfgang Kallab, *Vasaristudien* (Vienna: Karl Graeser; Leipzig: B. G. Teubner, 1908), 140–49.

28. Ibid., 141; my translation. I am grateful to James Sievert for his help in translating Kallab's text.

29. Ibid., 151–57.

30. Von Schlosser, *Lorenzo Ghibertis Denkwürdigkeiten*, 206–7: "Dazu gehört, was schon des öftern unterstrichen wurde, dass das praktisch-biographische Element, obwohl in der Florentiner Künstleranekdote, die an Vasari einen eifrigen Abnehmer fand, üppigst wuchernd, beinahe gar keine Beachtung findet—von den zwei, in ihrem feierlichen Legendenton ganz anders wirk endem Geschichten von Cimabue und dem kölner 'Gusmin' abgesehen—; im Leben des früher erwähnten, von ihm als Künstler hochgeschätzten Bonamico gebraucht er nicht einmal dessen volkstümlich gewordenen übernamen Buffalmaco und berichtet keine einzige de Anekdoten Sacchettis darüber (in dennen Vasari Schwelgt), obwohl deren überlieferung auch zu ihm gedrungen ist. Ebenso fehlt das ausserlich biographische Moment so gut wie ganz in seiner eigenen Selbstbiographie, der ersten, die jemals ein Künstler geschrieben hat."

31. Ibid., 207. Ghiberti was no humanist, as Ottavio Morisani argued. His text can be seen to be part of a long-established tradition of chronicles, such as Giovanni Villani's, rather than as an example of a new empirically based narrative history, the way that von Schlosser characterized it; see Lorenzo Ghiberti, *I Commentarii*, ed. Ottavio Morisani (Naples: Riccardo Ricciardi, 1947), ix–xi. Von Schlosser's view seems to have changed from the time of the publication of *Die Kunstliteratur*, where he insisted that the models for Ghiberti were chronicles: "i suoi ricordi corrispondono tuttavia alla letteratura memorialistica apparsa assai presto in Firenze, e di cui e prezioso esempio la cronaca domestica di Donato Velluti (m. 1370)" (Julius von Schlosser, *La letteratura artistica: Manuale delle fonti della storia dell'arte moderna*, trans. Filippo Rossi [Florence: La Nuova Italia, 1964], 103). In the later book on Ghiberti, he insists on the narrative aspects of the new genre, which, according to him, Ghiberti invented.

32. Von Schlosser, *La letteratura artistica*, 101 (my translation): "Una delle manifestazioni più essenziali del Rinascimento sta nel ridestarsi del senso storico, che il Medio Evo non aveva conosciuto, o in ogni modo, aveva conosciuto in maniera diversa. Dobbiamo perciò collocare alla sommità non il teorico più significativo, L. B. Alberti, ma la veneranda figura dell'antenato della letteratura storico-artistica nel vero senso della parola, il grande scultore in bronzo Lorenzo Ghiberti (1378–1455); tanto più che egli provenendo direttamente dalla bottega di un pittore giottesco del secolo precedente, congiunge nella sua persona l'età nuova con l'antica, e nel suo celebre secondo Commentario comincia la sua autobiografia con la genealogia dei trecentisti."

33. Von Schlosser, *Lorenzo Ghibertis Denkwürdigkeiten*, 202, 205. In light of these prerequisites for the art historian, it is significant that von Schlosser wrote his own biography and that it appeared in the same year as *Die Kunstliteratur*; see Julius von Schlosser, "Ein Lebenskommentar," in *Die Kunstwissenschaft der Gegenwart in Selbstdarstellungen* (Leipzig: [1924]), 95–40. For a discussion of some of von Schlosser's views of the history of art, see Michael Podro, "Against Formalism: Schlosser on Stilgeschichte," in *Wien und die Entwicklung der Kunsthistorischen Methode, 1. Sonderdruck* (XXV Internationaler Kongress fuer Kunstgeschichte, Wein 4-10, 1983: 1984), 37–43, where he sees an "insistence on the monadic insularity of individual artists" to be a prime aspect of von Schlosser's writing.

34. Giorgio Vasari, *Lives of the Most Eminent Painters, Sculptors and Architects*, trans. Gaston du C. De Vere (London: Macmillan and Medici Society, 1912–15; reprint, New York: AMS Press, 1976), 2: 143–44. In Italian: "Ma perchè rade volte è che la virtu non sia perseguitata dall'invidia, bisogna ingegnarsi, quanto si puo il piu,

ch'ella sia da una estrema eccellenza superata, o almeno fatta gagliarda e forte a sostenere gl'impeti di quella: come ben seppe, e per meriti e per sorte, Lorenzo di Cione Ghiberti, altrimenti di Bartoluccio; il quale meritó da Donato scultore e Filippo Brunelleschi architetto e scultore, eccellenti artefici, esser posto nel luogo loro, conoscendo essi in verità, ancora che il senso gli strignesse forse a fare il contrario, che Lorenzo era migliore maestro di loro nel getto" (Giorgio Vasari, *Le opere di Giorgio Vasari*, ed. Gaetano Milanesi (Florence: Sansoni, 1906; reprint, 1981), 2: 222).

35. Vasari, *Lives*, 2: 201. In Italian: "E cosi a' consoli con buone ragioni persuasero che a Lorenzo l'opera allogassero, mostrando che il pubblico ed il privato ne sarebbe servito meglio. E fu veramente questo una bontà vera d'amici, e una virtu senza invidia, ed un giudizio sano nel conoscere se stessi; onde piu lode meritarono, che se l'opera avessino condotta a perfezione. Felici spiriti, che mentre giovavano l'uno all'altro, godevano nel lodare le fatiche altrui! . . . Fu da'consoli pregato Filippo che dovesse fare l'opera insieme con Lorenzo; ma egli non volle, avendo animo de volere essere piuttosto primo in una sola arte, che pari o secondo in quell'opera" (Milanesi, ed., *Le opere di Giorgio Vasari*, 2: 335-36).

36. On the important theoretical discussion called the *Paragone*, see (with bibliography) Claire J. Farago, *Leonardo da Vinci's Paragone: A Critical Interpretation with a New Edition of the Text in the Codex Urbinas* (Leiden: Brill, 1992).

37. Antonio di Tuccio Manetti, *The Life of Brunelleschi*, ed. Howard Saalman, trans. Catherine Enggass (University Park: Pennsylvania State University Press, 1970), 46-51 (in English and Italian).

38. Ibid., 78-79.

39. Richard Krautheimer and Trude Krautheimer-Hess, *Lorenzo Ghiberti* (1956; Princeton: Princeton University Press, 1970); see especially the preface to the second edition, ix-xxiv; and chapter 20, "Ghiberti the Writer," 306-14.

40. Ibid., xiv-xv.

41. Von Schlosser himself recognized that the origin of the Renaissance itself was the central conclusion to be drawn from Kallab's and his own views on Ghiberti. This is already expressed in his essay that preceded his 1910 edition of the *Commentarii*, "The Gothic." This essay has been translated by Peter Wortsman in *German Essays on Art History*, ed. Gert Schiff (New York, Continuum, 1988), 206-33. See also the valuable remarks on von Schlosser by Schiff in the introduction, liii-lvi. The Krautheimers rely a great deal on von Schlosser in this essay.

42. Von Schlosser, *La letteratura artistica*, 102-3.

43. Von Schlosser, "The Gothic," in *German Essays on Art History*, 206.

44. Linda Nochlin, "Courbet's *L'origine du monde*: The Origin without an Original," *October* 37 (1986): 76-86.

45. Paul Duro, "Quotational Art: Plus ça Change Plus C'est La Même Chose," *Art History* 14 (June 1991): 294-95. This is a review of an important volume of essays on originals, copies, and reproductions. The volume and the review contain a significant bibliography on the subject of origin, originals, and originality.

46. Roland Barthes, "The Death of the Author," in *Image Music Text*, ed. and trans. Stephen Heath (New York: Hill and Wang, 1977), 146.

47. Ibid., 142-48; Michel Foucault, "What Is an Author?" in *Language, Counter-Memory, Practice: Selected Essays and Interviews*, ed. Donald Bouchard, trans. Bouchard and Sherry Simon (Ithaca, N.Y.: Cornell University Press, 1977), 113-38. A useful summary of the authorship issue has been provided recently by Keith Moxey, *The Practice of Theory: Poststructuralism, Cultural Politics and Art History* (Ithaca, N.Y.: Cornell University Press, 1994), 51-61.

48. Nicholas Green, "Dealing in Temperaments: Economic Transformation of the

Artistic Field in France during the Second Half of the Nineteenth Century," *Art History* 10 (March 1987): 59–78; John Christie and Fred Orton, "Writing on a Text of the Life," *Art History* 11 (1988): 545–64; Griselda Pollock, "Agency and the Avant-Garde: Studies in Authorship and History by Way of van Gogh," *Block* 15 (1989): 4–15. Pollock's work on the artist develops from her earlier feminist critique; see her classic article "Artists, Mythologies and Media Genius, Madness and Art History," *Screen* 21 (1980): 57–96.

49. See Pollock's works cited earlier and Linda S. Klinger, "Where's the Artist? Feminist Practice and Poststructural Theories of Authorship," *Art Journal* 50 (summer 1991): 35–47, which includes a useful bibliography on the feminist issues. In *Alice Doesn't*, Teresa de Lauretis put the problem of the absolute artist for the feminist most succinctly: "If the mythical mechanism produces the human being as man and everything else as, not even 'woman,' but non-man, an absolute abstraction (and this has been so since the beginning of time, since the origin of plot at the origin of culture), the question arises how or with which positions do readers, viewers, or listeners identify, given that they are already socially constituted women and men?" (121).

50. This was an argument I made in the paper "The Image of the Artist in Cultural History and Cultural Theory," delivered at the annual meetings of the College Art Association of America in February 1992 and written in fall of 1991. I am grateful to Keith Moxey for providing me with that opportunity to outline many of the ideas more fully developed here. Moxey wants to use a Lacanian notion of subjectivity and a relativist position regarding the truth value of history to overcome the impasse of the problem of the artist in the authorship debates (*The Practice of Theory*, 57–61). While my approach here does not deny, and indeed may support, the usefulness of his suggestions, especially his call for a semiotic impetus in the interpretative process, the epistemological outcome of our approaches may be different.

51. W. K. Wimsatt and Monroe C. Beardsley, "The Intentional Fallacy," in *The Verbal Icon: Studies in the Meaning of Poetry* (Louisville: University of Kentucky Press, 1954), 3–18. The quotations that follow in this paragraph are taken from this article. A useful survey of the issue of intention and authorship in terms of the composer is made in Randall R. Dipert, "The Composer's Intentions: An Examination of Their Relevance for Performance," *Music Quarterly* (April 1980): 205-21.

52. Barthes, "The Death of the Author," 143.

53. Foucault, "What Is an Author?" 119.

54. Stephen Heath in *Theories of Authorship: A Reader*, ed. John Caughie (London: Routledge, 1981), 162.

55. Richard Shiff, "Mastercopy," *Iris* 1 (September 1983): 127.

# 5 / The Artist in Myth

1. Ernst Kris and Otto Kurz, *Legend, Myth, and Magic in the Image of the Artist: A Historical Experiment* (New Haven: Yale University Press, 1979), 52.

2. Ibid., 7. "Art History without artists," also called "Art History without Names," has been criticized thoroughly from the Marxist position by Arnold Hauser, "The Philosophical Implications of Art History: 'Art History without Names,'" in *The Philosophy of Art History* (New York: Knopf, 1959), 119–276. See also my discussion in the previous chapter.

3. Kris and Kurz, *Legend, Myth, and Magic*, 7. They also say, "For we shall have to exclude from consideration all that pertains to the actual position of the artist in society—what it was like in different historical periods and how it evolved."

4. Sigmund Freud, *Leonardo da Vinci and a Memory of His Childhood*, trans. Alan Tyson, ed. James Strachey (New York: Norton, 1961), 91–92. I use this version of Freud's essay on Leonardo throughout because it is the one most accessible to students and libraries.

5. Ellen Handler Spitz, *Art and Psyche: A Study in Psychoanalysis and Aesthetics* (New Haven: Yale University Press, 1985), 26–32. Spitz tries to rescue Freud's psychoanalytic biography, "pathography," from the most serious charges of Romantic criticism.

6. Ibid., 32–33. Spitz supports this sentiment in order to argue for the validity of Freud's method in the Leonardo essay.

7. Freud, *Leonardo da Vinci*, 34.

8. Ibid.

9. Thus, E. H. Gombrich is profoundly misleading when he writes in the preface to the English edition of *Legend, Myth, and Magic*: "for we must not lose sight of the main aim of the book—the establishment of links between the legend about the artist and certain invariant traits of the human psyche which psychoanalysis had begun to discern" (xiii).

10. Ibid., 131.

11. Ibid., 132.

12. E. H. Gombrich, preface to *Legend, Myth, and Magic*, by Kris and Kurz, xiii. Before its publication in book form in 1934, *Die Legende vom Künstler* had appeared in 1933 in the psychoanalytic journal *Imago*, a forum "designed exclusively for the application of psychoanalysis to the mental sciences"; see Sigmund Freud, *On the History of the Psycho-Analytic Movement*, trans. Joan Rivière, ed. James Strachey (New York: W. W. Norton, 1966), 47. In his biography of Kris, Gombrich notes that Freud himself invited Kris to become an editor of *Imago*. Gombrich characterizes *Imago* as "the journal which had been specifically founded to provide a meeting-ground between psychoanalysis and the study of cultural subjects"; see E. H. Gombrich, *Tributes* (Ithaca, N.Y.: Cornell University Press, 1984), 225. The first editor of *Imago* was Otto Rank.

13. Gombrich, *Tributes*, 225.

14. On many of the complicated issues that touch on this dialectic, see Hayden White, *Metahistory: The Historical Imagination in Nineteenth-Century Europe* (Baltimore: Johns Hopkins University Press, 1973); and Georg G. Iggers, *The German Conception of History: The National Tradition of Historical Thought from Herder to the Present* (Middletown, Conn.: Wesleyan University Press, 1983). For a recent assessment of some of these issues in the context of the Viennese School of art history, especially in the work of Alois Riegl, see Margaret Iversen, *Alois Riegl: Art History and Theory* (Cambridge: MIT Press, 1993). I have discussed the convergence of aesthetics and historicism in my essay, "Historicism in Art History," in *The Encyclopedia of Aesthetics*, ed. Michael Kelly (New York: Oxford University Press, forthcoming).

15. See, for example, Thomas Mann, "Freud's Position in the History of Modern Thought," in *Past Masters and Other Papers*, trans. H. T. Lowe-Porter (Freeport, N.Y.: Books for Libraries, 1968), 172–73: "As a delver into the depths, a researcher in the psychology of instinct, Freud unquestionably belongs with those writers of the nineteenth century who, be it as historians, critics, philosophers or archaeologians, stand opposed to rationalism, intellectualism, classicism—in a word, to the belief in mind held by the eighteenth and somewhat also by the nineteenth century; emphasising instead the night side of nature and the soul as the actually life-conditioning and life-giving element; cherishing it, scientifically advancing it, representing in the most revolutionary sense the divinity of earth, the primacy of the unconscious, the pre-mental, the will, the passions, or, as Nietzsche says, the 'feeling' above the 'reason.' I have used the

word 'revolutionary' in what seems a paradoxical and logically perverse sense; for we are used to associate the idea with the powers of light, with the emancipation of the understanding and with conceptions looking futurewards, whereas here the leading is in just the opposite direction."

16. Thomas Mann, "Freud and the Future," in *Essays of Three Decades*, trans. H. T. Lowe-Porter (New York: A. A. Knopf, 1947), 421. I used this quotation in the introduction to my dissertation, Catherine M. Soussloff, *Critical Topoi in the Sources on the Life of Gianlorenzo Bernini* (Ph.D. diss., Bryn Mawr College, 1982), 3.

17. See, for example, the foreword by H. T. Lowe-Porter in Mann, *Past Masters and Other Papers*, 6.

18. Donald Spence, *Narrative Truth and Historical Truth: Meaning and Interpretation in Psychoanalysis* (New York: W. W. Norton, 1982), 26.

19. This quotation is from the fine foreword by Robert S. Wallerstein to *Narrative Truth and Historical Truth*, by Spence, 11.

20. J. Laplanche and J.-B. Pontalis, *The Language of Psycho-Analysis*, trans. Donald Nicholson-Smith (New York: Norton, 1973), 439.

21. Hayden White, "Narrativity in the Representation of Reality," in *The Content of the Form: Narrative Discourse and Historical Representation* (Baltimore: Johns Hopkins University Press, 1987), 24.

22. Freud's paper, "A Fantasy of Leonardo," and the remarks of those present, among them Otto Rank, when the paper was delivered can be found in *Minutes of the Vienna Psychoanalytic Society*: 2 (1908–10), ed. Herman Nunberg and Ernst Federn, trans. M. Nunberg (New York: International Universities Press, 1967), 338–52.

23. On the important topic of the various editions of this work, see James Strachey's editorial note in Freud, *Leonardo da Vinci*, 3–7.

24. Otto Rank, *Der Kunstler: Ansätze zu einer Sexual-Psychologie* (Wien und Leipzig: Hugo Heller, 1907), trans. Eva Salomon with E. James Lieberman from the 4th ed., in *Journal of the Otto Rank Association* 15 (summer 1980). Citations are to this translation throughout.

25. This information is available in the two studies of Rank on which I have relied here: E. James Lieberman, *Acts of Will: The Life and Works of Otto Rank* (Amherst: University of Massachusetts Press, 1985); and Dennis B. Klein, *Jewish Origins of the Psychoanalytic Movement* (New York: Praeger, 1981).

26. James Strachey, editorial notes to *Leonardo da Vinci*, by Freud, 4; Strachey states that "the immediate stimulus to writing the present work appears to have come in the autumn of 1909 from one of his patients who, as he remarked in a letter to Jung on October 17, seemed to have the same constitution as Leonardo without his genius." The suppression of Rank's contribution to Freud's thoughts on the artist has to do with his later break with his mentor, Freud. Rank himself wrote an assessment of his early writing in 1930 in which he carefully distinguished the differences and similarities between his ideas on the artist and Freud's; see "Literary Autobiography of Rank, 1907–1930," *Journal of the Otto Rank Association* 16 (summer 1981): 3–38. Leonardo appears in Rank's work as early as 1905; see Lieberman, *Acts of Will*, 37.

27. Rank, *Der Kunstler*, 7.

28. Ibid., 10.

29. Ibid., 6.

30. See Rank, "Literary Autobiography of Otto Rank," 4.

31. Ibid., 39.

32. Ibid., 40.

33. Freud, *Leonardo da Vinci*, 29.

34. Rank, *Der Kunstler*, 48.

35. Ibid., 59.

36. Ibid., 57.

37. Ibid., 34.

38. Yosef Hayim Yerushalmi, *Freud's Moses: Judaism Terminable and Interminable* (New Haven: Yale University Press, 1991), brilliantly explores the significance of Moses for Freud's identity and his work. See also my essay "Jewish Identity and the Artist," Cultural Studies Colloquium, University of California Santa Cruz, May 17, 1994. The murder of Moses is key in Freud's *Moses and Monotheism*. Yerushalmi attributes Freud's theory to a historian: "Freud found the thesis that Moses had been slain by the Jews advanced by a scholar with no psychoanalytic orientation whatever, but with an international reputation as a biblical historian and archaeologist" (25). The appearance of the thesis in Rank at this early date reveals that Freud must have had this interpretation of Moses before he found scholarly confirmation for it. The myth of Jewish religious origins, that is, the Moses story, belongs to the originary years of psychoanalysis, and it appears in Rank in association with a theory of the repression of sexuality in a story of cultural origins, that is, the myth of the artist.

39. Kris and Kurz, *Legend, Myth, and Magic*, 3: "These preconceptions have a common root and can be traced back to the beginnings of historiography. Despite all modifications and transformations they have retained some of their meaning right up to the most recent past; only their origin has been lost to sight and must be painstakingly recovered."

40. Otto Rank, *The Myth of the Birth of the Hero and Other Writings*, ed. Philip Freund (New York: Alfred Knopf, 1964), 96. The term "biographic hero myths" can be found on page 14 in this edition of the same essay. In a later essay, Freud revealed his view of the uses of psychoanalysis in other fields of knowledge, particularly the study of myth. The work of Rank is mentioned here, and it should be kept in mind, distinct from that of Jung and Abrahams; see Freud, *On the History of the Psycho-Analytic Movement*, 35–36: "Most of these applications of analysis naturally go back to a hint in my earliest analytic writings. The analytic examination of neurotic people and the neurotic symptoms of normal people necessitated the assumption of psychological conditions which could not possibly be limited to the field in which they had been discovered. In this way analysis not only provided us with the explanation of pathological phenomena, but revealed their connection with normal mental life and disclosed unsuspected relationships between psychiatry and the most various other sciences dealing with activities of the mind. Certain typical dreams, for instance, yielded an explanation of some myths and fairy-tales. Riklin [1908] and Abraham [1909] followed this hint and initiated the researches into myths which have found their completion, in a manner complying with even expert standards in Rank's works on mythology [e.g. 1909, 1911b]."

41. Freud, *Leonardo da Vinci*, 9.

42. Ibid., 8.

43. Rank, *The Myth of the Birth of the Hero*, 96.

44. A good, general assessment of the Freud essay can be found in Elizabeth Wright, *Psychoanalytic Criticism: Theory in Practice* (London: Methuen, 1984), 29–32. She relies on Richard Wollheim, "Freud and the Understanding of Art," in *On Art and the Mind* (Cambridge: Harvard University Press, 1974), 202–19. There are many other studies of the essay, most recently, Earl Jackson Jr., *Strategies of Deviance: Studies in Gay Male Representation* (Bloomington: Indiana University Press, 1995), 53-73.

45. Freud, *Leonardo da Vinci*, 35. For my purposes here, it makes no difference whether the bird dreamed by Leonardo and translated by Freud was a vulture or a kite.

46. Ibid.

47. Wright, *Psychoanalytic Criticism*, 29.

186/ Notes to Chapter 5

48. Freud, *Leonardo da Vinci*, 16.

49. Laplanche and Pontalis, *The Language of Psycho-Analysis*, 92. Freud's theorizing of countertransference took place in an essay published in the same year as his work on Leonardo, 1910; see ibid., 93.

50. Wollheim, "Freud and the Understanding of Art," 202–5; Spitz, *Art and Psyche*, 56–58.

51. On the legendary Leonardo, see A. Richard Turner, *Inventing Leonardo* (Berkeley and Los Angeles: University of California Press, 1992).

52. Freud, *Leonardo da Vinci*, 91–92.

53. Spitz, *Art and Psyche*, 57.

54. Richard Wollheim, ed., *Freud: A Collection of Critical Essays* (Garden City, N.Y.: Anchor, 1974), ix.

55. Meyer Schapiro, "Freud and Leonardo: An Art Historical Study," in *Theory and Philosophy of Art: Style, Artist, and Society, Selected Papers* (New York: Braziller, 1994), 177. Schapiro's most recent thoughts on Freud's Leonardo essay appear in the same volume, 193-208.

56. Freud, *Leonardo da Vinci*, 9.

57. On the use of evidence by Freud and by art historians, see Carlo Ginzburg, "Clues: Roots of an Evidential Paradigm," in *Clues, Myths and the Historical Method*, trans. John and Anne Tedeschi (Baltimore: Johns Hopkins University Press, 1989), 96–125. The dialectic between the evidentiary and the unconscious raises the issue of intention, a full discussion of which is beyond the scope of this book; see Michael Baxandall, *Patterns of Intention: On the Historical Explanation of Pictures* (New Haven: Yale University Press, 1985). Gombrich also criticized psychoanalysis and Freud's essay on Leonardo in an article which predates Schapiro's by three years. The grounds for Gombrich's critique are that the point of interpretation should be the art object, not the artist. By making claims based on expressivity analyzable only through the connoisseurship of the expert and based on stylistic standards and on the lack of reliability on the part of psychoanalysis to interpret the intentions of the artist through motifs in his productions, Gombrich augments Schapiro's arguments based on an empirical critique; see Ernst Gombrich, "Psycho-Analysis and the History of Art," in *Meditations on a Hobby Horse* (London: Phaidon, 1963), 30–44.

58. See, however, Spitz, *Art and Psyche*, 54–65.

59. Schapiro, "Freud and Leonardo," 147.

60. Ibid., 178.

61. Ernst Kris, *Psychoanalytic Explorations in Art* (New York: Schocken, 1952), n.p.

62. Ibid., 57–58.

63. Gombrich, *Tributes*, 230.

64. Ibid., 228.

65. Ernst Kris and E. H. Gombrich, *The Principles of Caricature* (Harmondsworth: Penguin, [1940]).

66. Gombrich, *Tributes*, 232.

67. Kris, *Psychoanalytic Explorations*, n.p.

68. Saul Friedlander, *When Memory Comes*, trans. Helen R. Lane (New York: Farrar, Straus, Giroux, 1979). Friedlander writes in reference to his forced conversion from a Jewish atheism to Catholicism.

69. Joseph Koerner has recently remarked on this result of Schapiro's critique of Freud's *Leonardo da Vinci*; Joseph Leo Koerner, "The Seer," *New Republic*, January 9 & 16, 1995, 33–39.

70. See most importantly White, *Metahistory: The Historical Imagination in Nineteenth-Century Europe*. I am also indebted to the following three books on this

complicated historiographical issue, but there are many others to be consulted as well, for which see the bibliographies: Paul A. Bové, *Intellectuals in Power: A Genealogy of Critical Humanism* (New York: Columbia University Press, 1985), particularly 113–208; Iggers, *The German Conception of History*, particularly 174–268; and Peter Novick, *That Noble Dream: The "Objectivity Question" and the American Historical Profession* (Cambridge: Cambridge University Press, 1988).

71. On this, see the important book with earlier bibliography on the topic of Jewish emigration in the academy by H. Stuart Hughes, *The Sea Change: The Migration of Social Thought, 1930–1965* (New York: Harper & Row, 1975), 1: "In the perspective of the 1970's, the migration to the United States of European intellectuals fleeing fascist tyranny has finally become visible as the most important cultural event—or series of events—of the second quarter of the twentieth century."

72. Meyer Schapiro, "The New Viennese School," *Art Bulletin* 18 (June 1936): 258–66.

73. An exception would be the references to Viennese Jews in Colin Eissler, "*Kunstgeschichte* American Style: A Study in Migration," in *The Intellectual Migration: Europe and America, 1930–1960*, ed. Donald Fleming and Bernard Bailyn (Cambridge: Harvard University Press, 1969), 544–629. Eissler's work on this topic is an important ethnography of the discipline. I would also like to recognize his contribution at the Annual Meetings of the College Art Association of America in 1987 in the session on Panofsky chaired by Michael Ann Holly, in which he spoke of these same issues. See Margaret Olin, "The Absence of Jews in Art History," in *Too Jewish*, exhibition catalogue, Jewish Museum, N.Y., 1996. Karen Michels of the University of Hamburg has forthcoming a study of all German émigré art historians. I recently chaired a session on "Jewish Identity in Art History" at the annual meetings of the College Art Association of America, in which some of these issues were discussed. The papers delivered there will be published by University of California Press in a volume edited by myself. As an example of the pervasive influence of Jewish art historians, I use my own professional genealogy. As an undergraduate at Bryn Mawr College from 1969 to 1973, I studied with Charles Mitchell, who had been trained in England and influenced at the Warburg by Otto Kurz; James Snyder, who had worked at Princeton with Panofsky, as had Charles Dempsey; Arthur Marks, trained at the Courtauld Institute of Art; and Dale Kinney, a younger scholar who had just been at the Institute of Fine Arts, New York University, working with Richard Krautheimer and Walter Friedlaender. To my knowledge, only Marks was Jewish, but all of them were taught by Jewish refugees from Germany and Austria.

74. See John Murray Cuddihy, *The Ordeal of Civility: Freud, Marx, Lévi-Strauss and the Jewish Struggle with Modernity* (New York: Basic Books, 1974); Peter Gay, *Freud, Jews, and Other Germans: Masters and Victims in Modernist Culture* (New York: Oxford University Press, 1978); Yerushalmi, *Freud's Moses*; Sander L. Gilman, *The Case of Sigmund Freud: Medicine and Identity at the Fin de Siècle* (Baltimore: Johns Hopkins University Press, 1993).

75. David Carroll, foreword to *Heidegger and "the jews,"* by Jean-François Lyotard, trans. Andreas Michel and Mark S. Roberts (Minneapolis: University of Minnesota Press, 1990), vii.

76. Saul Friedlander, *Memory, History, and the Extermination of the Jews of Europe* (Bloomington: Indiana University Press, 1993).

77. Robert Wistrich, *Socialism and the Jews: The Dilemmas of Assimilation in Germany and Austria-Hungary* (East Brunswick, N.J.: Associated University Presses, 1982). In a later book, Wistrich cites Arthur Schnitzler's view of the possible responses to assimilation: "The choice of being counted as insensitive, obtrusive and cheeky; or of

being insensitive, shy and suffering from feelings of persecution," as quoted in *Between Redemption and Perdition: Modern Anti-Semitism and Jewish Identity* (Routledge: London, 1990), 99.

78. See especially the excellent study by Marsha Rozenblit, *The Jews of Vienna, 1867–1914: Assimilation and Identity* (Albany: State University of New York Press, 1983). A general survey of this problem can be found in George E. Berkley, *Vienna and Its Jews: The Tragedy of Success, 1880–1980s* (Cambridge, Mass.: Abt Books; Lanham, Md.: Madison Books, 1988), especially 29–67.

79. The autobiography by Stefan Zweig, a refugee of Vienna, is an example of the effects of the prewar dilemma of assimilation; see Stefan Zweig, *The World of Yesterday: An Autobiography* (New York: Viking, 1943). The excellent study by Leo Spitzer examines these issues of discrimination, exile, and assimilation in three case studies, only one of them of a Jew; see Leo Spitzer, *Life in Between: Assimilation and Marginality in Austria, Brazil, West Africa, 1780–1945* (Cambridge: Cambridge University Press, 1989). For the American situation, see Leonard Dinnerstein, *Anti-Semitism in America* (New York: Oxford University Press, 1994), esp. 105–74.

80. Udo Kulturmann, *The History of Art History* (n.p.: Abaris Books, 1993), 227–49.

81. Gombrich, *Tributes*, 242: "In March 1938 Hitler occupied Austria, in September of that year there followed the Munich crisis. The anxieties for relatives and friends still left at the mercy of their persecutors and the dread of the devastation that would accompany the almost unavoidable war created a nightmare situation which even those of us who lived through it find hard to recapture, let alone convey. Kurz had managed to arrange for his father to join him in England, but his mother had wished to stay close to her own mother and ultimately perished at the hands of the Nazis. It was a blow which he never mentioned even to his friends." On Kurz's reticence in another, later area of his personal life, the illness of his wife, see ibid., 246. The interesting and important recent interview of Gombrich by Didier Eribon reveals that Gombrich wants to downplay his Jewishness and the anti-Semitism in Vienna before the war; see Ernst Gombrich with Didier Eribon, *Looking for Answers: Conversations on Art and Science* (New York: Abrams, 1993), 27–28, 37–38.

82. Gombrich, *Looking for Answers*, 38.

83. Gombrich, *Tributes*, 238.

84. Ibid., 239–40.

85. Ibid., 240. It appears that Kris's wartime project on totalitarian propaganda at the New School of Social Research in New York with Hans Speier, which resulted in a book on German radio propaganda, *German Radio Propaganda: Report on German Home Broadcasts during the War* (Oxford: Oxford University Press, 1944), may have been the outcome of this interest in the prohibition of images; see Gombrich, *Tributes*, 231.

86. Gombrich, *Looking for Answers*, 180.

87. Lyotard, *Heidegger and "the jews,"* 28.

88. Erwin Panofsky, *Meaning in the Visual Arts* (Chicago: University of Chicago Press, 1955), 321–46. Compare this statement with Novick's thesis in *That Noble Dream*, cited earlier. For a discussion of Panofsky's adjustment to America, without, however, an emphasis on his Jewishness, see Joan Hart, "Erwin Panofsky and Karl Mannheim: A Dialogue on Interpretation," *Critical Inquiry* 19 (spring 1993): 534–66. I am grateful to the author for sharing her views on Panofsky's Jewish identity with me, although we differ on this subject significantly.

89. The place to begin assessing the genealogy of Panofsky's influence in art history, not the subject of this chapter, is Michael Ann Holly, *Panofsky and the Foundations of Art History* (Ithaca, N.Y.: Cornell University Press, 1984), and the bibliography cited

there. See also Silvia Ferretti, *Cassirer, Panofsky, and Warburg*, trans. Richard Pierce (New Haven: Yale University Press, 1989). The account of a symposium held in March 1992 in Berlin whose aim was to "reconsider Panofsky's position, achievements and influence" makes the same criticisms of art history's inability to understand its own history in light of the methods of even its most famous practitioners, precisely because it must deny its own institutional, national, and ethnic roots; see Charlotte Schoell-Glass, "Hamburg: A Symposium on Erwin Panofsky," *Burlington Magazine*, August 1992, 547–48: "There was, however, another feature to the conference that is more difficult to pinpoint—as by its very nature it could not come expressly to the fore: it seemed as if the proceedings were influenced considerably by what was not said, by avoided areas and topics. . . . Between the participants at the conference and the history of art history (for which Panofsky had to stand) there was *our* history. It seems hardly feasible to discuss the history of the discipline without acknowledging the fundamental changes that have thrown over most of the assumptions at the basis of our own judgments. How can one 'historicise' Panofsky, judging his judgments on the Cold War, or his concept of humanism, without taking into account one's own, rather turbulent most recent history? Can one really analyse post-war restoration objectively without referring to one's own role in the politics of institutionalised art history during the 1960's and 1970's?"

90. See, for example, Erwin Panofsky, *Perspective as Symbolic Form* (New York: Zone Books, 1991).

91. The language used by the Nazis is most applicable to thinking about this problem; see Berel Lang, *Act and Idea in the Nazi Genocide* (Chicago: University of Chicago Press, 1990). I hope to take up many of the ideas presented in this chapter in my next book, a study of the Viennese School of art history and its Jewish practitioners. Much of the material found in this chapter is necessarily suggestive due to the fact that it has only been the subject of study in very recent years.

92. Lyotard, *Heidegger and "the jews."*

# 6 / The Artist in the Text

1. Rosalie Colie, *The Resources of Kind: Genre Theory in the Renaissance*, ed. Barbara K. Lewalski (Berkeley: University of California Press, 1973), 17.

2. Giovanna Perini, "Biographical Anecdotes and Historical Truth: An Example from Malvasia's 'Life of Guido Reni,'" *Studi Seicenteschi* 31 (1990): 149–60.

3. Giovanni Pietro Bellori, *Le vite de pittori, scultori et architetti moderni* (Rome: Mascardi: 1672), 212.

4. Perini, "Biographical Anecdotes and Historical Truth," 156–58.

5. Ibid., 150.

6. Ernst Kris and Otto Kurz, *Legend, Myth, and Magic in the Image of the Artist: A Historical Experiment* (New Haven: Yale University Press, 1979), 2.

7. The best examples of the feminist and Marxist views are Griselda Pollock, "Artists, Mythologies and Media—Genius, Madness and Art History," *Screen* 21 (1980): 55–96; Roszika Parker and Griselda Pollock, *Old Mistresses: Women, Art, and Ideology* (London: Routledge, 1981); J. R. R. Christie and Fred Orton, "Writing a Text on the Life," *Art History* 11 (December 1988): 544–64; Griselda Pollock, *Vision and Difference: Femininity, Feminism, and the Histories of Art* (London: Routledge, 1988). An important critique of the methods for understanding the artist put forward by the Marxist critics has emerged in the work on van Gogh by Debora Silverman; see "Weaving Paintings: Religious and Social Origins of Vincent van Gogh's Labor," in *Rediscovering History: Culture, Politics, and the Psyche*, ed. Michael S. Roth (Stanford: Stanford

University Press, 1994), 137–68. Silverman wants a more nuanced idea of "the emergence of the notion of free artistic individualism that we assume to reign triumphant among the modernist avant-gardes of Europe" (149). While I would agree that every artist's idea of artistic individualism differs in degree, I would argue that "free artistic individualism" is not and never has been confined to only the avant-garde. It adheres to the concept "artist" from the Renaissance on.

8. Roland Barthes, *Mythologies*, trans. Annette Lavers (St. Albans: Paladin, 1973; reprint, 1976), 109–59.

9. Claude Lévi-Strauss, *Myth and Meaning: The 1977 Massey Lectures* (New York: Schocken Books, 1978); Claude Lévi-Strauss, *Structural Anthropology*, trans. Claire Jacobson and Brooke Grundfest Schoepf (New York: Harper/Collins, 1963), especially 206–31; C. G. Jung, *The Archetype and the Collective Unconscious*, trans. R. F. C. Hull, 2d ed., Bollingen Series, vol. 20 (Princeton: Princeton University Press, 1968); Bronislaw Malinowski, *Myth in Primitive Psychology* (Westport, Conn.: Negro Universities Press, 1926); and what follows later here, especially the bibliography in Detienne and Kris and Kurz. For a recent historiographical approach to myth, see Marc Manganaro, *Myth, Rhetoric, and the Voice of Authority: A Critique of Frazer, Eliot, Frye, and Campbell* (New Haven: Yale University Press, 1992).

10. Marcel Detienne, *The Creation of Mythology*, trans. Margaret Cook (Chicago: University of Chicago Press, 1986), 63. The words in quotation marks are taken from Xenophon, *L'art de la chasse*.

11. Barthes, *Mythologies*, 158–59: "It seems that this is a difficulty pertaining to our times: There is as yet only one possible choice, and this choice can bear only on two equally extreme methods: either to posit a reality which is entirely permeable to history, and ideologize; or, conversely, to posit a reality which is *ultimately* impenetrable, irreducible, and in this case, poetize. In a word, I do not yet see a synthesis between ideology and poetry (by poetry I understand, in a very general way, the search for the inalienable meaning of things)." See also his preface to the 1970 edition in the volume cited here, 9.

12. Roland Barthes, "The Death of the Author," in *Image, Music, Text*, ed. and trans. Stephen Heath (New York: Hill and Wang, 1977), 142–48; Michel Foucault, "What Is an Author?" *Language, Counter-Memory, Practice: Selected Essays and Interviews*, ed. Donald Bouchard, trans. Donald Bouchard and Sherry Simon (Ithaca, N.Y.: Cornell University Press, 1977). See also Alexander Nehamas, "Writer, Text, Work, Author," in *Literature and the Question of Philosophy*, ed. Anthony Cascardi (Baltimore: Johns Hopkins University Press, 1987), 265–91; and Keith Moxey, "Authorship," in *The Practice of Theory: Poststructuralism, Cultural Politics, and Art History* (Ithaca, N.Y.: Cornell University Press, 1994), 51–61.

13. The best work on *auteur* theory and theories of authorship in film studies can be found in *Theories of Authorship: A Reader*, ed. John Caughie (London: Routledge, 1981). Griselda Pollock has tried to integrate a variety of approaches to authorship in her investigation of her project on van Gogh; see Griselda Pollock, "Agency and the Avant-Garde: Studies in Authorship and History by Way of van Gogh," *Block* 15 (1989): 4–15.

14. Bill Nichols, *Representing Reality: Issues and Concepts in Documentary* (Bloomington: Indiana University Press, 1991), 254.

15. Hayden White, "The Value of Narrativity in the Representation of Reality," in *The Content of the Form: Narrative Discourse and Historical Representation* (Baltimore: Johns Hopkins University Press, 1987), 1–25.

16. For this and what follows here, see Hayden White, "The Fictions of Factual Representation," in *Tropics of Discourse: Essays in Cultural Criticism* (Baltimore: Johns Hopkins University Press, 1978), 126–29.

17. Catherine M. Soussloff, *"Lives* of Painters and Poets in the Renaissance," *Word and Image 6* (April-June 1990): 154–62. The use of the early *Lives* of poets as models for the *Lives* of artists is related in many significant ways to the formation and models of the former.

18. White, "The Fictions of Factual Representation," 126.

19. Tzvetan Todorov, *Genres in Discourse*, trans. Catherine Porter (Cambridge: Cambridge University Press, 1990), 3. Todorov is quoting Aristotle's *De Poetica* here.

20. I have spoken about the differences between the two in Soussloff, *"Lives* of Poets and Painters in the Renaissance," 158.

21. Gilles Deleuze, "The Fold," *Yale French Studies* 80 (1991): 227–47. See also Gilles Deleuze, *The Fold: Leibniz and the Baroque*, trans. Tom Conley (Minneapolis: University of Minnesota Press, 1993).

22. Pollock, "Agency and the Avant-Garde," 4–15, makes some of these same conclusions regarding other genres of writing about the artist and art.

23. Kris and Kurz, *Legend, Myth, and Magic*, 11: "Speaking in the most general terms, we can say that we seek to understand *the meaning of fixed biographical themes.* In this sense the anecdote can be viewed as the 'primitive cell' of biography. While this is obviously valid of biography in general, it is particularly true and historically proven in the case of the biography of artists." The use of the adjective "primitive" in this context is significant given that the authors seek an understanding of "the time when the graphic artist became a member of the 'community of geniuses' and when his environment began to regard him as it did other creative personalities" (12). The idea of a pre-legend or image of the artist, the "primitive cell" of the image of the artist, relates to ideas of the primitive, especially in art, which Marianna Torgovnick has explored in her book; see Marianna Torgovnick, *Gone Primitive: Savage Intellects, Modern Lives* (Chicago: University of Chicago Press, 1990).

24. Kris and Kurz, *Legend, Myth, and Magic*, 11.

25. On the circle of critical interpretation, see David Hoy, *The Critical Circle: Literature, History, and Philosophical Hermeneutics* (Berkeley, Los Angeles, London: University of California Press, 1982).

26. Joel Fineman, "The History of the Anecdote: Fiction and Fiction," in *The New Historicism*, ed. H. Aram Veeser (New York: Routledge, 1989), 49–76. In all of what follows from Fineman I am referring to the same paragraph, found on page 67, in his essay. A large part of his essay concerns itself with representations of history seen through the problematic of anecdote, and as such is not central to my argument here. I am grateful to Harry Berger Jr. for bringing this article to my attention in our jointly offered seminar "Culture and Society in Early Modern Europe," winter and spring 1992, and to our student Scott Mobley for his observations.

27. Roland Barthes, "The Reality Effect," in *The Rustle of Language*, trans. Richard Howard (Berkeley and Los Angeles: University of California Press, 1989), 141–54. Compare what Barthes says here of the "referential illusion" with Detienne's myth residing in the "site of illusion," quoted earlier.

28. On artist anecdotes in Greek writing, see the fundamental study by J. J. Pollitt, *The Ancient View of Greek Art: Criticism, History, and Terminology* (New Haven: Yale University Press, 1974), who states that the artist anecdote "can be traced at least as far back as Duris of Samos (ca. 340–260 B.C.)" (9).

29. Pliny the Elder, *Natural History*, trans. H. Rackham, the Loeb Classical Library (Cambridge: Harvard University Press; London: William Heinemann, 1984), 309–10. For Pliny's artist anecdotes, see also Pliny the Elder, *The Elder Pliny's Chapters on the History of Art*, trans. K. Jex-Blake, ed. E. Sellers (London: Macmillan, 1896); Jacob Isager, *Pliny on Art and Society: The Elder Pliny's Chapters on the History of Art* (Lon-

don: Routledge, 1991); and the important review of the last by Alice Donohue, *Bryn Mawr Classical Review* 3 (1992): 192–97.

30. Pollitt, *The Ancient View of Greek Art*, 78.

31. Charles Dempsey, *Annibale Carracci and the Beginnings of Baroque Style* (Gluckstadt: J. J. Augustin Verlag, 1977), 72.

32. Norman Bryson, *Vision and Painting: The Logic of the Gaze* (New Haven: Yale University Press, 1983), 1.

33. Fredric Jameson, *Signatures of the Visible* (New York: Routledge, 1990), 139, 140.

34. Ibid., 140.

35. James Clifford, *The Predicament of Culture: Twentieth-Century Ethnography, Literature, and Art* (Cambridge: Harvard University Press, 1988), 40–41; Geertz's essay is most accessible in Clifford Geertz, *The Interpretation of Cultures* (New York: Basic Books, 1973), 412–53.

36. There are essential elements of the original narrative that the anecdote inhabited that are missing in its citation by Clifford and in the construction of the anecdote in Geertz's own narrative. Some of these are discussed by Kathleen Biddick in her gloss of the police raid, when she focuses on the missing body of Mrs. Geertz, who accompanied her husband on this field work and appears earlier in the essay; see Kathleen Biddick, "Bede's Blush: Postcards from Bali, Bombay, Palo Alto," in *Past and Future of Medieval Studies*, ed. John Van Engen (Notre Dame, Ind.: University of Notre Dame Press, 1994), 18–23.

37. Kris and Kurz, *Legend, Myth, and Magic*, 10.

38. See the excellent introduction by Arthur E. R. Boak to the translation of *Anekdota*: Procopius of Caesarea, *Secret History*, trans. Richard Atwater (Ann Arbor: University of Michigan Press, 1961), v–xvi.

39. Ibid., viii.

40. For an excellent overview of all of the aspects of secrets, see Sissela Bok, *Secrets: On the Ethics of Concealment and Revelation* (New York: Pantheon Books, 1982). In my thinking about the impact that printing had on the anecdote and the revelation or subversive publication of the secrets of the form, I am indebted to Elizabeth Eisenstein's work on the invention of printing and its impact on public knowledge in the Early Modern period; see Elizabeth Eisenstein, *The Printing Press as an Agent of Change: Communication and Cultural Transformations in Early Modern Europe* (Cambridge: Cambridge University Press, 1979). I have also benefited here from Alvin Kernan, *Samuel Johnson and the Impact of Print* (Princeton: Princeton University Press, 1987).

41. The important bibliography on these complicated topics can only be covered superficially here. On the status of the artist in the Early Modern period, begin with Bruce Cole, *The Renaissance Artist at Work: From Pisano to Titian* (New York: Harper & Row, 1983); and Svetlana Alpers, *Rembrandt's Enterprise* (Chicago: University of Chicago Press, 1990). On the guild system, changing regulations, and the art market, see Michael Baxandall, *Painting and Experience in Fifteenth-Century Italy: A Primer in the Social History of Pictorial Style* (Oxford: Clarendon, 1972); and Richard A. Goldthwaite, *Wealth and the Demand for Art in Italy* (Baltimore: Johns Hopkins University Press, 1994). On the early academies of art and their aims and practices, see Nikolaus Pevsner, *Academies of Art Past and Present* (Cambridge: Cambridge University Press, 1940); Dempsey, *Annibale Carracci*; and *Children of Mercury: The Education of Artists in the Sixteenth and Seventeenth Centuries*, exhibition catalog, Brown University, 1984.

42. Giorgio Vasari, *Lives of the Most Eminent Painters, Sculptors and Architects*,

trans. Gaston du C. De Vere (London: Macmillan and Medici Society, 1912–15; reprint, New York: AMS Press, 1976), 2: 78.

43. *Oxford English Dictionary*, 2d ed., s.v. "gossip."

44. See, for example, Martin Kemp, "Lust for Life: Some Thoughts on the Reconstruction of Artists' Lives in Fact and Fiction," in *XXVIIè Congrès International d'Histoire de l'Art, Actes. L'Art et les révolutions*, ed. Sixten Ringbom (Strasbourg: Société Alsacienne pour le Developpement de l'Histoire de l'Art, 1992), 182. In this article Kemp attempts to come to terms with the tension in artists' biographies and in the monographs on the artist by focusing on the dichotomy, fact and fiction. He situates "the practice of historical biography" and the production of art "in a special and wholly incestuous relationship." I am obviously in agreement here with this assessment except for the fact that *incestuous* is a term with a negative culture connotation, a sentiment that I would not impute to the biographies and the production of art but rather to the practice or limits of art history in dealing with these texts up until now.

45. John Guare, *Six Degrees of Separation* (New York: Random House, 1990), 117–18.

46. Kris and Kurz, *Legend, Myth, and Magic*, 12.

47. Claude Lévi-Strauss, *Totemism* (Boston: Beacon Press, 1963). For a recent assessment of the basics of Freud's totem theories by a historian, see the provocative book by Yosef Hayim Yerushalmi, *Freud's Moses: Judaism Terminable and Interminable* (New Haven: Yale University Press, 1991), especially 113 n. 6, for a bibliography of the criticism of Freud's theory of culture.

# Index

Compiled by Jeanne Lance

*Catherine M. Soussloff* is an associate professor of art history and visual culture at the University of California, Santa Cruz, where she teaches the history of European visual culture, including the philosophy, aesthetics, and postmodern theories of visual media. Professor Soussloff has published numerous articles in interdisciplinary journals and lectured internationally on subjects related to the critique of visual culture. *The Absolute Artist* is the result of six years of research in England, Italy, and New York, where she was Visiting Fellow at the Institute for the Humanities at New York University and the recipient of a National Endowment for the Humanities Fellowship for College Teachers.